How to draw and paint
texture

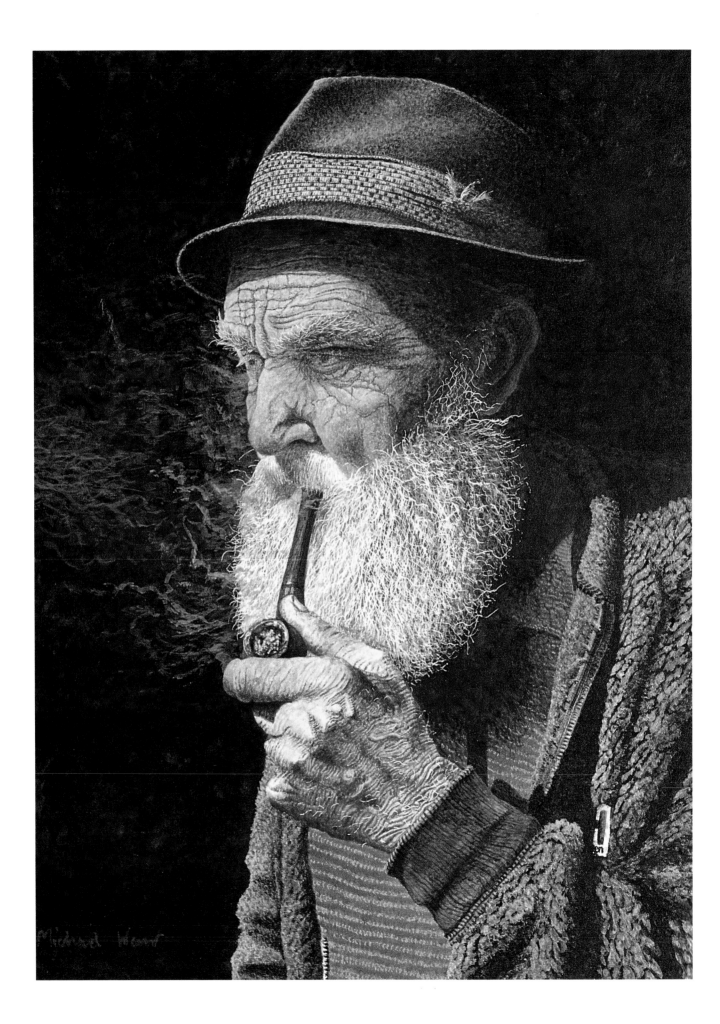

How to draw and paint
texture

Martin Davidson

CHARTWELL
BOOKS, INC.

A QUARTO BOOK

Published by Chartwell Books
A Division of Book Sales, Inc.
110 Enterprise Avenue
Secaucus, New Jersey 07094

This edition produced for sale in the U.S.A.
its territories and dependencies only.

ISBN 1-55521-790-7

This book was designed and produced by
Quarto Publishing plc
The Old Brewery
6 Blundell Street
London N7 9BH

Senior Editor Hazel Harrison

Senior Art Editor Penny Cobb
Designer Allan Mole

Picture Researcher Mandy Little
Photographers Paul Forrester, Jon Wyand

Art Director Moira Clinch
Publishing Director Janet Slingsby

Typeset in Great Britain by En to En
Printed in Singapore by
Star Standard Industries Private Ltd
Manufactured in Singapore by
Eray Scan Private Ltd

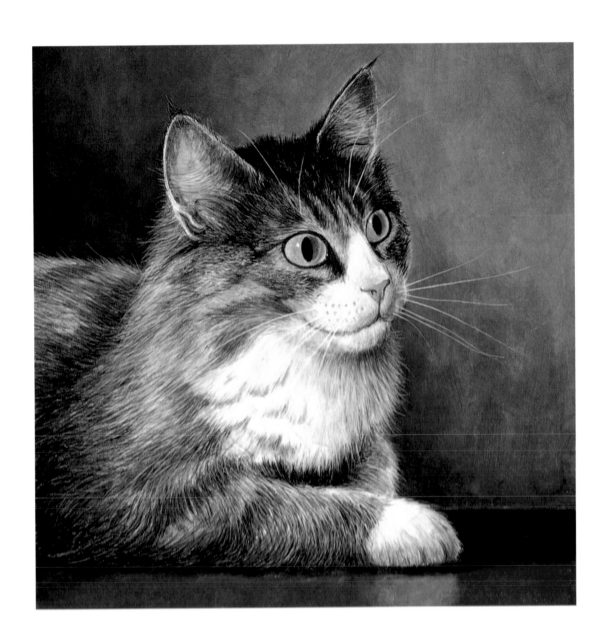

Contents

Introduction

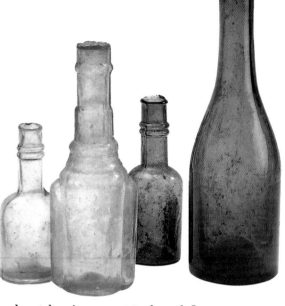

The idea for this book began many years ago when I was teaching painting at an American university. While taking a drawing class, one of my students asked: "How do you draw a cat's ear?" Never having considered the problem before, and not having a cat to hand, I was stumped. I confessed that I didn't know but suggested it might be similar to drawing the fur on the rest of the animal. It was an unwise reply, because the next question also defeated me: "How do you draw fur?"

In many cases the artist can get away with suggestion. The smudge of the pencil, a jerky broken contour line or a well-placed brushstroke all become tricks of the trade, part of the language to convey the characteristics of a surface. However, there are often occasions when the description of textural qualities is central to what the artist is trying to express, and the surfaces and materials have to be studied in greater depth. For example, the texture of an old gatepost or lichen-covered rock may be the focal point of a landscape, or you may want to bring out the soft bloom of a peach in a still life or the feeling of silk, satin or velvet in a portrait.

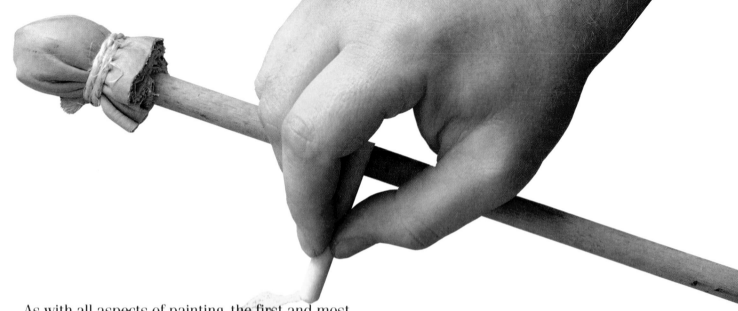

As with all aspects of painting, the first and most important task is learning to analyse your subject and grasp the essential elements, but technique also plays a vital role. Without it, even though you may understand a texture very well and be able to relate it to form and colour in your mind, you could find yourself without the

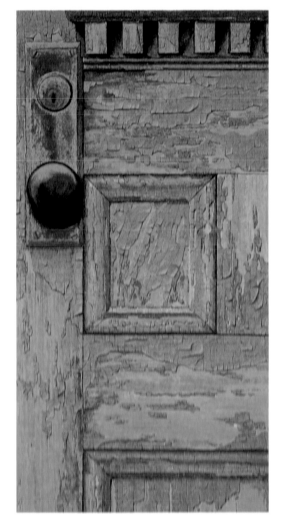

means to describe it. This book provides some ideas about how each of the drawing and painting media can best be used to represent the surface features of a wide variety of subjects, from plants, trees and stones, through animals and birds, to the most elusive and challenging of all subjects, skin and hair.

Each chapter begins by outlining general principles, such as composition and lighting, and then gives complete coverage of all the drawing and painting media. The text is illustrated with finished paintings by a wide range of artists as well as clear step-by-step demonstrations showing a selection of useful techniques, some conventional and others less so. The purpose is not to provide a rule book of how to paint fur, fruit or tree bark, but to offer some of the options. Ultimately, all artists have to find their own solutions to painting "problems", and hopefully this book will help you towards this goal.

Fruit, vegetables and other edibles have always been among the most popular painting subjects. Not only do they display a marvellous range of

▶ For a subject like this, with its delicate colours, hard surface and crisp edge qualities, watercolour or mixed media could be a good choice. Arrange the lighting carefully so that it brings out the descriptive highlights.

FRUIT & FOOD

▲ The soft outer skin and thin delicate membranes of fungi can make an exciting challenging subject, whichever medium is chosen.

textures and colours, they also stimulate the taste buds. A skilful artist can almost make us feel the soft down on a peach and taste a crusty, crumbling loaf of fresh bread. This chapter looks at some of the techniques that can be used to convey these qualities as well as providing ideas on choosing subjects and setting up a still life group which provides an interesting range of textural contrasts.

▶ Fish scales can be difficult to capture, but often you can create the effect by picking out just one or two scales.

◀ Crumbly, oily, pitted, sometimes glazed and sometimes streaked, cheeses offer a wide variety of textures.

▶ The leaves of a Savoy cabbage combine texture and pattern, making an absorbing subject.

▲ Nuts, too, provide a wide range of textures, from smooth and shiny to deeply indented and pitted.

▶ Slicing vegetables or fruit in half opens up further possibilities.

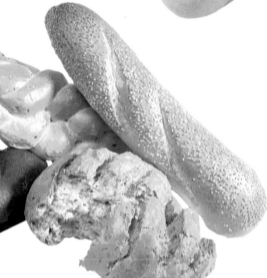

▲ The contrasting textures of the glazed crust and the crumbly inside have attracted many artists.

▲ The characteristic soft down on a peach softens both the contours and the colours.

▶ The familiar string of garlic offers a ready made still life.

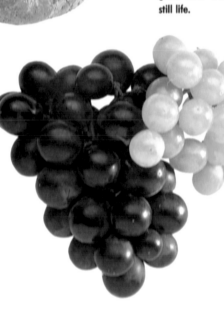

▲ Careful observation of the highlights is the key to describing the elusive bloom and translucency of grapes.

▶ Still life painters often achieve contrasts of texture and pattern by cutting a fruit in half.

When you are choosing a culinary still life subject the first thing to remember is that you don't necessarily need a huge variety of different objects, but if you want to make the most of textures, you do need some contrast. A bowl of mixed fruit, such as apples, oranges and peaches, would provide a variety of textures, and you could increase the range by combining raw and cooked food, for example a loaf of bread and perhaps a piece of cold pie with a selection of fruit or vegetables.

Also, try to choose objects to paint that really excite you and provide a challenge in terms of technique. Fine paintings can be made from very simple subjects such as one or two apples on a rough wooden table but apples are so familiar that it is easy to just go through the motions on "auto-pilot". Don't decide to draw or paint something just because it is there – go to the supermarket or greengrocer and have a look round for inspiration. The less familiar you are with the subject the more closely you will have to look at it and consider the best way of tackling the different textures.

A common way of introducing more visual interest into a still life painting has been to reveal the inside of the fruit or vegetable. A galia melon, for example, with a slice cut out, creates a fascinating subject, the orange flesh contrasting with the hard, neutral outer skin. It is quite common to see paintings featuring pomegranates, torn apart to reveal the soft translucent fruit inside, and peeling fruit, too, can provide an intriguing mixture of textures and forms. In many Dutch still lifes you will see the importance given to the spiralling form of orange peel, which not only provides compositional interest but also acts as a foil to the translucent flesh of the fruit.

In the past, vegetables were less popular than fruit as still life subjects, perhaps because of their more lowly status, but possibly also because they do not appeal to the taste buds in the same way. Nowadays, however, more and more artists are discovering their possibilities, and if you look at the extraordinary range of textures, colours and shapes you can see why. To take a few examples, there are the delicate velvety mushrooms, the thin-skinned, subtly coloured onions, the rough, horny swedes or celeriac, the delightfully crinkly Savoy cabbage and the shiny, light-reflecting aubergines and green and red peppers. Any of these, like fruit, can be cut to provide additional textural contrast and introduce a pattern element, which widens the range still further.

Drawing & Painting

FRUIT & FOOD

Training the eye

Starting with a monochrome drawing can be an excellent way of gaining familiarity with textures. Because you are denied the luxury of colour you are forced to observe very closely and use your ingenuity to find marks that will convey what you see. Pencil is a good medium to begin with, as it combines precision with great flexibility. Here the artist has started with a clear linear contour within which light hatching and scribbles suggest the elusive reflective surfaces. The drawing below is in pen and ink, which demands a more methodical approach. A loose crosshatching has been used to control the tones, with a variety of marks, including light scribbling, delineating the shiny skin and dark markings. The form is hinted at by a few small parallel lines near the lower line of the fish.

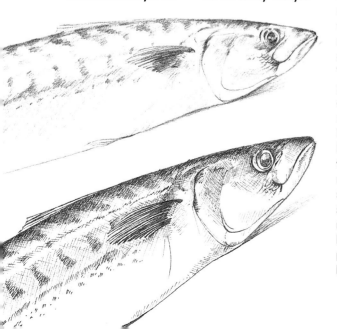

THE ARRANGEMENT

One of the best pieces of advice I was ever given about still life was to study the range of foods and objects on a table during or after a meal. Whether it was a boiled egg and a piece of toast or the remains of a three-course meal, the range of subjects seemed endless, while the rather haphazard arrangement of the food and other objects often suggested interesting and natural-looking compositions. In general, a still life should not look too "posed", but the casual look we see in a painting such as Chardin's *La Brioche* (see page 26) is in fact achieved only by careful arrangement of objects. Most still life painters will spend a considerable amount of time carefully considering the options before deciding to start a painting, experimenting by bringing in objects, removing others and adjusting groupings – always looking to the main overall composition.

For the beginner it is always best to start off with a limited number of objects – perhaps no more than five or six – and to arrange them in a simple composition. In the Chardin painting the objects are organized in a rough pyramid, the bowl and bottle being at the base and the blossoming orange twig at

the apex. All the other objects are fitted into this basic structure, giving a composition which is both straightforward and natural.

In choosing the objects for the painting pay special attention to the contrast and balance of different textures, so that you can juxtapose smooth with rough, shiny with matt and hard with soft.

The more visual excitement and contrast you can introduce into the subject the more challenging it will become and the more you will be able to get out of it. But don't overdo it; just as in a play or film, too many contrasts and dramatic juxtapositions will tend to confuse the viewer.

RHYTHMS AND RELATIONSHIPS

These are the cement that binds a composition together. The more disparate the objects in a composition the more important it is to establish strong visual links between them all. To achieve this it is necessary to employ a number of simple strategies.

The first of these is to simplify the arrangement of the objects by forming groupings so that the eye does not constantly have to leap from one to another. If you have decided on fruit, for example, try grouping them together next to a bowl, or linking the colours in them to other objects.

Don't be afraid to overlap objects so that there are no awkward pauses or sudden jumps – overlapping establishes relationships, and so does allowing shapes and lines to find echoes elsewhere in the composition.

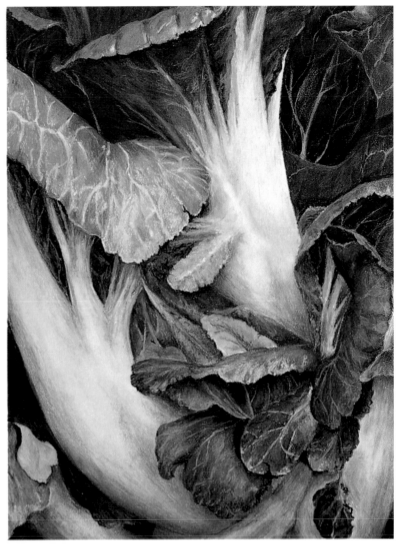

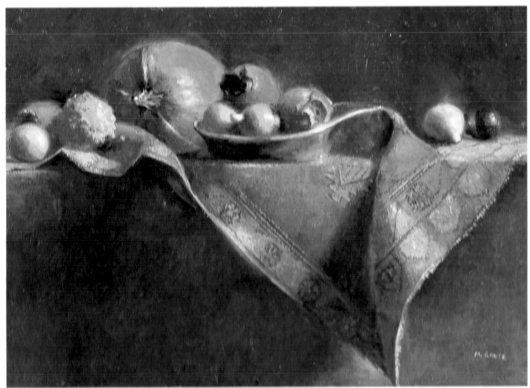

▲ **Sometimes Stir Fried**
BILLIE NUGENT
Oil pastel
A detail of a subject can often make an unusual and bold composition. Here the artist has chosen to explore both the pattern of light and dark and the varied textures, contrasting thick white stalks with crinkly and delicately veined leaves.

◄ **Autumn Still Life**
MARY ANNA GOETZ
Oil
This group has clearly been chosen for its vivid but harmonious colour, but the artist has also shown the subtle textural differences, painting wet-in-wet with skill and assurance.

If you have round fruit and perhaps a round jug, see if you can arrange them so that the edge of the fruit finds an echo in the line of the jug, or perhaps in part of the background.

LIGHTING

Once you have arranged the group you will need to think about how best to light it so that you can see the textures and colours clearly. This will almost certainly involve some trial and error, but it is worth taking time before you start to paint, as both the strength of the light and its direction will affect the subject quite dramatically. A harsh light from directly in front, for instance, is seldom satisfactory, as it flattens out the subject. If you are using light from a window, try moving the table or tray on which you have set up your group until you find the best position.

The new daylight simulation bulbs, which can be placed in an ordinary table lamp, are useful for still life. They provide a constant and unchanging light source, unlike daylight which changes from one hour to the next.

Light coming from behind and to one side of the artist is one of the commonest forms of illumination. It will provide good lighting for both your working surface and the subject without too many shadow areas. Oblique lighting is particularly well suited to subtle textures such as fruit where the highlight is towards the middle of the object and the receding planes reflect less light, thus helping to give form and volume.

Consider also the side from which you want the light to strike your still life. It is widely held by many artists that having the light coming in from the left is the most natural direction – we read from left to right, and this is also the way in which we "read" paintings. In most of Chardin's paintings the source of light is to the left, so that the eyes follow the direction of the light, with the objects in the composition carefully arranged to assist the movement.

MEDIA AND METHODS

Although many of the textures of fruit, vegetables and food can be rendered equally effectively in a number of media it is worth while to consider their relative strengths and weaknesses by trying out several different ones. You will find that some are well suited to represent a particular texture, while others will have to be stretched to breaking point to be even half as successful.

Pastel

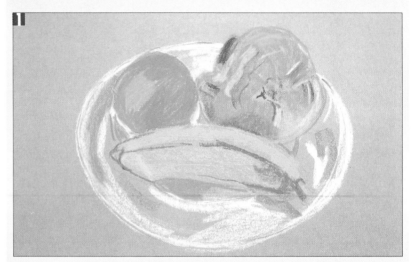

1 **The artist has chosen neutral grey paper to bring out the bright colour of each object. She begins by loosely blocking in the main forms of the fruit,** pepper and plate.

2, 3 **She can now tackle the individual textures. The slightly rough waxy surface and broken highlights of** the orange are rendered with short stabbing strokes, while for the banana and pepper she allows the pastel stick to smoothly follow the form.

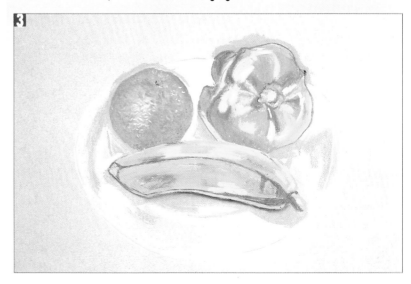

2 Oil

3 **Painting wet-in-wet can result in over-blending, but the artist is careful to avoid this. If there is insufficient contrast the painting could become flat and lifeless.**

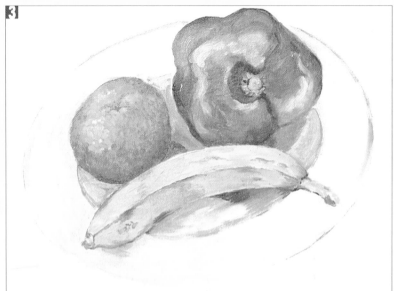

1 **Here the approach is more methodical, with the artist paying careful attention to the balance of tones. She thins the paint with a mixture of turpentine and a medium called Liquin, which makes it smooth and malleable,** and blends the colours by painting wet-in-wet.

2 **White paint mixes with the green on the painting surface to create a cool highlight.**

3 Watercolour

1 **Once the light pencil drawing is completed, masking fluid is applied to reserve the highlights.**

2, 3 **Notice how the artist has kept the surrounding tone light so the highlight does not assume too much prominence.**

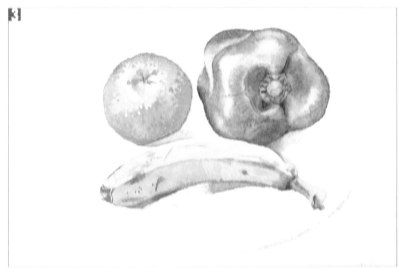

PENCIL AND COLOURED PENCIL

Drawing fruit and vegetables can be an excellent introduction to the idea of representing texture. The wide range of different surfaces, colours and shapes will challenge your skills on many different levels, in particular testing your ability to adapt your drawing style to suit the subject.

The pencil is one of the most versatile of all drawing implements, offering an almost infinite range of marks and effects which will suit most approaches and styles. Take care, however, not to grip the pencil as though you were going to write with it, as this will always lead to stiff and rather formal drawings. Instead try out different and perhaps unfamiliar ways of holding the pencil so that you can extend the vocabulary of marks, and try to use the pencil in different ways, drawing with the side of the lead, hatching and crosshatching, scribbling, smudging and so on. If you want to explore the more suggestive possibilities of the pencil, don't sharpen it all the time – experiment with a worn, rounded soft-leaded pencil or even a graphite stick to broaden your range.

For those who find it difficult to draw fruit and culinary subjects in monochrome, coloured pencils can be an exciting alternative. They can be used in similar ways to the pencil but are also capable of some marvellous colour effects. To get the most out

▶ Walnuts
GERALD NORDEN
Oil
Without seeing this painting it might be hard to imagine a successful and inspiring still life painting made from nothing more than a simple bowl of nuts, painted almost in monochrome. Yet it works wonderfully well, partly because of the careful, beautifully balanced arrangement and partly because of the close attention to the intricate texture of the walnuts themselves.

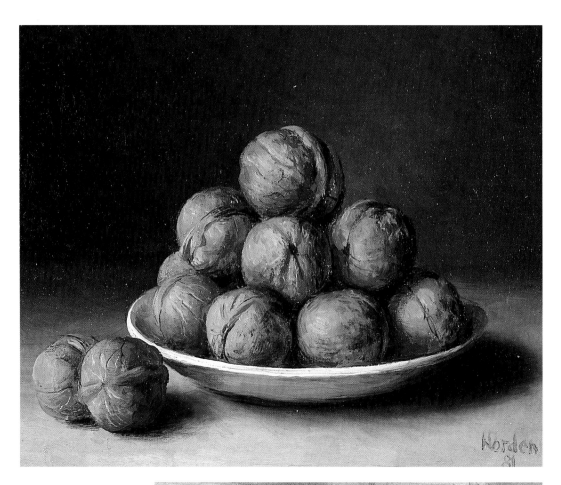

of them be sure to use a paper with a slight grain so that you can build up the drawing. If the paper is hard and smooth, the colours will lack depth, and the result will look rather thin.

PASTEL

Soft pastel is a wonderfully sympathetic medium for drawing soft-skinned fruit such as peaches or apricots. The vivid colours and opaque, matt surface perfectly recreate those of the subject. The dry, crumbly nature of pastels also makes them highly suited for rendering foods which have a similar texture, such as cakes, bread and biscuits.

One thing to remember about pastels, however, is that the effects you achieve depend very much on how you use them. Blending colours together with a finger, a piece of cotton wool, or a special implement called a torchon (a very tight roll of paper with a point at one end) will produce a soft effect, with colours and tones merging together almost imperceptibly. This technique is well suited to smooth objects with matt or shiny surfaces such as eggs, aubergines or peppers, but less so for rougher textures. In such cases you could try overlaying colours without blending, which gives a lively, broken-colour effect suggestive of texture. You do not have to stick to one

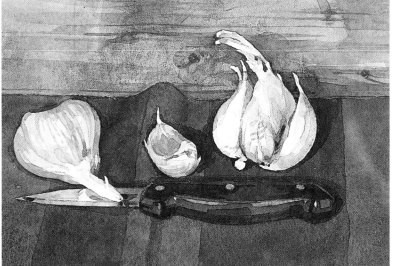

method throughout; if your still life has a balance of rough and smooth textures you can juxtapose areas of blended colour with rapidly applied, scribbled marks or small dots and dashes made with the point of the pastel stick.

You can also let the paper help you describe texture. The papers sold for pastel work have a slight "tooth" to prevent the pigment falling off the surface, and they are sold in a wide range of colours. Pastels can be done on white paper, but coloured surfaces

▲ Garlics on a Blue Cloth
RONALD JESTY
Watercolour
This is another simple arrangement in which texture plays the starring role, but in this case contrast is also an important element, with the different textures played off against each other.

String of onions

1 **A very careful pencil drawing has been made as the first stage, as the artist finds this helps him to come to terms with the subject and decide how to treat it. He then lays in pale washes, allows them to dry, and begins to build up the textures of the wood and rope by the dry-brush method.**

2 **The onions are then painted, with particular care taken with the highlights. These are achieved by blotting out wet colour, leaving the light tone of the original wash exposed.**

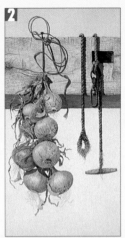

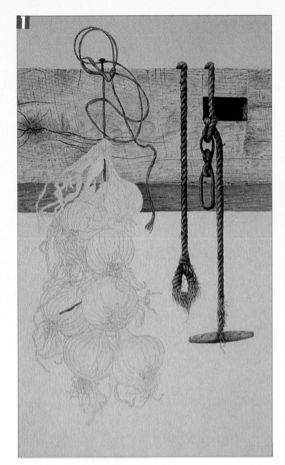

3 **The final stage, requiring great patience and precision, is to paint the dark background around and behind the objects. The proportion of space above and below the beam is important to the composition, and the artist had previously made a colour study to work out the relationship of light and dark tones.**

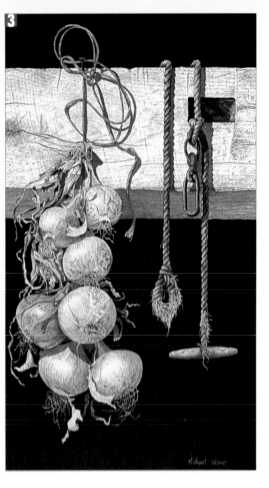

4 **The whiskery dried roots, silhouetted against the dark background, give a lively sense of movement to the picture.**

are normally used because it is difficult to cover the surface completely, and specks of white showing through the pastel marks tend to detract from the picture. If you choose a paper colour that harmonizes with your subject and apply the pastel lightly for the rough-textured area and use thicker, blended colour for the smooth ones you will immediately achieve a contrast of surfaces.

Used in a linear way, pastel can be used to convey detailed and complex textures and colourings. The technique of feathering, in which individual strokes of colour are drawn alongside each other (like the barbs of a feather) to create vivid colour effects, is especially useful. The effectiveness of the method lies in the fact that each pastel stroke remains as a discrete mark, thus creating a shimmering colour area similar to the effects in an Impressionist painting.

WATERCOLOUR

There are certain fruit and vegetables that seem to lend themselves well to the delicate,

OIL

Bread

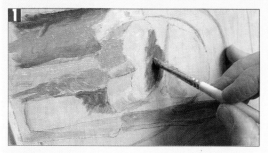

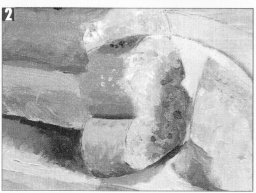

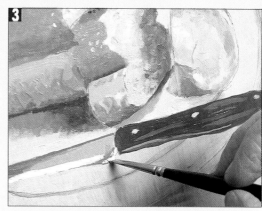

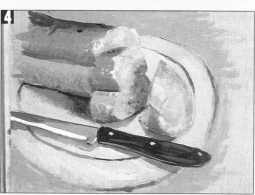

1 The artist begins with well-thinned blue oil paint, and then establishes the contrasting areas of warm yellow-brown.

2 After the main colours have been blocked in, he paints the crumbly texture of the bread with a stippling technique.

3 The shiny, reflective knife blade provides a counterpoint, with the sharp highlight contrasting with the softer bread texture.

4 To a large extent, common sense dictates the brushwork needed for different textures: a flowing stroke for a smooth surface and a dabbing technique for a crumbly one.

translucent effects of watercolour. For example, gentle, transparent washes can beautifully convey the quality of inner light seen in thin-skinned fruit such as grapes or plums, and it also seems the perfect medium for rendering the delicate membranes of the skin that covers a vegetable such as the onion or garlic.

Shiny fruit and vegetables with clear highlights are also suitable subjects, but because watercolour is such a fluid medium it is less easy to make it describe rougher textures. In such cases you might think about combining watercolour with gouache. There are some ideas about mixing media later in the chapter.

Highlights A disadvantage with watercolour is that it is difficult to make major corrections, so you do have to plan from the outset, making a preliminary drawing and paying particular attention to the placing of highlights, which are vital clues to the texture of the fruit. The traditional method of creating highlights in watercolour is to "reserve" them by painting round the area to remain white. This produces a clearly defined, hard-edged white shape which could be ideal for a cherry or aubergine seen under bright light. Not all highlights are white, of course, indeed very few are, but you can use the reserving method for a coloured highlight by laying a wash the

colour of the highlight, allowing it to dry and then painting around the area with darker colour.

Another method of reserving highlights is to use masking fluid, a kind of liquid rubber sold in small bottles. This is painted onto the paper after the preliminary drawing and before any colour is put down. When the fluid is dry, washes are laid on top, and the fluid is removed by gently rubbing with a finger when the painting is complete (and dry). The advantages of this method is that firstly it enables you to establish a positive shape, and secondly allows you to paint freely without fear of losing any of these precious white areas. You will often find that the highlight, being pure white, is too bright, but you can modify it very easily with a brushstroke or two of the correct colour.

Highlights can also be painted on as a final stage with Chinese white or zinc white gouache paint after the watercolour has dried. This doesn't produce such a clear white as reserving pure white paper, but is often more effective for this very reason. It also makes it possible to paint a broken-textured highlight, such as you might find on an orange.

The softer and rougher-skinned the object is, the duller and more diffused the highlight will be. In the case of matt surfaces you can soften the edges of the highlight shapes with

▶ **Apples in a Basket with Jug**
GERALD NORDEN
Oil
Here the textures of the fruit are painted with complete realism, in contrast to the more impressionistic treatment seen in the pastel. The highlights on the dry, unpolished skins of these apples are wonderfully observed.

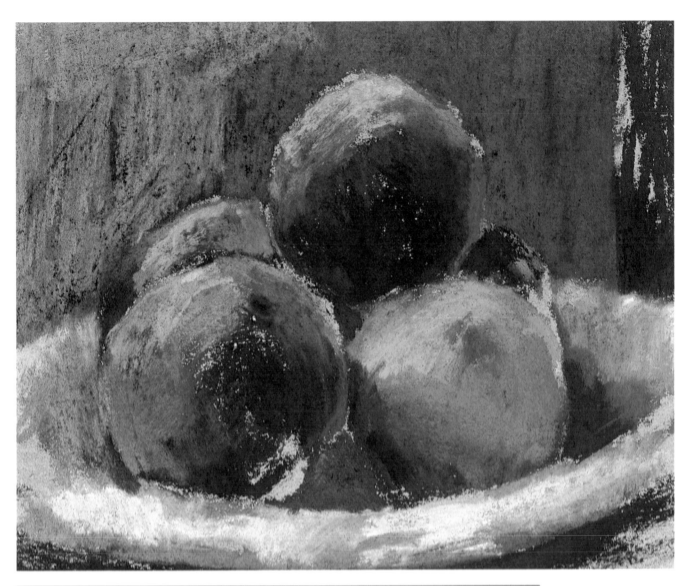

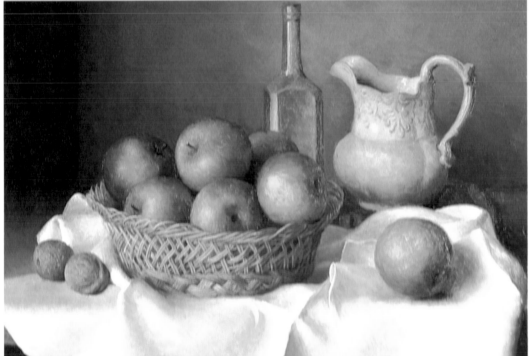

▲ Peaches
MARTIN DAVIDSON
Pastel
The peaches were lit from
above to emphasize the
highlights on the soft,
downy skin. The pastel was
done on a rough, light grey
paper, with layers of colour
built up and sprayed with
fixative at regular intervals.
The final strokes of pastel
were only lightly fixed, thus
retaining the freshness of
colour.

a moist brush, and for rougher-skinned subjects, try the excellent method of lifting out. This simply means removing some of the paint with a small sponge or piece of tissue. It is easiest to do while the paint is still wet, for instance you can create a large, soft highlight simply by pressing a sponge into the damp paint, but you can lift out dry paint too. Rubbing gently with a moistened cotton bud will probably not remove all the paint, but it will take away enough to produce a soft highlight. The only problem with this method is that you cannot control the shape very precisely.

MIXED MEDIA

Finding the most appropriate medium for your subject requires an open mind and a certain amount of experimentation. In many cases you will find the best way forward is to mix your media rather than attempt to adapt a reluctant one. I have found that the greatest incentive to opening up into other media is to make mistakes. A watercolour, for example, that becomes tired and overworked can be revived by bringing in accents of other media, such as gouache or acrylic.

Gouache, which is simply a more opaque version of watercolour, and is sometimes described as "body colour", is often used in combination with "true" watercolour, and is particularly useful where you want a contrast between fluid washes of transparent colour

PASTEL Fish

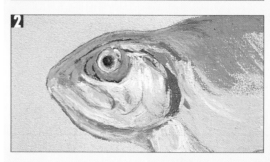

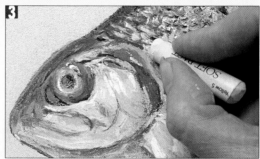

1 A grey paper, close to the main colour of the fish, is chosen for this pastel rendering, as this allows areas to be left uncovered. The main lines are then marked out in different colours.

2 The pastel colours are then built up more thickly to produce a rich, paint-like effect. The artist has analysed the subtle colour shifts of the reflective skin very carefully, and has chosen a bold palette.

3 The pastel strokes used for the head are smooth and sweeping, but for the scales, short, jabbing marks are made with the edge of the stick. The mid-tone yellow has also been used on the head, helping to integrate the head and body of the fish.

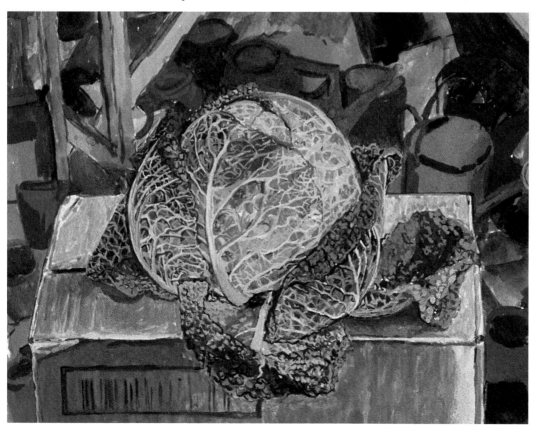

◄ Cabbage on Cardboard Box
CAROLYNE MORAN
Gouache
The painting shows that even the most complex textures can be simplified by a methodical approach. The cabbage has been first modelled as a sphere and painted with a limited tonal range of green, with the details added afterwards. The background objects, freely and sketchily treated, throw the more precise description of the leaves into prominence. Gouache is well suited to subjects where a broad range of effects are required; it can be used both thick and thin, boldly or with great precision.

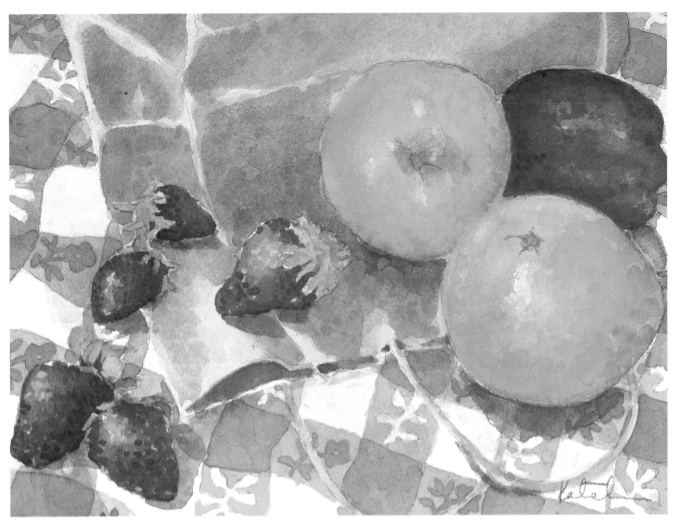

▲ Bag of Fruit
CAROLE KATCHEN
Watercolour

The moist heaviness of ripe strawberries and gentle highlights of the oranges have been wonderfully captured by working wet-in-wet so that there are no hard edges. The paint has been controlled with great skill; notice the lightly overlaid washes on the top of the oranges, suggesting their slightly pitted texture, and the careful reserving of the pale yellow highlights. Here the definition is more controlled, with some of the washes worked wet on dry.

WATER COLOUR

Vegetables

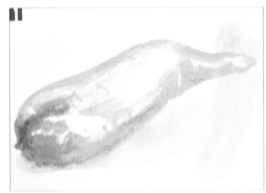

1 The artist begins by laying thin, transparent watercolour washes.

2 White gouache is then added, to describe the ridges and markings.

3, 4 The detail and the final painting show an effective use of paint "dragged" over rough paper.

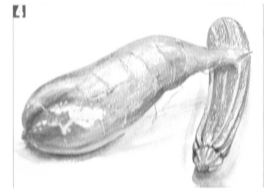

WATER COLOUR

Melon

1 Starting with a careful outline sketch in pencil, the artist has laid in the flesh and outer skin of the melon by working wet-in-wet with transparent watercolour. She then allows these washes to dry before adding crisper, darker details with a pointed brush.

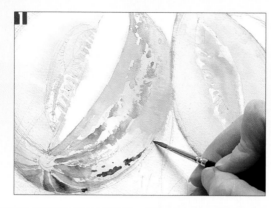

2 An orange-brown coloured pencil is used to define the finer detail of the pips.

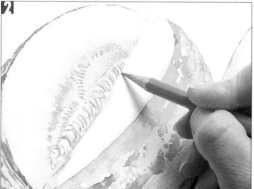

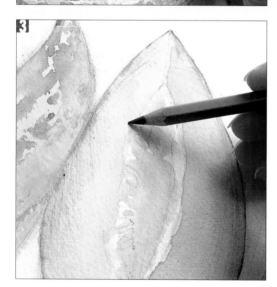

3 Coloured pencils can also be used to shade and modify areas of wash.

4 The final painting shows a well-integrated use of mixed-media and varied techniques.

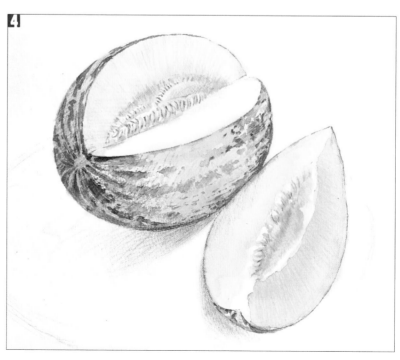

and areas of thicker paint used to describe, say, a loaf of bread or a root vegetable. Acrylic can be used in exactly the same way as gouache, the only problem being that the plastic resin used to bind the pigment is impermeable, and you cannot remove the paint once it has dried. You can, however, paint over mistakes, which is more difficult to do with gouache since each new layer of colour "melts" the one below, causing the paint to mix on the paper.

If there is a general rule about when to mix the media, it is to let the subject dictate the means. There is no point in being a purist by sticking to one medium if you find you are unable to resolve a tricky textural problem. If for example you require a soft scumbling effect on a rather flat watercolour area then try adding some pastel, which combines very well with watercolour. Or if some of the detail has been lost in a watercolour, try working into it with pencil, or coloured pencil or watercolour crayons.

OIL

Oil paint is such a versatile medium, with the possibility of rendering so many different textures in such a variety of ways, that it is almost impossible to choose any one technique over another as particularly suitable for culinary subjects. However, a good general rule is to try to use the paint so that its physical nature has some affinity with that of the subject. You cannot do this with either watercolour or pastels, which have their own uncompromising natures, but oil

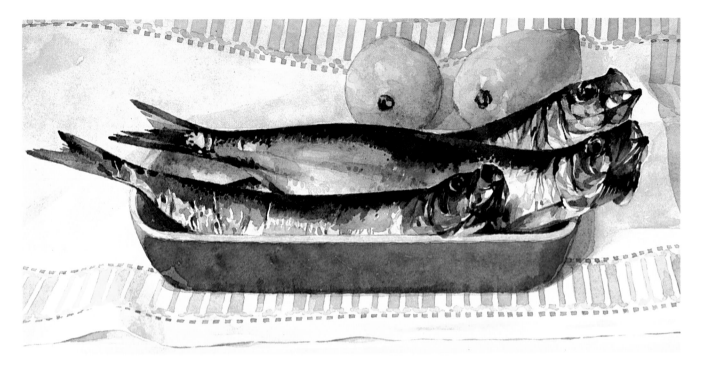

paints are endlessly adaptable – they can be used thin and semi-transparent, with almost invisible brushmarks, or thick and oily, with brushstrokes playing an important part in the finished painting as well as imitating a range of textures. If you look at Chardin's painting of bread on page 26 you will see that he has varied the texture of the paint itself and its manner of application to the textures of the subject.

Smooth textures One of the great beauties of oil paint is that, because it takes a long time to dry you can carry out a good deal of blending and colour mixing on the surface of the canvas or board. Until about the middle of the 19th century the traditional way of working was to build up paintings in layers, beginning with an underpainting, and leaving each layer to dry before applying the next (painting wet-on-dry). The Impressionists, who liked to work spontaneously out of doors, abandoned this method, and by painting "alla prima" (the term for paintings completed in one session) found that laying one wet colour over another created softer, more natural-looking effects, as each new colour was slightly modified by the one below.

Wet into wet can be a useful method for smooth-textured fruit and vegetables such as grapes and aubergines, but it does require some practice and a sure hand, as too many colours applied one over another can result in a muddy mess. If you find this happening, scrape off the paint and begin again – another of the great advantages of oil paint is that mistakes can be rectified.

Smooth textures can to some extent be emulated by using the paint very thinly, diluted with a mixture of linseed oil and turpentine and applied with soft brushes instead of the more usual bristle ones. This also allows for very subtle blending effects. In this case you could try beginning with an underpainting to establish the general arrangement of tones and colours and build up from this – many artists still like to work in this way. You can use acrylic for the underpainting if you have it, as this dries very quickly. Alternatively, use oil paint well thinned with turpentine or white spirit, which is also relatively fast-drying.

Smooth-textured food can also be rendered very successfully with thick paint. The American artist Wayne Thiebaud has produced a series of paintings of subjects such as cakes and hot dogs where the paint has been mixed to the consistency of heavy cream to render the smooth icing on a cake or a squirt of tomato ketchup on a hamburger.

Impasto Thicker, dryer paint will evoke the more uneven surfaces of subjects such as a melon skin, a cabbage or a loaf of bread. The term for paint applied really thickly is impasto, and it is one of the most useful techniques for imparting a richness and density to textures. Sometimes impasto is used only for certain parts of a painting, such as highlights or one area of rough texture, in which case you can use paint straight from the tube. If you want to employ the method on a large scale, however, you will save on paint – and produce a thicker mixture – by using some form of additive.

An impasto medium sold specifically for

▲ **Bloaters**
RONALD JESTY
Watercolour
This artist works almost exclusively wet-on-dry, laying wash over wash to build up colours and textures, but never overworking the painting. The technique requires a careful and methodical approach, and it is essential to plan from the outset which areas are to be reserved as highlights. The heads are beautifully observed, the complex dried areas of the mouth and gills expressed in small overlapping brushstrokes of neutral browns and greys. Notice also the way in which the forms of the wrinkled skin are summarized on the nearest fish. Each fold has been painted with its own shadow, leaving the white of the paper to act as the highlight.

this kind of work is Oleopasto, which is mixed with the paint and bulks it out without changing the colours. You can also thicken paint with a resin medium such as heavy Copal medium, but this does require some skill in handling. Chardin is reputed to have used this in many of his paintings. A less well-known additive is whiting, which when mixed with the paint absorbs excess oil and creates a stiff, crumbly paste-like material – ideal for rough textures, but only if you are prepared to sacrifice the traditional oil paint gloss.

Since the early part of this century painters have experimented with many other substances to give body and texture to the paint, although permanence is not guaranteed. These have included marble dust, sawdust, fine sand and, for the French painter Georges Braque (1882-1963), even coffee grounds!

Scumbling This is a technique that can be useful for several different kinds of texture and is used in gouache and pastel work as well as in oil painting. It involves scrubbing – rather than painting – dry colour over another layer of dried paint so that part of the underlying colour shows through to create a veil-like effect. Scumbling light over dark is a marvellous way of suggesting the delicate blooms you see on plums, or the dry, neutral greys that modify the glowing colours of a peach. Although light over dark is the most usual way of working, there is no reason why you should not adapt the technique and experiment with dark over light scumbles to imitate the textures of subjects such as nuts or root vegetables.

TIPS

● When painting in pastels or oils, try and keep your highlights and darkest shadows to the end.
● A sharp and well-defined highlight indicates a smooth surface; a soft and diffused light shows a rough or soft surface.
● The colours of highlights will depend on the source of light, but you will usually find that there is a contrast between the colour "temperature" of the highlight and that of the fruit. A warm surface will take on a cool highlight; a cool surface a warm highlight.
● If you want to bring out the translucency of a fruit don't be afraid to exaggerate – let a little more light through than you can actually see.
● Don't be afraid to mix the media. If you are working with watercolour and can't capture the soft bloom on fruit try a touch of pastel on top.

▼ Peaches
SALLY STRAND
Pastel
Some of the peaches have been cut to provide both a more interesting composition and a greater range of textures. The delicate fabric of the tablecloth also contrasts well with the solid forms of the peaches, and the artist has heightened this effect by the techniques she has used. The peaches are built up thickly, with successive applications of colour, while the filmy effect of the fabric is achieved by the light scumbling of pale colours over a darker one beneath.

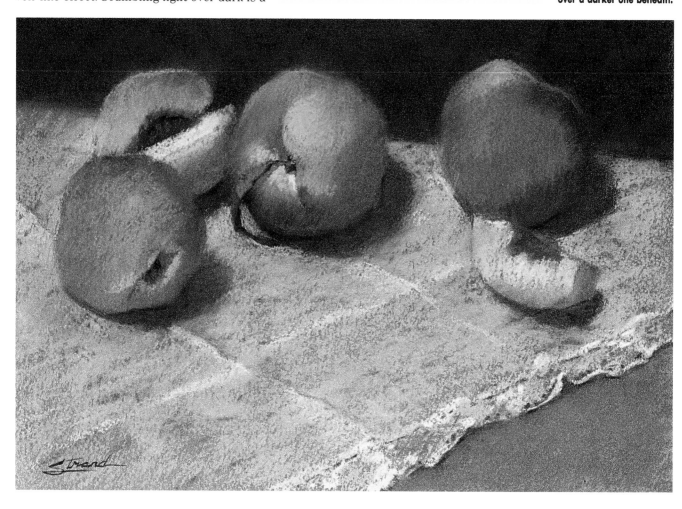

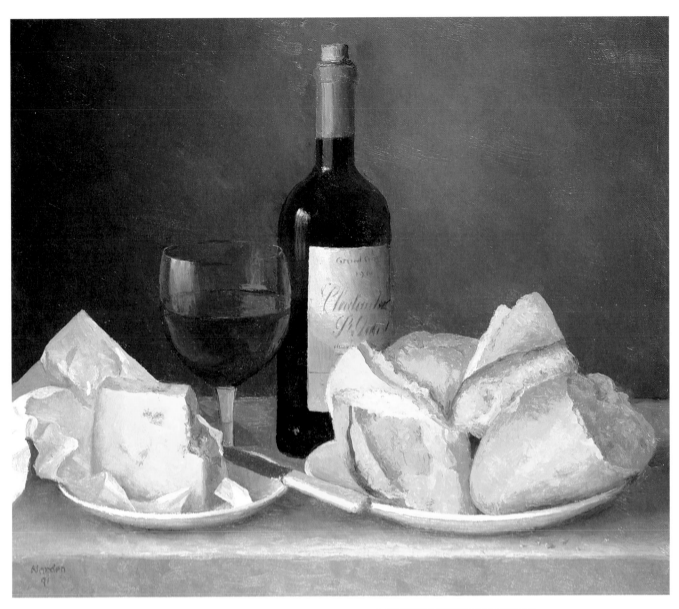

▲ **Still Life with Wine and Cheese**
GERALD NORDEN
Oil

The wet-in-wet technique has also been used in this painting to create a wide range of different effects. Notice how the artist tailors his brushwork to each individual texture. On the bottle and glass, vertical or curved strokes follow the directions of the highlights, while the crusty texture of the bread is conveyed by a multitude of tiny brushstrokes going in different directions, and often crisscrossing.

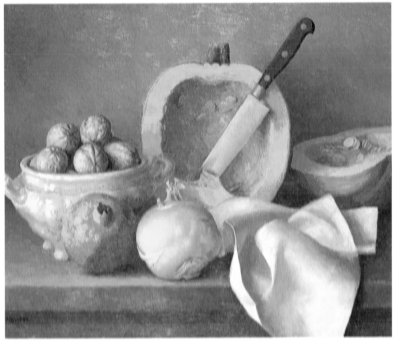

◀ **Still Life with Melon**
GERALD NORDEN
Oil

The dramatic diagonal of the knife blade across the soft flesh of the melon gives a marvellous sense of life and movement to the painting. Norden's approach to still life is traditional, and many of the elements in these two paintings are reminiscent of the old masters.
However, unlike painters such as Chardin (see page 26), he works on a white canvas and paints mainly wet-in-wet. The blending of colours produced by this technique is most evident on the melon.

Jean-Baptiste Chardin (1699-1779) is generally regarded as one of the greatest of still life painters. He brought to the genre a simplicity and directness which was much admired by contemporaries as well as by later artists such as Cézanne and Braque. Chardin was less interested in the kind of detailed description of objects that you find in many Dutch still lifes (see the painting on page 80) than in their overall form and substance. In addition to still life, he painted numerous small canvases depicting scenes from everyday life, usually containing no more than one or two figures.

FOCUS ON

Chardin

▶ Chardin was secretive about his technique, and only a few records have survived from contemporaries. One such is a description by the French writers, the Goncourt Brothers, of an unfinished sketch for a painting called *The Housekeeper:* "... trails of dry white paint had produced on the canvas a rough outline. Nothing but white and grey; no more than a hint of pink on the face and hands, a hint of violet on a ribbon, a speck of red on the trim of the skirt; and yet, there is a face, a dress, a woman, and already the entire harmony of the painting in the dawn of its colour."

▶ Sadly, the painting is badly cracked, but it is possible to see how the colours of the peaches have been slowly formed from the brown underpainting, over which successive applications of paint and subtle scumbles of colour were laid. For the brioche itself, Chardin has used thick impasted paint, almost "sculpting" the forms so that the textures of the paint seem to mimic those of the bread. Where the crust is glazed and shiny the paint has been applied smoothly, with a scumbled cool highlight; but in the rougher, more open-textured areas you can see distinct brushmarks and ridges of paint.

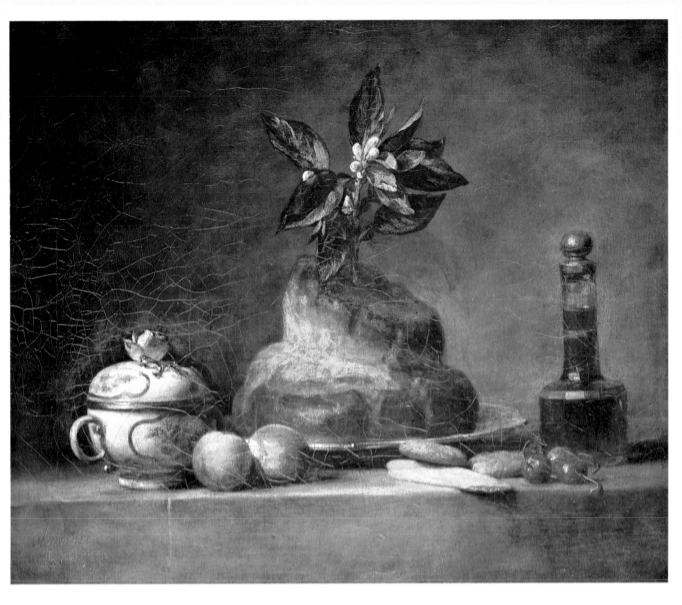

LA BRIOCHE
Oil on canvas
Louvre, Paris

◄ The smooth, translucent skin of the cherries is beautifully summarized by the blend of different shades of red. To achieve this Chardin has painted wet into wet, finishing off with a touch of crisp white paint for the highlight.

The biscuits again show his use of thick paint, and make an interesting foil to the smooth-skinned cherries. The dry, dusty textures have been achieved almost solely by the physical handling of the paint. Notice how relationships are established between the cherries and the rest of the composition by linking the textures and colours of the fruit to those of the bottle, and also by including the red reflected light on the table.

Plants and flowers are amongst the most familiar subjects, but once you start looking at them in the context of

PLANTS, LEAVES & FLOWERS

▲ The varied textures of dried leaves make a challenging subject.

▲ The texture of grass can be simplified by looking through narrowed eyes.

texture they take on a different look, with each part of the plant assuming a special character. Leaves are composed of great rivulets of veins; stems which initially appeared smooth have small armies of thorns, and the petals of flowers seem to be made of satin or silk. Nature loves contrast. Everywhere you look there are interesting juxtapositions of shapes, forms, colours and textures.

▼▶ Lighting is extremely important when setting up a flower subject. You may need to experiment with the direction and strength of the light. Also pay attention to the background tone. Light-coloured flowers are best against a darker background and vice versa.

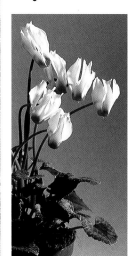

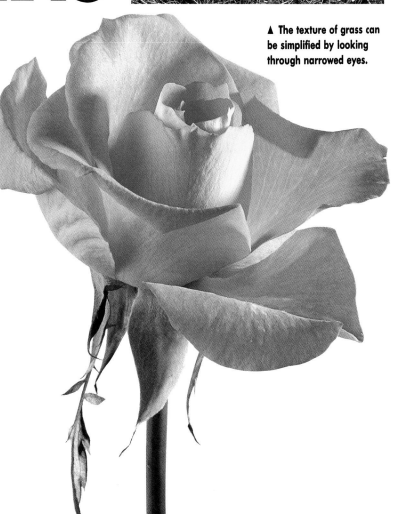

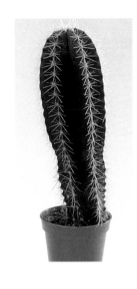

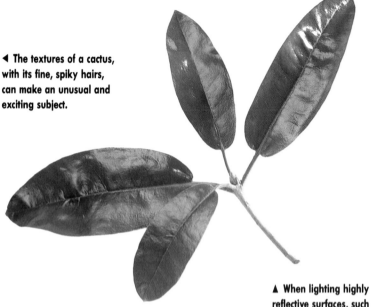

◄ The textures of a cactus, with its fine, spiky hairs, can make an unusual and exciting subject.

▲ Many small highlights reveal the complex structure of mosses.

▼ A raking light shows up the structure of a fir cone very well.

▲ When lighting highly reflective surfaces, such as these leaves, check the angle of light, so that the surface information is not lost in a dazzle.

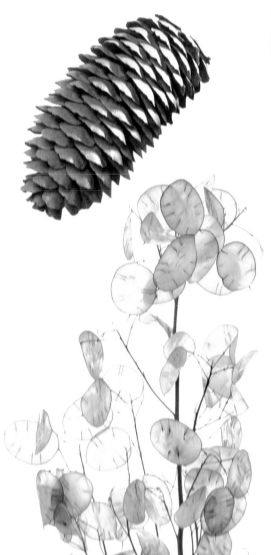

▲ The soft powdery textures of the buds require a delicate touch.

◄ With the translucent dried pods of honesty, a strong backlighting can be effective.

▼ Side lighting will help to define and simplify the complex texture of teasels.

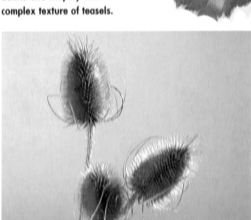

▲ Sharp prickles and smooth surfaces make an interesting subject.

Those who have not attempted the subject before would do well to start off by choosing a comparatively straightforward subject such as the wild poppy, which combines a variety of textures on a generous scale. The petals, for instance, are a delicate translucent crinkled satin which make a wonderful contrast with the soft velvety grey-black seed head. Underneath this large fragile flower there lies a thin whiskery stem with the familiar irregularly shaped leaves.

The rose is another plant that offers a challenging array of textures. When drawing or painting the flower, see if you can emphasize the differences in the parts of the plant so that there is a real contrast between them. You might work outdoors and paint a portion of a rose bush, with the soft buds and opened flowers standing out dramatically against a background of thick striated stems and large irregular thorns. This kind of contrast is an important theme in Oriental painting, where a common subject is pale plum blossom set against the spiky needles and gnarled branches or mottled bark of the pine tree.

In general, there is less textured contrast between the flower petals of different species than there is between the leaves, which vary enormously, from hard and shiny to soft and velvety. Smooth, regular-shaped leaves are generally the easiest subject to start drawing, because the general forms and structure are not too confusing. As you get more accustomed to capturing the curves of the leaf and relating it to the stem, then start attempting more complex subjects.

When drawing rougher-textured leaves, look closely at the edges. Much of the information about the general texture can be conveyed by the character of this contour line, for example if the leaf has a slightly furry texture then try to indicate this by a broken or dotted line.

The stems of plants also present a fascinating array of textures, and even the hairs can differ, some being thick and felted while others are fine and more spread out. The thorns of prickly plants and shrubs also vary considerably even within the same family, for instance some roses are covered in thin, needle-like thorns which grow at right-angles to the stem, while others have thorns that resemble a hooked claw, growing downwards.

Drawing
& Painting

PLANTS, LEAVES & FLOWERS

Training the eye

SINGLE PLANTS

Plants and flowers can be painted as mixed groups in indoor arrangements, or in their natural habitat, but they can also be treated singly, the most obvious example of this kind of treatment being botanical studies. Although this is a specialized branch of painting and illustration, primarily done for scientific purposes, many such paintings are beautiful works of art, and amateur artists often find them a source of inspiration. Careful studies of this nature can also prove a very effective teaching aid; whenever I feel confused or defeated by an unusual texture of a leaf or flower I usually turn to a painting by a botanical artist to resolve the difficulty.

It is best to begin with a comparatively simple subject such as a single flower or plant with just a few leaves, as in the drawings shown below. Lay it on a sheet of paper nearby and try out a few sketches just to see how the plant can be shown to best advantage. To get the "spirit" of the plant don't be afraid to exaggerate a little; see if you can get a rhythm that will go through the whole plant to create a lively composition.

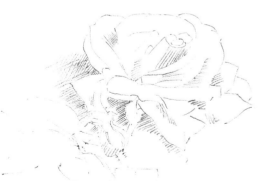

drawing, in pencil, is composed of a series of swinging curves, capturing the overall spiral form of the rose. Watercolour washes, used in the second drawing, are ideal for suggesting the delicate tonal ranges of petals.

Before you begin a complex flower piece, it is a good idea to make some drawings or colour studies of single leaves or blooms. The more you draw, the better you will understand the textures, shapes and structures. The first

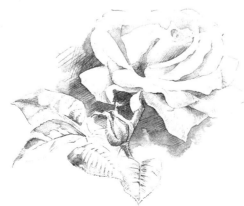

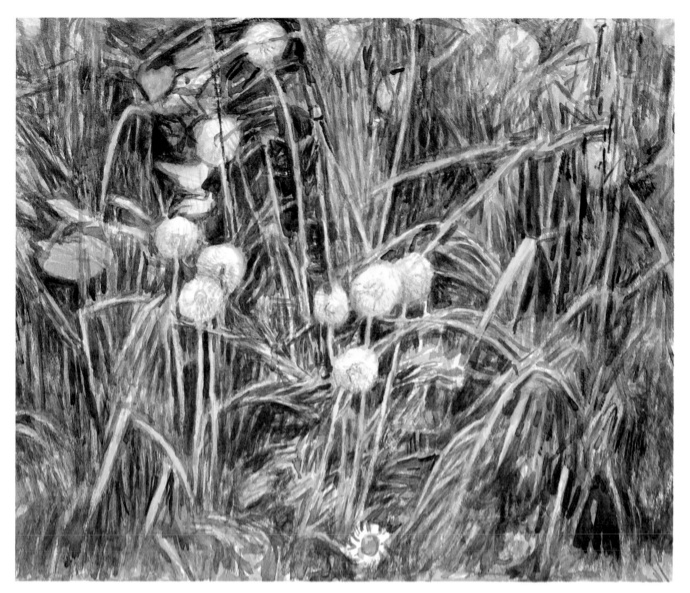

▲ **Dandelion Clocks**
DONALD PASS
Watercolour
The painting is composed
of a multitude of delicate
brushstrokes, each one laid
over the other to create a
slightly shimmering effect.

▶ **Constant Nymph**
JOHN PLUMB
Watercolour
In contrast, the watercolour
here is used boldly, at full
strength. Backlighting can
be a wonderfully effective
way of revealing the
textures of plants. Here the
artist has ingeniously
explored the combination
of translucency and
reflected light to bring out
the delicate textures.

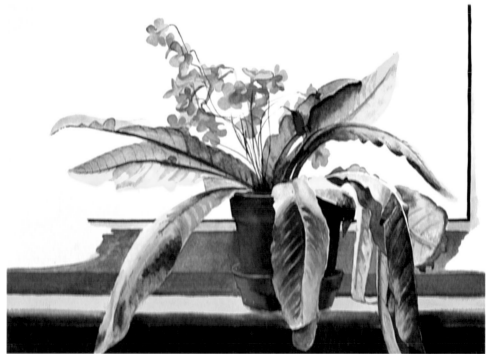

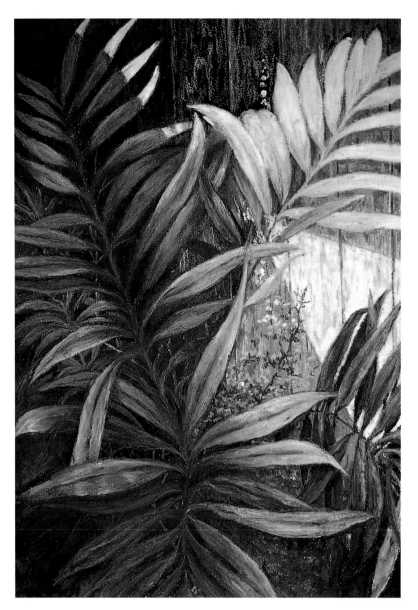

▲ Cool Light
BILLIE NUGENT
Oil pastel
The sinuous shapes and smooth sheen of the leaves have been beautifully described by means of carefully blended colour. Oil pastel can produce very broad, bold effects, but is also excellent for detailed work if the colour is "melted" with white spirit and applied with a small brush (see the demonstration on page 38).

flowers. The French painter Henri Fantin Latour (1836-1904), who specialized in flower paintings, used a neutral grey-brown space to set off the rich colours and also to act as a foil for the textures of the flowers. Edouard Manet (1832-83), in his late flower pieces, favoured a dark background to produce a more dramatic contrast of light and texture. Whatever background you eventually decide upon make sure that the plant is fully integrated into the painting. There is always a tendency, especially with plant drawing, to give special emphasis to the contour line, thus effectively isolating the plant from the other elements in the picture.

You will probably have to experiment a little to find the best lighting for the subject, but try for a soft, natural effect. Harsh, slanting light creates dramatic contrasts of light and shade but will distort the colours in a way that does not suit delicate subjects like flowers, and will not show up the textures well. Also, avoid lighting coming from directly in front, as it flattens the forms.

You might try backlighting, placing the flowers or plant against a window. This kind of lighting is not usually best suited to textured subjects because the distinctive features tend to disappear in the shadow areas, but it can be very effective for leaves or petals, as the light shining through them will reveal details of the structure, such as the veining of leaves. Because backlighting silhouettes the subject, it can also be very effective for plants such as spiky-leaved cacti, where the jagged outline provides a powerful indication of the texture.

INDOOR ARRANGEMENTS

If you have decided on a pot plant as your subject, you won't have to worry about arrangement, but flowers do need some thought. When you set up a floral still life pay special attention to the balance between the flowers, the stems and the container. For example, do you want the flowers to be in a wide-mouthed jug or container so that they are splayed out or do you want a more controlled display in which the flowers spill over the edge? Such compositional factors should be considered before starting to paint so that once you are involved in the work they can be forgotten.

Give some thought also to the background and the lighting. The simplest and in many ways the most effective way of treating the background is to suggest an empty and indeterminate space behind the plant or

NATURAL HABITAT

Working outdoors provides a wonderful opportunity for discovering new habitats and settings for plants. A group of primroses set below trees in a wood or foxgloves growing in front of a drystone wall can make a more exciting composition than the same flowers treated in isolation or placed in a vase. Also you will have a further range of textures to contrast with the plants themselves. In a wood, for example, you could include any natural objects that lie next to the plant to provide a context. Dying leaves and broken twigs can give a special dry atmosphere to the work, while mosses and fungi can suggest a damper and lusher environment.

The garden also has much to offer, but this time see if you can ring the changes a little by bringing in unusual themes or textures. Surprising juxtapositions of plants and other materials, such as bamboo poles set amongst

▶ **Anemones**
RONALD JESTY
Watercolour

By using deep, rich colours and the minimum of tonal contrast, the artist has suggested the velvety texture of the flowers, cleverly enhancing it by contrast with the hard, shiny glass and the smooth, plain surface of the jug in the background.

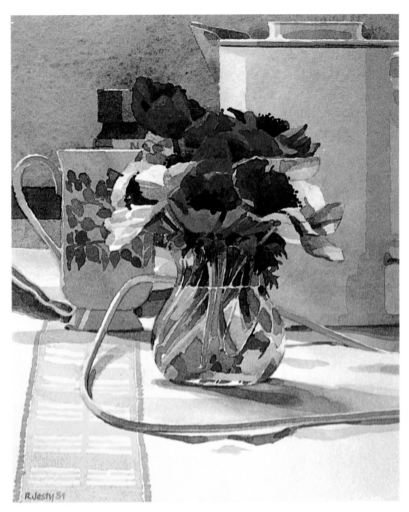

▼ **Poppies**
BRIAN BENNETT
Oil

Wild flowers wither quickly when picked and brought indoors, and apart from this practical consideration they usually look best in their natural surroundings. Here the grass and background trees provide the perfect ready made setting for the brilliant poppies. Bennett works entirely with painting knives of various shapes and sizes, and the picture shows what delicate and precise implements these can be when used with skill.

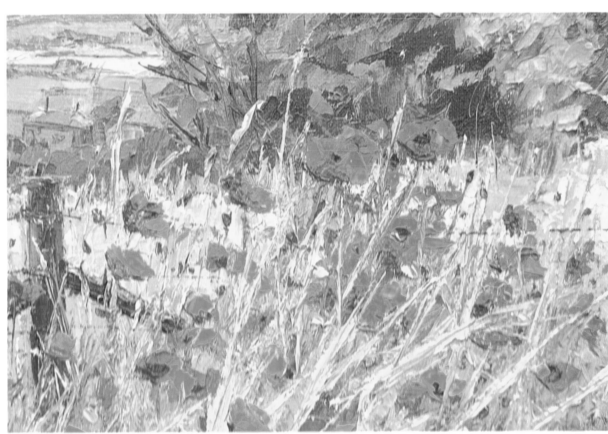

sweet peas or strawberry plants lying on a bed of straw, can open up many new possibilities.

The quality of light outdoors is very different from that inside. Indoors there will always be a certain direction to the lighting, resulting in a characteristic play of light and shade. Outside, however, the overhead daylight will tend to envelop the plant, revealing aspects of the texture perhaps not noticed in other conditions. The overhead lighting will make the underneath of the leaves darker and the top surface, especially if it is shiny, will have a cooler and bluer light. With some plants their distinctive textures can be conveyed by silhouette alone, for example thistles set against a bright sky will

▼ Drying Beauty
MICHAEL WARR
Watercolour
Here the artist has made dramatic use of a dark background to show off the light, dry textures of the flowers, painted in a dry-brush technique. Notice how the edge of the background has been left roughly painted so that it does not detract from the sharp detail of the subject.

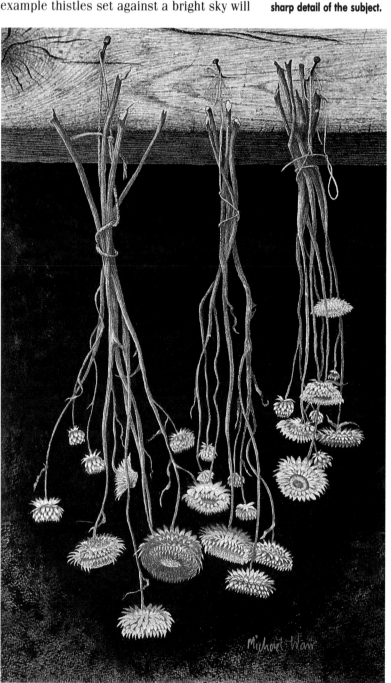

make wonderful abstract patterns of light and shade. In such cases pay special attention to the "negative shapes", the areas of the sky between the hard and spiky forms, as the interplay of positive and negative shapes will give the painting a tension.

DRIED MATERIAL

The great advantage of choosing dried leaves and flowers as a subject is that they don't change. They are thus ideal both for artists who wish to make long, detailed studies and for those who can only paint intermittently. A favourite for many painters is the plant honesty, well named because the forms are comparatively straightforward and direct. The flat, dried seed pods with their silky sheen have almost the appearance of mother-of-pearl, providing an opportunity to explore a texture not usually found in the plant world.

Other dried material can make interesting additions to still lifes. The dried cow parsley, for instance, with its ribbed stem and shower of black seeds, could make a nice contrast with cut flowers, or could be a subject in its own right. The dried seed pods of plants such as the poppy also make fascinating subjects to draw, combining smooth surfaces with a variety of fluted and ridged textures.

Such subjects need not always be drawn or painted indoors; if you go out to the countryside in winter you can study nature in skeletal form. Stripped of much of their summer foliage, plants and bushes assume a different character. Evergreens counterpoint dead, dried vegetation and grasses, while branches once covered by leaves can be studied for the subtle textures of lichen, bark and fungal growths.

MEDIA AND METHODS

Botanical paintings were and still are nearly always done in watercolour, and this is the media we most readily associate with the delicacy and detail of plant and flower subjects.

PENCIL AND WATERCOLOUR
The watercolour can be used on its own, but is frequently paired with pencil, which provides precision and detail, while coloured washes convey the delicate gradations of colour and tone.

Pencil and watercolour is a delightful combination, in many ways easier to handle than the other traditional technique for flowers, pen and watercolour. The pencil

lines, being lighter, "mesh" more readily with the colour. A general rule is to keep the pencil drawing to a minimum so that the watercolour can be given as much freedom as possible. Use the pencil to indicate the main lines of the plant and the watercolour to establish the fluid forms, including the shading. There will be a temptation to put that little bit extra into the pencil drawing, but try and resist, as the result will look overdone and will tend to weaken the effect of the watercolour. Be particularly careful with pale-coloured leaves and flowers, as a too-hard pencil outline around these forms will make them appear unnatural.

PURE WATERCOLOUR

For anybody starting watercolour the best introduction is to learn by experimenting. Don't use the medium to just "colour in" a drawing but let go the reins and find out what the watercolour can do. A good starting place is the wet-in-wet technique, in which new colour is brushed onto existing wet watercolour washes so that the colours run into each other to produce a subtle blending of colours and tones, this can be perfect for the graded tones you find on petals or the stem of a flower, but it is an unpredictable method – you are never quite sure what the result will be. This is, of course, part of its charm, but it takes some practice to learn to control wet-in-wet successfully.

For crisp edges use the more controlled method of painting wet-on-dry, in which new washes are applied over paint that has already dried. With this technique, areas of the watercolour can be built up by overlaying washes to form darker and richer colours and tones.

**▲ Harvest Time
ROSALIND CUTHBERT**

Egg tempera

Tempera, which is pigment bound with yolk of egg, was the main painting medium before the invention of oil paint. It is now enjoying a minor revival, and is well suited to precise work such as this.

**▶ Cactiscape Series
PAT BERGER**

Acrylic on canvas

Acrylic, used thinly, is also ideal for the kind of near-photographic realism seen in this painting.

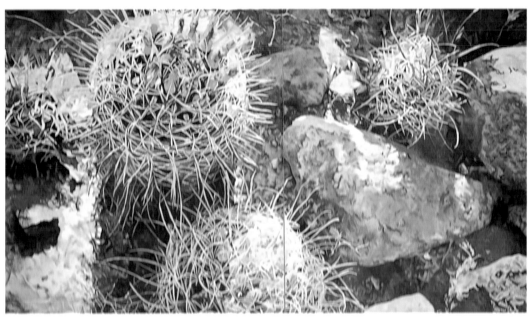

The textures of many flowers lend themselves perfectly to the use of these two techniques, separately or together. Try experimenting by laying on transparent washes, sometimes painting wet-in-wet and sometimes wet-on-dry to create the soft and hard edges of the leaves and petals. Further subtleties can be achieved by blotting some of the washes when partially dry and introducing stronger colour at the tip of the brush to create a gradated wash.

GOUACHE

The more complex and layered textures of some plants and flowers such as cacti or thistles make special demands on the medium used. In many cases it is necessary to use a more opaque one such as gouache, which will effectively cover underlying layers

Oil

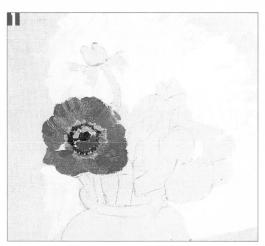

1 **The artist is painting on smooth board primed with acrylic primer and then given a buff-coloured ground so that white can be used to greater effect on the right-hand flower.**

2 **He works wet-in-wet, which gives a lushness to the petals as well as providing subtle gradations of colour.**

3 **Directional brushstrokes are used for the petals, and a stippling action for the soft velvety textures of the seed head.**

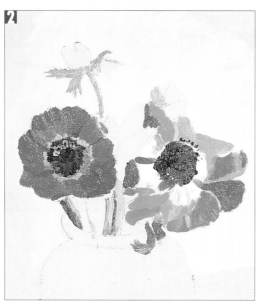

2 Watercolour

1 **A quick pencil sketch is an essential starting point for watercolour, and here the artist has made a careful outline drawing before beginning to paint. This enables her to place the first colours with confidence.**

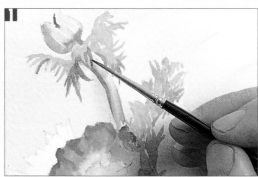

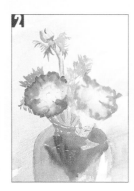

2 **Watercolour works best when applied directly without fiddling around, so keep the colours and tones clear and distinct.**

3 **The artist has avoided overworking the flowers, although she has built up the colours quite strongly.**

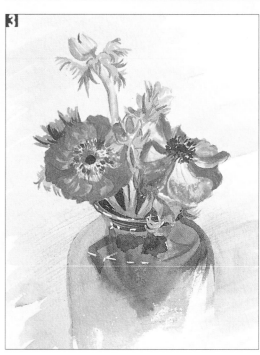

3 Pastel

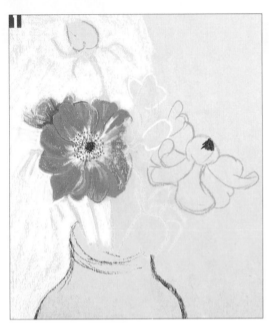

1 The buff-coloured paper acts as a useful neutral mid-tone on which lighter and darker colours can be built up. Pastels come in a wide range of colours, and the artist has chosen a different one for each part of the flower, using them initially for an outline drawing.

2 The pastel colours have been blended with a finger to give the soft effect of the petals, and now the artist adds small touches with a stub of white pastel.

3 The background has been roughly sketched so that the broken effect contrasts with the smooth velvety texture of the petals.

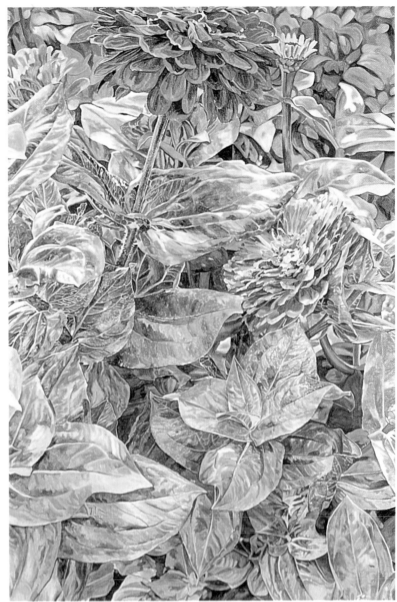

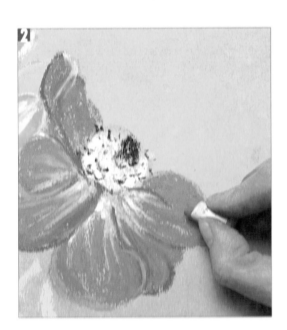

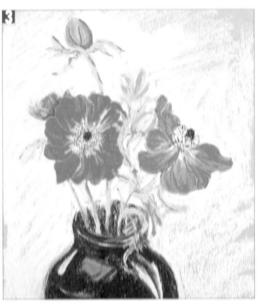

▲ Partita
THERESA BARTOL
Oil on canvas
In this painting you can sense the quality and brilliance of the light. The artist has managed to capture the detail of the textures without making the painting too complicated; it is dense without being congested. Notice also how skilfully she has modelled the highlights so that the range of whites, greys, greens and blues helps to give form to the leaves.

Cheese plant

1 Oil pastels, a versatile and flexible medium, are used for this drawing. The artist has begun by lightly drawing with different greens.

2 A brush dipped in white spirit is then used to paint over parts of the drawing. When moistened in this way, the colours spread out on the paper, behaving very much like paints.

3 Once dry, further colour can be added, and the process repeated.

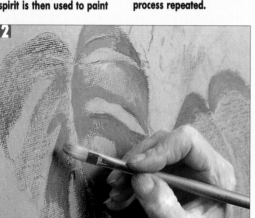

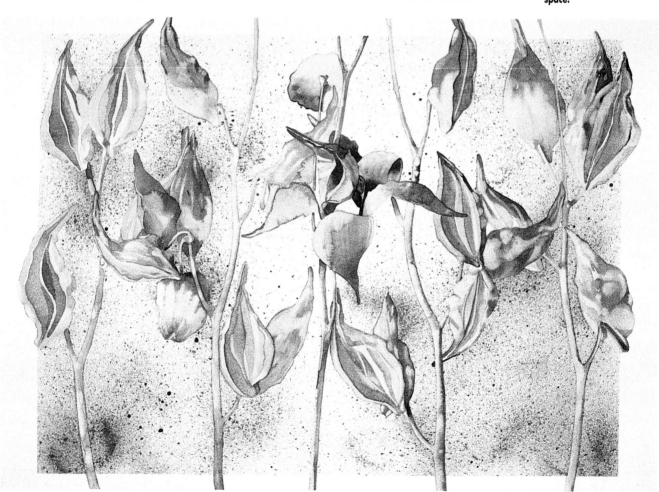

▼ **Vestige II**
NANCY LAMBERGER
Watercolour
Dried plant material provides a good opportunity to explore a limited palette. Here the dried leaves and open seed pods have been arranged with a careful eye to the final composition; notice how the overlapping, twisting forms create a rhythm across the vertical stems. The plants are painted in a loose, free style, with fluid washes, while in the background spatter work is used to suggest an indeterminate space.

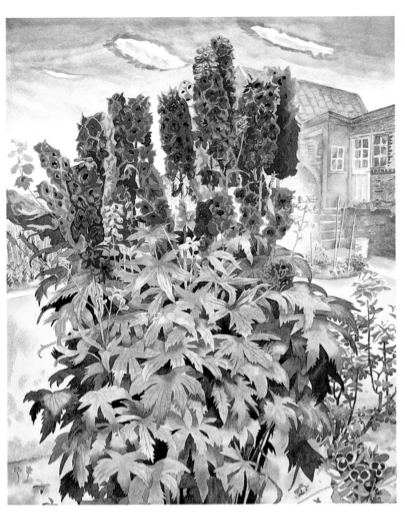

Cactus

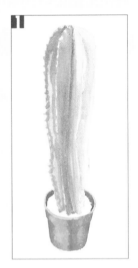

1 **The artist begins with pale watercolour washes.**

2, 3 **Opaque gouache is used for the detail of the spiky hairs, applied carefully with a very small brush. A similar effect might have been achieved by scraping back, but the artist felt he had more control with the gouache.**

4 **Final details are added with coloured pencil.**

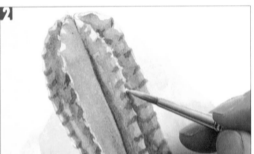

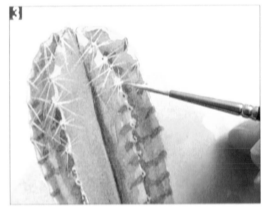

to build up complex or finely detailed textures. In the case of the cacti, for example, the small hard spikes springing from the succulent forms would test the skills of any watercolourist, but if you use gouache, or a combination of watercolour and gouache, you can approach the problem as a two-stage operation, laying washes of thin paint for the underlying forms and opaque colour later for the spikes and hairs of the plant.

White flowers such as magnolia can always present a few problems in watercolour, especially on white paper where the very subtle tonal ranges required can easily be lost. The answer is to use gouache on tinted paper so that the full range of soft tones can be established from the paper tint right through to the white highlights. This technique also has the advantage of allowing you to paint the white of the flowers positively.

COLOURED PENCIL

Coloured pencils are well suited to rendering the subtle textures of leaves and flowers. They can either be used to produce rapid sketches of plants in situ, or for more detailed studies in which precision and detail are

▲ **Delphiniums**
ROSALIND CUTHBERT
Watercolour
One of the most difficult tasks when composing a painting of flowers outdoors is to make sure that the background is not too intrusive. The artist has cleverly brought the main group of flowers forward by tonal contrast; darkening the outside leaves of the plants and making areas of the background, such as the house, lighter.
The forms and textures of the leaves and flowers are beautifully conveyed by the differences in the edges. Those of the leaves are crisp and clear, with sharp contrasts of tone, while the flowers are softer and more blurred.

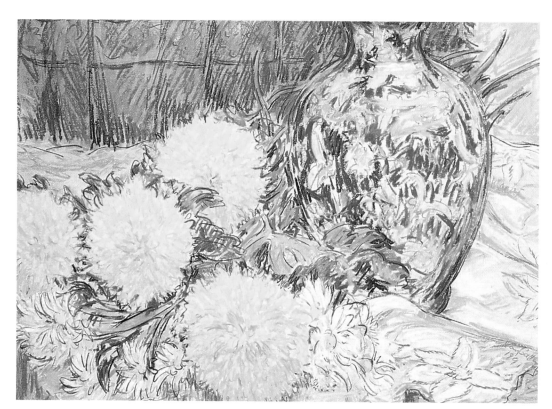

◄ **Chrysanthemums**
KAY GALLWEY
Pastel
This is a wonderfully spirited pastel, full of movement and life. The yellow flowers are beautifully summarized with the minimum of colours.

▼ **Flowers and Fruit**
NICK LANG
Oil
Here the artist has adapted his technique to suit individual textures. Thick paint straight from the tube is used throughout, but while the flower heads are painted with short jabs of the brush, the leaves are described with flowing, directional brushstrokes.

required. Because they come in very large colour ranges, they have the enormous advantage of allowing you to select hues very close to those of the subject without having to mix, which makes both sketching and detailed studies relatively trouble free. If you need more subtle blends and colours, you can use techniques such as hatching, cross-hatching and feathering, in which strokes of individual colour are laid over one another, or in the case of feathering, side by side, so that the resulting colour is an optical mix of them all.

For more rapid sketches outdoors try the water-soluble version of coloured pencils, which can be used as both a drawing and a painting medium. When dry they behave exactly like pencils, but when brushed over with water they turn into the equivalent of watercolour washes – though some colours are slightly muddy and opaque. Speckled textures can also be achieved by holding a pencil above a wet wash and brushing it across sandpaper so that the particles fall into the paint and dissolve in soft blurs of colour.

OIL

Oil paints might not seem the most sympathetic medium for the soft and delicate textures of flowers, but they can impart an incomparable richness to the subject. The most important thing to remember is that the surest way to destroy the impression of a living, growing organism is to overwork the

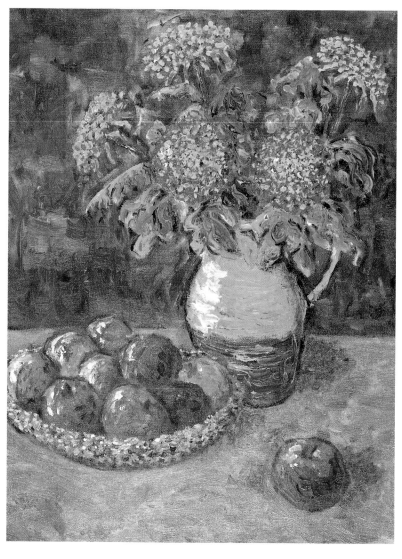

painting. Don't pile on more and more paint in an effort to record every tiny detail; instead try to use a bold approach. The beauty of oil painting is that you can use the brush almost as a drawing implement by letting it follow the shapes and forms of petals, leaves and stems. Often one brushstroke of thick, juicy paint is all you need for each petal, and this can describe the smooth, silky texture better than niggling away with a small brush.

The slightly uneven texture of oil paint used really thickly also lends itself perfectly to subjects such as newly opened roses, carnations, or the crinkly appearance of dahlias, while for smooth-leaved plants a wet in wet technique in which the colours are painted over and into each other while still wet will give a softly blended effect.

▼ Magnolia Leaves
BILLIE NUGENT
Oil pastel

A single leafy branch might not strike everyone as a promising subject, but here the artist has managed to capture both the sunlight and the textures, to produce a pastel that seems to glow with warmth. The

oil pastels have been built up in successive layers so that the colours could be blended and modified with greater ease. Notice how the white highlights have been kept to a minimum so that attention is held by the mottled surfaces of the leaves.

Daffodils

2 As he works, he checks the colour he is using by placing the brush next to the flower. This immediately tells him whether the colour is too light, dark, warm or cool, and he can then make any necessary adjustments.

1 The artist is working in oil, and begins with an underdrawing in pencil. He likes to paint on a coloured ground, and has chosen a dark brown to contrast with the yellow.

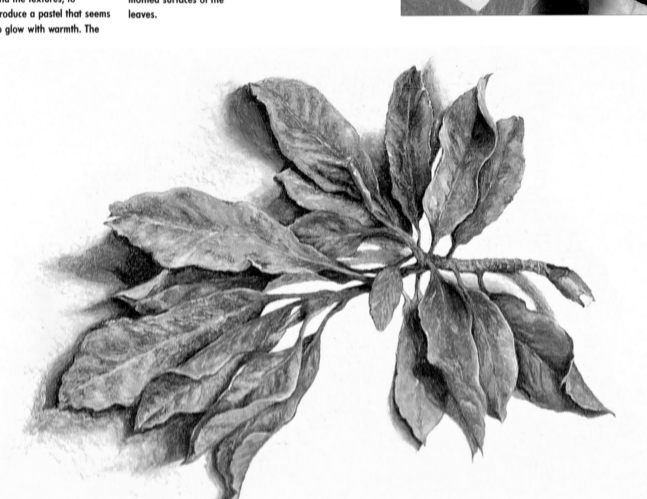

WOOD, STONE & BRICK

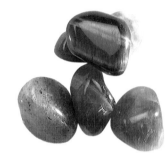

▲▼ Drawing or painting stones or old bricks is excellent practice for tackling larger-scale forms and textures in a landscape. Objects like these could also make interesting features in a still life group.

▲ Painting polished surfaces requires careful attention to highlights.

The widely varying textures of wood, stone and brick – from polished furniture to rough tree bark, and from smooth marble to weathered rock and old brick or stone walls – are an essential part of their character, and representing them successfully is an exciting artistic challenge. This chapter looks at some of the many techniques that will help you to achieve convincing results.

◀▼ Roof slates and weathered driftwood present a complete contrast; one obvious and the other very subtle.

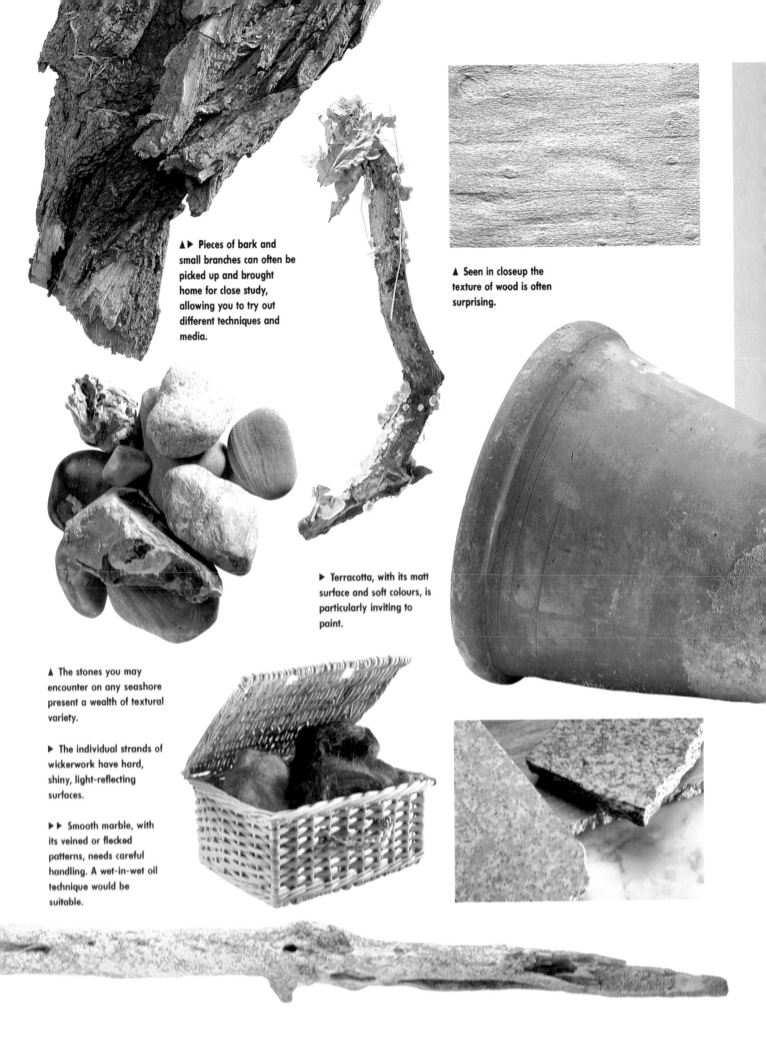

▲▶ Pieces of bark and small branches can often be picked up and brought home for close study, allowing you to try out different techniques and media.

▲ Seen in closeup the texture of wood is often surprising.

▶ Terracotta, with its matt surface and soft colours, is particularly inviting to paint.

▲ The stones you may encounter on any seashore present a wealth of textural variety.

▶ The individual strands of wickerwork have hard, shiny, light-reflecting surfaces.

▶▶ Smooth marble, with its veined or flecked patterns, needs careful handling. A wet-in-wet oil technique would be suitable.

The textures of tree barks, wooden buildings or gates, rocks and stone or brick walls offer a marvellous opportunity to try out new techniques and to use the painting and drawing media in ways that you might never have thought of before. "Tricks of the trade" such as spattering watercolour or applying it with sponges, scratching into oil paint or using wax resist methods are all perfectly valid painting techniques as long as the result successfully conveys the textures. In this chapter we look at a variety of these unconventional methods as well as the more traditional descriptive approaches in which the control of form and detail are of equal importance.

WOOD

Drawing
& Painting

Wood offers one of the greatest ranges of textures of any natural material. In addition to the huge variety of woods seen out of

WOOD, STONE & BRICK

Training the eye

doors, from tree barks to weathered, twisted driftwood, there is an almost infinite number of finishes seen indoors on furniture – the result of sawing, axing, planing and polishing many different types of wood.

You won't always want to emphasize the texture of the barks in a landscape; for example in a woodland scene painted on the spot you may only need to suggest it in broad terms, but when a tree is a foreground feature attention to the texture of the bark can give a focus to the picture.

Decayed or rotting wood in the form of gateposts, fences or mooring jetties also make exciting foreground features in a landscape, or can even be the main centre of interest. Here you will see a whole range of textures, from the dry, hard fissures of weatherbeaten posts to the soft and crumbling parts of decomposing wood. There is always a rather romantic and attractive quality to these decaying wood structures, as though they truly belonged to their surroundings, and the great British landscape painter John Constable (1776-1837) loved to include features like these in his paintings to convey the freshness and dampness of the scene. "Old rotten banks, slimy posts and brickwork. I love such things. . . They made me a painter."

STONE

When you start drawing textures it is always a good idea to practise by trying to master a simple example. John Ruskin (1819-1900), the critic and artist, used to advise his students to begin by going outside and picking up the first stone they came to in the garden or road. He maintained that learning how to render the special texture and character of this stone, you could learn how to draw anything.

As he made clear, the principle of light, reflected light and shadow are as true for the minutest crack in a pebble as for a large ravine – scale makes no difference. In many ways the textures that you find on smaller stones are very similar to those on a cliff face or in a quarry, and given the right light and angle can often serve as useful models for larger landscape features.

Once you have thoroughly understood forms and textures you can begin to simplify, and this is nearly always necessary when painting large, complex rock surfaces such as cliffs. There is no easy recipe for this, but I usually find that trying to commit a scene to memory is helpful, as it compels you to concentrate on the main forms and textures

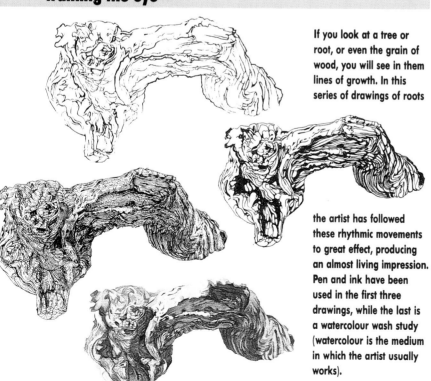

If you look at a tree or root, or even the grain of wood, you will see in them lines of growth. In this series of drawings of roots

the artist has followed these rhythmic movements to great effect, producing an almost living impression. Pen and ink have been used in the first three drawings, while the last is a watercolour wash study (watercolour is the medium in which the artist usually works).

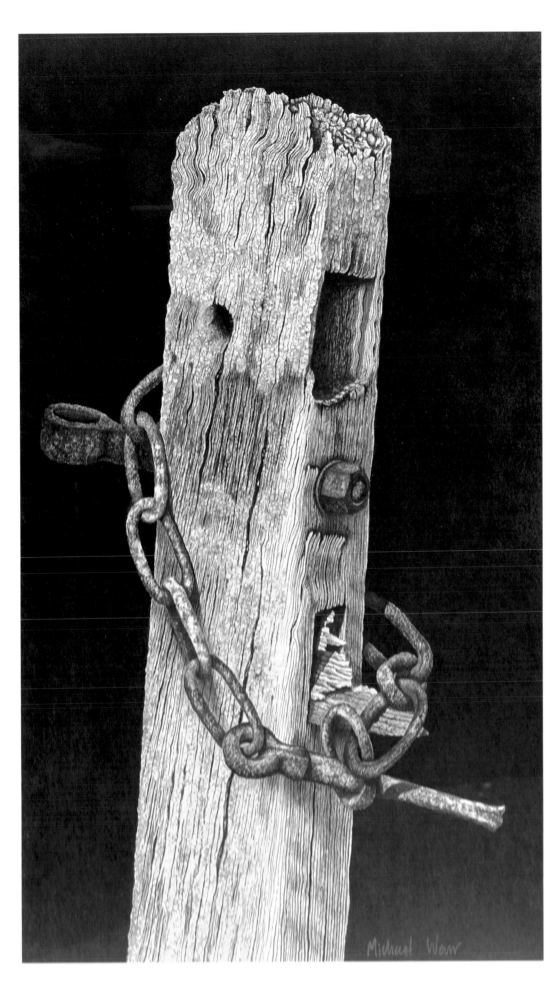

Post
MICHAEL WARR
Watercolour

Wood and metal left to rot and rust can be a rich source of subject matter, as this painting shows. The artist has achieved many of the textures by using a dry brush technique. If you look closely at the cracks you can see how the solid lines peter out as the colour on the brush is gradually used up, producing a broken, dry line that mimics those in the wood. The soft, mottled textures of the lichen and the rust have also been painted with great skill. Here washes and dry brush combine in a careful building-up process, beginning with the lightest tones and finishing with the darker ones. Many of these have been painted in a meticulous stippled technique. The soft, muted colours also help to convey the weatherbeaten textures as well as giving an overall unity to the picture.

and thus effectively filters out detail. Once the main structure and overall textural effect has been grasped then other information can be slotted into place.

BUILDING MATERIALS

Walls and buildings made of stone, brick or wood are always an attractive feature in a landscape, often providing a focal point as well as an indication of scale. The texture of buildings or other manmade structures, whether a drystone wall, an old wooden barn or a brick-built mansion, is a vitally important part of its character. You can paint a tree with no more than a broad general indication of the texture of its bark, or even none at all, but a painting of a building described in flat colour will look both unconvincing and dull.

Ruskin's approach to understanding cliffs and mountains, mentioned earlier, is equally valid for features such as drystone walls and old brick buildings, which often have quite complicated textures, particularly when the stone is old and weathered. If you are lucky enough to find loose stones or bricks lying about, you might find it helpful to take one home and make some detailed drawn studies. Another thing you can do is experiment with different lighting conditions, because this will show you how much the direction of the light affects the way you see the textures.

When you are working on the spot you obviously cannot control the lighting in quite the way you can indoors, but you can choose the time of day. In general, both colours and textures show up best in low sunlight, which makes tiny shadows that describe small irregularities on the surface. If the sun is too high, the shadows will be minimal, flattening out the textures and bleaching the colours.

MEDIA AND METHODS

Soft pencils with long, tapering points, which produce both line and tone with ease, are an excellent and sensitive drawing medium for conveying the wide range of textures found in wood and stone.

PENCIL

Pencil is also capable of recording the smallest detail as well as the most subtle tonal difference, particularly if you use pencils of different hardnesses in one drawing, which gives you complete control. Try starting the drawing with a fairly hard pencil such as an H or HB to indicate the main

Oil

1 **Starting with a pencil sketch on primed board, the artist has begun by blocking in the main colours.**

2 **Once satisfied with the relationship between the tones and colours, he is ready to develop details and textures, paying close attention to the highlights. Notice how next to the stock of the guitar the reflection takes on the colour and tone of the shadow, while on the front the main reflection is bright and warm.**

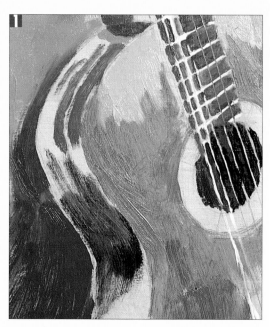

3 **Thicker paint is added with a bristle brush following the principle of "fat over lean" (thick paint over thin).**

4 **The grain of the wood is suggested very simply, by allowing the brush to follow the downward direction on both front and sides of the guitar. A small sable brush has been used to paint the darker knot running across the grain.**

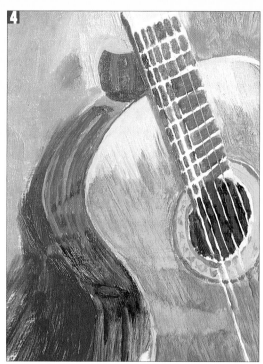

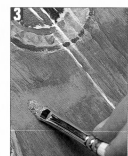

2 Watercolour

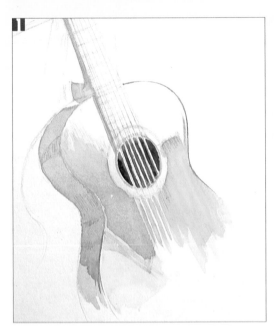

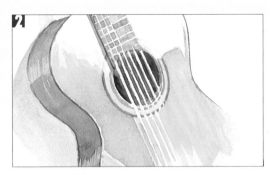

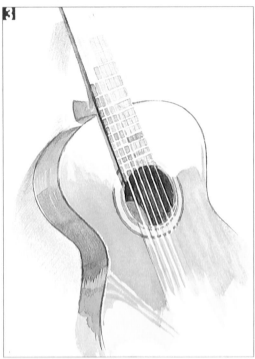

1 **A pencil sketch is first made to ensure the correct shape and proportions, and watercolour washes are then applied to the body of the guitar, with the white paper reserved for the highlight.**

2 **Once the wash has dried the light pencil lines are removed with a soft eraser.**

3 **The edge of strong reflections are always tricky. Here the artist introduces both hard and soft edges.**

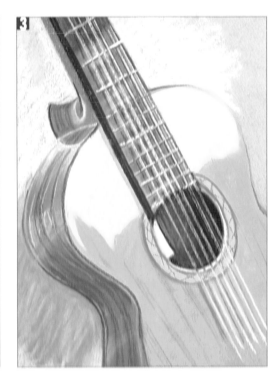

3 Pastel

3 **Once the main forms have been established, details such as the wood grain and the guitar strings are added.**

1 **In this first blocking-in of the colours, care is taken to establish the correct relationship between the highlight and the rest of the guitar.**

2 **Identifying the colour and tone of a highlight is always a little tricky, particularly when the light is very strong, as in this case. Here the artist has chosen a bright, warm yellow to indicate the light source.**

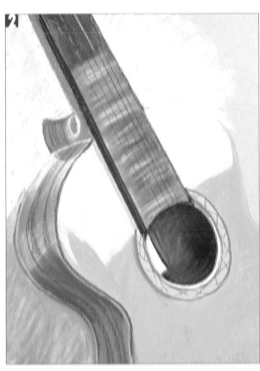

lines and placings, and then proceed to use the softer grades such as the B and 2B to suggest the light tones before bringing in a softer grade such as 4B for the darkest area.

FROTTAGE

This is the most direct and immediate of methods for creating a wood or stone texture. The word means "rubbing" and the method is exactly the same as that used for making rubbings of stone and brass plaques in churches – a sheet of paper is placed on top of the object and rubbed over with a drawing material. The different features of the underlying texture show up as variations in the "drawing", providing a complete record of the surface qualities.

This method is ideal for wood grain, brick and anything with a fairly flat surface, but cannot be used for sharply curved, jagged or spiky surfaces. The paper should not be too thick or it will not pick up the texture or so thin that it becomes difficult to work on. The choice of drawing implement is another important consideration. I find graphite sticks or conté crayons the most sensitive, but soft pastels and oil pastels can also give

good results. Frottage "studies" can be integrated into a drawing, as in the example shown here, or used as reference, together with other on-the-spot sketches.

WATERCOLOUR

Although most watercolour techniques can be adapted to render the textures of wood and stone, there are some methods that can effectively short-circuit the more traditional approaches. The following techniques may not give you an exact rendering of a particular surface, but they can give a convincing impression of an overall texture. They are also enjoyable to experiment with, and may suggest wider applications and new ways of working.

Wax resist This is a technique which is highly suited to the rather rough and irregular textures of tree barks or rocks. The method is based upon the mutual antipathy of water and oil (wax): when marks are made with a wax crayon or candle on the paper and watercolour washes laid on top, the colour will slide off the wax, producing a fractured or broken tone. The wax can either be lightly

▶ **Lyme Regis Beach**
RONALD JESTY
Watercolour
Painting a large expanse of textured foreground without it becoming over-obtrusive can be quite difficult. Here the artist has dealt with it by avoiding a too-specific treatment and keeping the area largely in monochrome. Using a series of warm and cool grey washes, laid wet-on-dry, he has built up the tones gradually, giving a convincing impression of the stones without painting every one.

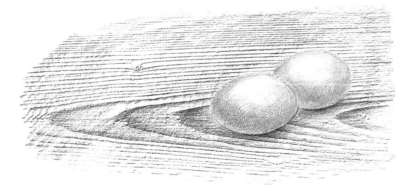

▲ **Eggs on a Table**
MARTIN DAVIDSON
Coloured pencil
Integrating frottage into drawings can often present some problems. Firstly, it can be difficult to relate the essentially two-dimensional texture rubbing to solid objects, and secondly, if objects are drawn on top of the frottage, the texture may not be covered completely. Here the second problem has been tackled by drawing the eggs first with coloured pencils and then adding the wood

texture afterwards. This was done by placing the working paper face up on a grainy piece of wood and shading around the eggs with a brown conté crayon. The rippling "waves" of the wood grain have been carefully placed to provide an elongated "echo" for the eggs, giving a lively movement to the composition and the light, delicate treatment of the eggs is in keeping with the wood grain, ensuring there is no jarring contrast.

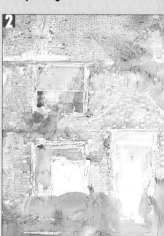

WATER COLOUR

Ruined house

2 Using a broad chisel brush, he then lays a deliberately uneven wash of yellow ochre. This acts as a warm underpainting, helping to give unity to the final painting.

1 The artist begins his watercolour with an accurate pencil drawing, traced from a photographic slide projected onto the paper. Masking fluid is then painted on those areas he wishes to remain white including the fine detail of the pointing. He uses a fine sable brush for this, cleaning it regularly to prevent the masking fluid clogging and ruining the hairs.

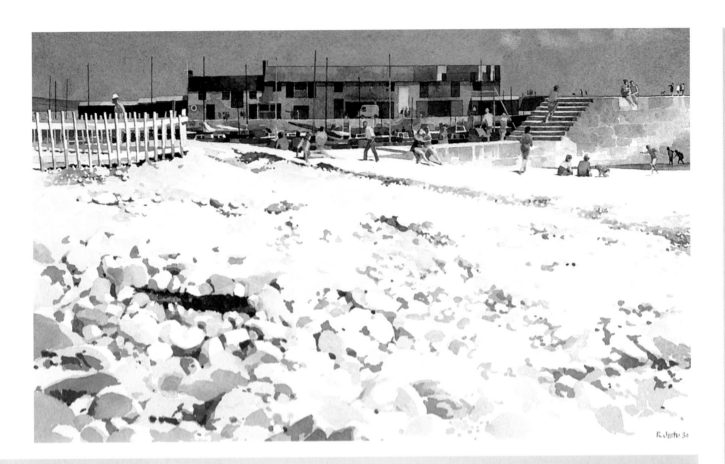

3 Once the first wash is dry, further wet-in-wet washes are added for the brickwork and roof areas, using a combination of cadmium red, yellow ochre and cobalt blue. When dry the masking fluid is rubbed away and the exposed beams, window frames and door painted with the same colour combination.

4 Although many of the effects are the result of a methodical approach, the artist has also experimented with less predictable techniques. The texture of the brickwork, for example, was achieved by smudging the colour with the palm of his hand and lifting out colours with water and tissue in some areas. The detail of the ivy has also been created by lifting out. First the overall shape was painted in a dark green, and when dry each individual leaf was picked out by damping with a brush and water and then blotting.

▼ Wet or Fine
MICHAEL WARR
Watercolour
The predominant technique used here is dry brush, with colours lightly over underlying paint to build up rich and complex effects. Fine lines such as the cracks in the bricks were added with a tiny sable brush, while the cobweb was achieved by scratching out with a point. Scratching should be the last stage in a painting, as it scuffs the paper and makes it difficult to lay colours on top.

dragged over the surface to give a mottled effect or used more positively to establish large light areas. The sharp, sparkling effect is particularly effective for indicating reflected light from wet stones and rocks.

Spattering Other more random and irregular textures can be established by flicking colour onto the paper. The rather haphazard arrangement of the drops of watercolour is wonderfully suggestive of sand and small stones on a beach or the mottled and pitted textures that you find on many rock surfaces. The spatter effect can be achieved in a variety of ways, but the most usual method is to dip a small, stiff brush, such as a toothbrush, into the watercolour, hold it about 15cm (6in) above the paper and drag your thumb across the bristles to release a stream of droplets.

Sometimes you may find the spatter

produces an effect which is too "focused" and thus dominates the picture. You can avoid this by lightly dampening the paper before starting the spatter work so that the spots of paint will partially dissolve and blend together in a gentler, less ostentatious way.

To prevent the spatter from going onto the rest of the painting use some kind of mask or stencil such as newspaper, putting it in contact with the paper for a hard edge lifting it away from the surface for softer boundaries. If you want to spatter a small, intricately shaped area you can cut a stencil from thin card, cartridge paper or stencil paper.

Salt spatter Another way of producing the effect of the pitted, irregular textures seen on weathered rocks is to sprinkle coarse rock salt into a wet watercolour wash. The salt

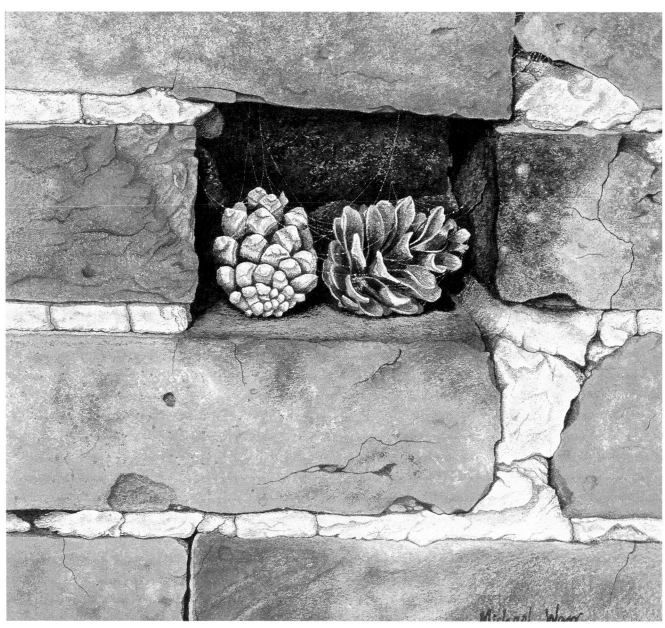

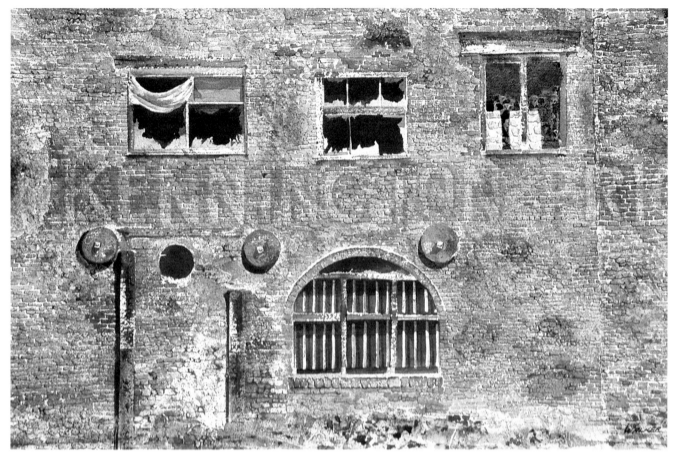

▲ Pottery, Stoke on Trent
SANDRA WALKER
Watercolour
One of the most difficult qualities to capture in old brick is the soft, crumbling surface. Walker has used a similar technique to that seen in Warr's painting, a combination of washes, dry brush, spattering and scraping back with a razor.

▶ Green Drawers
DEBORAH DEICHLER
Pastel
Careful blending and a heavy build up of colours gives this pastel almost the appearance of an oil painting, and it is not surprising that Deichler normally works in oils. She describes herself as a realist painter who loves intricate detail, and who creates mystery in her paintings – both qualities can be clearly seen here.

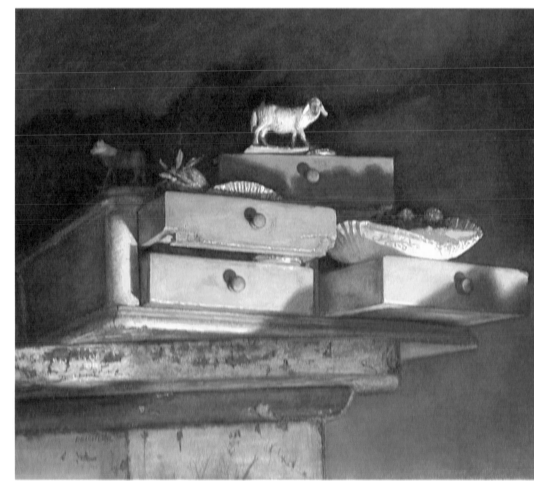

Rocky beach

1 From a loose pencil sketch the artist quickly blocks in the main features with light watercolour washes.

2 Next the shadow areas are painted wet on dry, with a delicate broken wash suggesting the rough underside of the rocks.

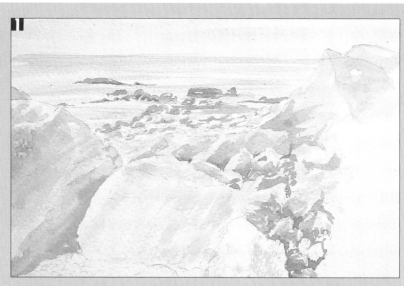

3 An ordinary household candle is then used to scribble over the foreground rocks. The wax will repel new applications of watercolour, resulting in uneven stone-like textures.

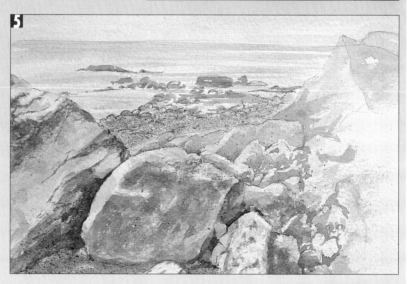

4 To suggest sand and pebbles in the foreground, the artist uses a toothbrush to spatter paint, having cut a mask to protect the rest of the work. For accuracy the stencil has been cut from tracing paper, with the areas to be spattered traced with pencil before cutting out.

5 In the final picture you can see how the artist has concentrated on the foreground textures, leaving the background rocks as they were in the initial stages.

absorbs the paint, and is removed when dry, leaving a delicate pattern of pale, crystalline shapes. This technique, although it sounds simple, takes a little practice, as the effect you obtain depends both on the wetness of the watercolour wash and the density of the salt granules. In general, salt sprinkled into very wet paint gives large, soft-edged shapes, and smaller, more granular shapes are produced if the paint is just damp. Once you have mastered the method you will find you can build up quite complicated areas of texture by successive applications, but it is a slow process as the salt takes some time to dry and must not be removed prematurely.

Sponge painting Sponges are an invaluable tool in watercolour work, and a quick way of creating varied, open textures is to paint with the sponge, dabbing colour directly onto the paper. As with most texturing techniques, experiment is needed. Try out different natural and synthetic sponges, densities of watercolour and pressure of application.

An interesting variation on sponge painting is to use the sponge to remove colour. This

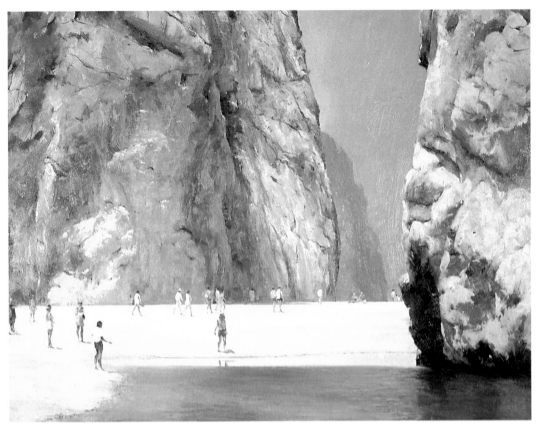

◀ **Beach and Cliffs, Torrent de Pareis, Majorca**
DAVID CURTIS
Oil

In this dramatic composition the artist has to some extent simplified the cliffs, but the textures are wonderfully suggested by concise directional brushwork.

▼ **Last Visitor I**
WALTER GARVER
Oil

This artist is fascinated by textures, and has clearly revelled in the contrast of the crumbling plaster and the stonework below. He uses his oil paints almost like watercolour, in thin washes which allow him to describe every detail with meticulous care.

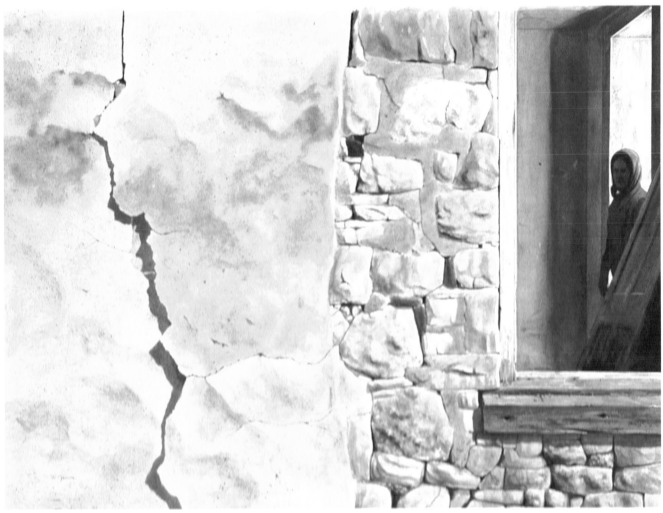

Tree bark

1 Acrylic paint is used here, on watercolour paper. The tree trunk was first outlined with dark grey, fairly thin paint, and then the overall shape was filled in with a warm neutral colour.

2 Small areas of brighter colours are then laid, and while the paint is still wet, it is blotted with newspaper to produce rough and varied textures. This technique also reveals underlying paint surfaces, and the process can be repeated several times to build up the texture.

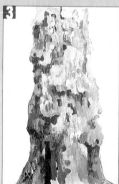

3 At this stage the rendering lacks detail, but is already an attractive and colourful interpretation of the texture.

4 The final stage was to paint the thin dark lines that suggest the flaking of the bark. A small watercolour brush was used for this.

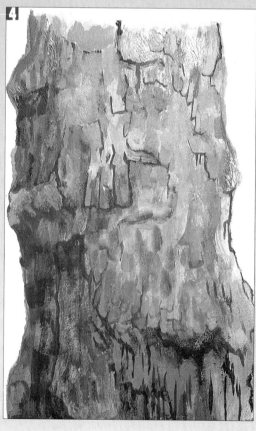

was recommended in Chapter 1 as a highlighting method, but it is equally useful in this context. After applying a watercolour wash, let it partially dry and then gently press a damp, clean sponge onto it. The sponge will remove only those parts of the wash it comes into contact with, leaving its texture "imprinted" in the paint. For more fractured and flaky textures such as the barks of pine and cedar trees, try lifting out parts of the watercolour by drawing into it with a wet brush and then blotting.

Washing off This is another technique based on the fact that wet watercolour can be removed by washing, leaving the dried watercolour unaffected. The method is often used to remove mistakes, but can also be adapted for creative purposes. After applying loose watercolour washes, dry the areas you wish to preserve with a hair dryer, shielding or masking the parts you want to remove. When the paper is washed under a tap those areas still wet will be removed, leaving only a slight stain, while the dried washes will be unaffected. If necessary the process can be repeated, building up complex textural areas.

Scoring For tree barks with strong directional ridges or furrows, or for rocks with pronounced fissures, the texture is best achieved by suggestion. Watercolour washes can be applied following the main lines of the form, and while the paint is still wet the crevices and dark fissures can be established by scoring with a point, such as the end of a paintbrush, into the damp paper (the broken fibres of the paper will make the tone darker). When dry the ridges between these lines can be scraped to provide the light areas. With techniques such as this it is best not to be too methodical or literal about positioning the lines; nature does not work so uniformly. Try to follow the sweep of the tree or rock face, letting the scored lines overlap or drift apart.

Granulation Another way of introducing an interesting and largely unpredictable wash area is to exploit the nature of the pigments themselves. You may have noticed that when using mixed colours to paint large wash areas such as skies the pigment tend to separate out, producing a slightly speckled effect. This is due to the different weights of the pigments, which prevent them forming a homogenous wash; you can see the effect very clearly if you mix French ultramarine with a heavy, slightly opaque pigment such as light red or Venetian red. Some control can be provided by adjusting the amount of water you use and also by tipping the paper.

**▶ Winter Store
MICHAEL WARR**
Tempera on board
**Tempera, pigment bound
with egg, is a medium
capable of extremely
precise and detailed effects,
but it is not an easy
medium to handle.
Many artists prefer acrylic
on paper, which can yield
similar results.**

**▼ Violin on Chair
PAUL DAWSON**
Mixed media
**Dawson also uses a
meticulous technique to
achieve his almost
photographic realism,
combining watercolour with
gouache and sometimes
acrylic.**

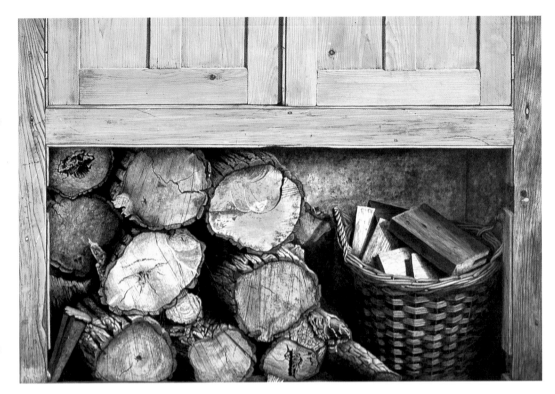

PASTEL

The dry and crumbly nature of soft pastels makes it ideal for rendering subjects with similar textural qualities, such as old brickwork, where the effects of flaking infill and the rough, discoloured surfaces of the brick can be conveyed by working on a fairly coarse pastel paper.

As we have seen in Chapter 1, pastel is also capable of gentle transitions when colours are blended together, and can also render the smooth and delicate textures of a subject such as highly polished wood. However, over-use of blending can look very bland, so it is wise not to overdo it. In general, it is less easy to create a range of different textures with pastel than with watercolour or oil, so you may have to consider a mixed-media approach, using watercolour or gouache for smoother passages and pastel for the rougher ones of wood and stone.

Oil pastel A cruder medium, but in many ways a more malleable one than soft pastel, with great potential for creating texture effects as well as rich colours. The main difference between oil pastels and soft pastels is that the latter are made from pigment bound with gum tragacanth, while the binding medium for oil pastels is oil. They can be used in exactly the same way as soft pastels – although they handle differently, being heavy and buttery rather than dry – but they can also be turned into paint by mixing them with white spirit.

You can do this in two ways. One is to block

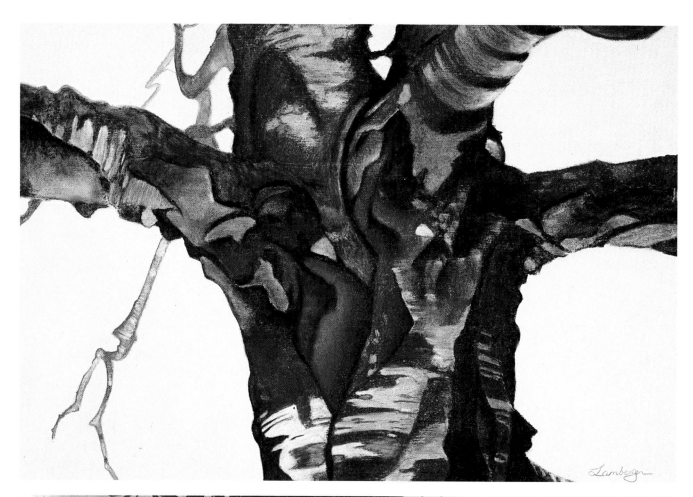

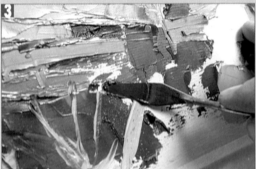

3 The flat of the blade will produce broad strokes, each one bordered by a ridge of thicker paint, providing a lively and expressive surface. For detail, the tip of the blade can be used.

4 Knife painting is at its best when the paint is applied confidently. Too much overlaying of colours can produce a muddy mess.

1 Patches of thick oil paint are laid with a painting knife over a simple preliminary pencil drawing.

2 The structure of the painting follows that of the wall, with separate blocks of colour used to represent individual stones.

◄ **Wolf Birch**
NANCY LAMBERGER
Oil pastel
The bark textures have been tackled in a schematic way by simplifying the shapes and forms. Like pieces of armour or scales, each segment of bark is carefully modelled to encircle the tree. The artist has used a limited number of oil pastels and paid close attention to the areas of transition where one colour blends into another.

◄ **Autumn**
WALTER GARVER
Oil
The flame-like segments of bark have been painted with directional brushstrokes.

in colour with the side of the pastel stick and then spread it over the paper with a rag or brush dipped in white spirit, and the other is to apply colour directly with a bristle brush by first dipping it in white spirit and then rubbing it over the pastel, just as you would dip a brush into a paintbox. In this way you can achieve flat areas of colour, which you can then draw over with the dry pastels where you want to express texture.

OIL

Knife painting This is probably the boldest of all oil painting techniques — and one of the most exciting to use. Painting knives, which are purpose made, with delicate, flexible blades and cranked handles, come in a wide variety of shapes and sizes, from tiny pear shaped blades to large, straight ones, allowing you to vary the marks you make. The effect of thick paint applied with blades is quite different from brushwork; the flat surface of the knife squeezes the paint, giving small ridges at the edge of the stroke, making

it particularly suitable for multi-facetted subjects such as a quarry or cliff face.

The technique requires a confident approach, as too much overworking quickly destroys the effect. You may find it difficult at first, but persevere, as once you have got used to the different method of application, the technique is capable of great subtlety. A painting knife can be used in a variety of ways. Used like a trowel it will distribute the paint in bold sweeps; used as a blade it can quickly establish edges and lines; and using the flexible tip, the paint can be pushed around to soften forms and to add detail.

Sgraffito This technique, which was mentioned earlier under oil pastel, has probably been used by most painters at one time or another, either knowingly or accidentally. The term derives from the Italian *graffiare*, meaning to scratch, and literally entails scratching with some implement back into the wet paint to reveal underlying paint surfaces. Rembrandt (1606-

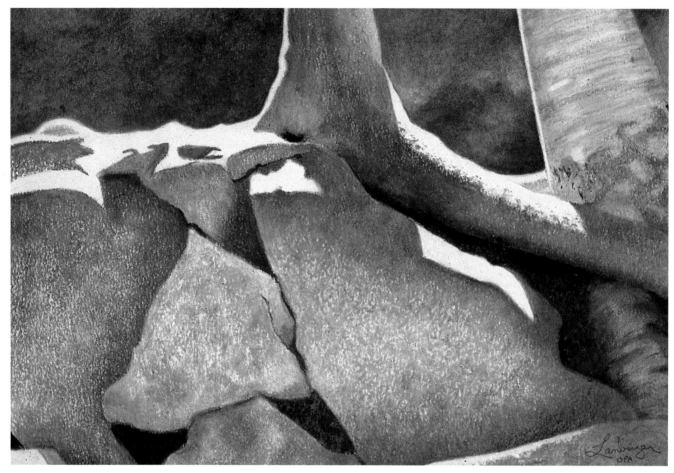

▲ **Silent Footsteps**
NANCY LAMBERGER
Oil pastel
The textures of the rock have been achieved by applying light pressure with the pastel so that the texture of the paper comes through. Firmer pressure, which fills the grain and the paper, is used for the darker areas.

69), to whom we are indebted for many of the techniques used today, used to scribble into thick paint with the handle of a brush to describe facial hair or lace fabrics. Sgraffito can be used for a wide variety of textures, but is especially appropriate for wood grain.

To use the technique to full advantage you need to think ahead and construct the painting in terms of layers of paint. Begin with the darker tone of the grain, and then when this has dried paint the lighter wood tone on top, working back into the surface with an appropriate instrument to reveal the underlying colour. Try using a variety of implements, such as a pencil, matchstick or comb, and discover for yourself which would be the most suitable. Bear in mind that other variables such as the thickness of paint and the amount of painting medium used will affect the final result. In very thick paint the scratching will create distinct ridges, more fluid paint will tend to fill in.

If you find the effect is rather too crude and fails to blend in with the rest of the painting try very lightly removing the build-up of paint by blotting with a sheet of newspaper or tissue paper. This will soften the effect and, if used with a varying pressure, will partially reveal the underlying colour and so create a subtle blend of the two.

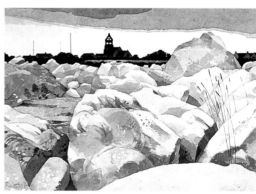

▲ **Portland Quarry**
RONALD JESTY
Watercolour
Jesty has built up the shapes and textures of the rocks by means of a series of carefully placed washes, worked wet-on-dry so that each one has a clear, crisp edge.

▶ **Brandenberg, Namibia**
HAZEL SOAN
Watercolour
You can almost feel the heat in this brilliantly lit landscape. The only cool colours are the shadows on top of the rocks, everything else is coloured by warm reflected light. The artist has combined wet-in-wet and wet-on-dry to produce both softly blended colours and crisp edges.

◀ The Blue Gate – a Farmhouse in Galway
MILTON MEYER
Pastel

When you are painting a landscape it is important to decide where your interests lie. Here the contrasting textures play as important a role as colour and composition, giving the picture much of its charm and atmosphere.

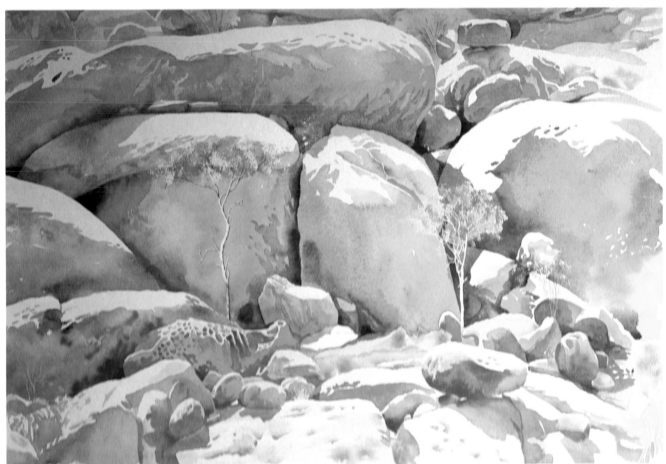

FOCUS ON Wyeth

Andrew Wyeth (b.1917) is a painter steeped in the tradition of rural painting in America. Comparatively uninterested in and unaffected by trends in international art movements, he has continued to plough his own very personal furrow, mixing close observational detail with a strong poetic instinct. He usually paints in watercolour or tempera, and his works all depict people and places either around Chadd's Ford in Pennsylvania, where he lives, or the area of Maine where he has a summer home.

▶ This work was painted in memory of close neighbours of the Wyeth's, Alvaro and Christina Olson. Wandering around the empty building after their death he was struck by this scene, which seemed to evoke the personalities of the people who had lived there. "I went in there and suddenly that door seemed to me to express those two people, the basket and the beautiful blue door with the strange scratches on it that the dog had made — all gone."

▶ Wyeth is a master of suggestion. From a distance the painting seems to be a model of near-photographic realism, but close up you realize how much he has simplified. In this detail, for example, you can see splashes of watercolour and loose washes underlying carefully controlled detail, achieved by blotting parts of the wash and manipulating other areas with a fine brush. For Wyeth, good dry brush work is best done over a very wet technique of washes. "I work in dry brush," he says, "when my emotion gets deep enough into the subject. So I paint with a smaller brush, dip it into colour, splay out the brush and bristles, squeeze out a good deal of the moisture and colour with my fingers so that there is only a small amount of paint left. Then I stroke the paper with the dried brush and start to develop the forms of whatever object it is until they start to have real body."

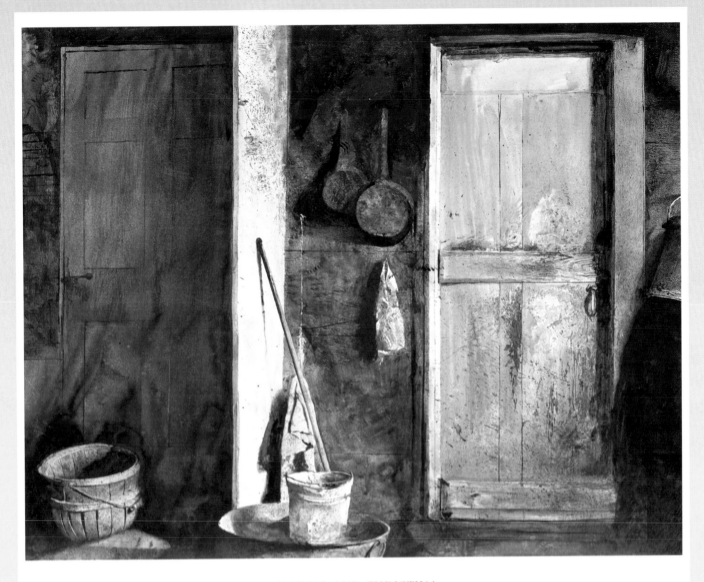

ALVARO AND CHRISTINA
Watercolour
William A. Farnsworth Library and Art Museum,
Rockland, Maine

▶ Here Wyeth has used a similar gestural watercolour underpainting, but has built up the textures in a more methodical way. He employs many different techniques to obtain effects, sometimes using sandpaper on the watercolour, sometimes pressing the palm of the hand on a wash to give transparency, and sometimes painting with opaque white to bring back the highlights.

Notice that here he has made use of loose, uneven areas to give the basket a battered, well-used look. In all his watercolour paintings Wyeth guards against getting too caught up in the dry-brush detail. "I want to keep the quality of a watercolour done in twenty minutes but have all the solidity and texture of a painting."

The word texture usually conjures up the image of a rough surface, but smoothness is a texture too, and this is the main quality shared by glass and metal. Both are reflective surfaces, but

METAL & GLASS

while metal reflects most of the light that falls on it, glass – except when used as a mirror – lets most of it through. Here we show you how to make the most of reflections, and how to represent glass convincingly by paying special attention to highlights.

◀ Cut glass, with its multiplicity of small highlights and shadows, is a tricky but rewarding subject.

▶ The pinkish glow of copper can be brought out by arranging other warm-coloured objects nearby.

▲ Polished metals, being highly reflective, are very much affected by their surroundings, but the "yellow" metals have their own basic colours as well. Notice the difference between the horse brass and the copper pan (above and top).

▶ Convex metal surfaces concentrate reflections in distinct areas, giving high-intensity shadows and highlights. Chrome, unlike copper and brass, has almost no colour of its own, and appears as predominantly white, grey and near-black.

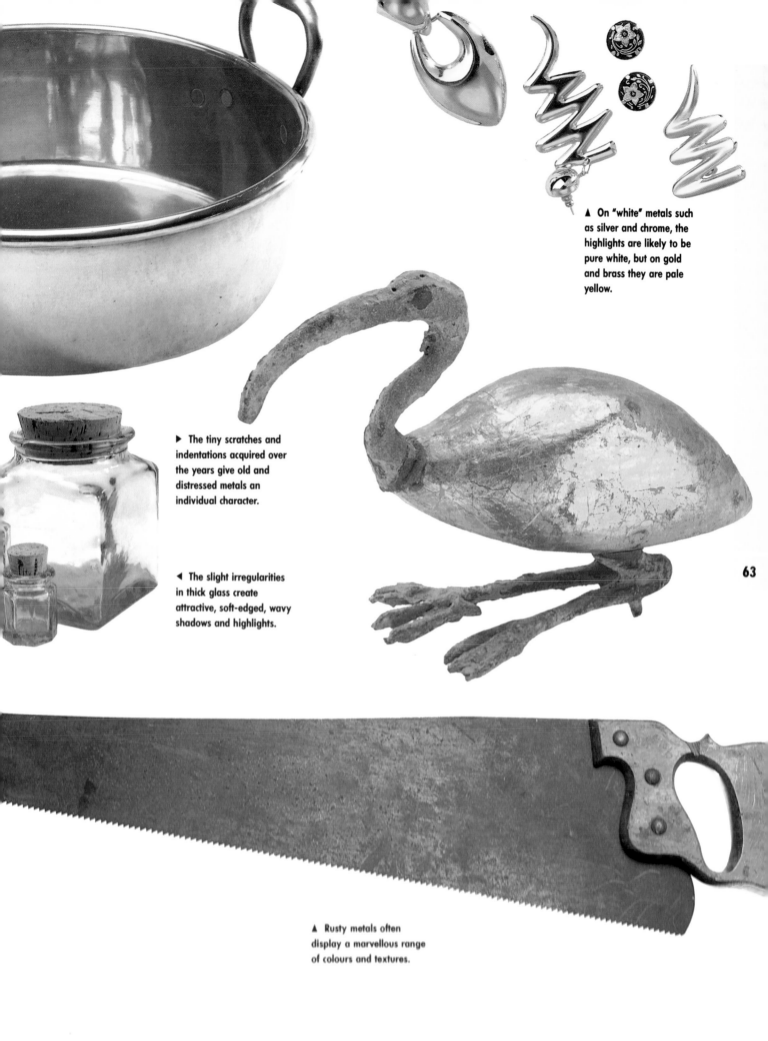

▲ On "white" metals such as silver and chrome, the highlights are likely to be pure white, but on gold and brass they are pale yellow.

▶ The tiny scratches and indentations acquired over the years give old and distressed metals an individual character.

◀ The slight irregularities in thick glass create attractive, soft-edged, wavy shadows and highlights.

63

▲ Rusty metals often display a marvellous range of colours and textures.

There are strong similarities between metal and glass, though in a sense they are opposites. Both have hard, smooth and reflective surfaces, but while metal reflects all the light falling on it, glass lets most of it through. Painting objects made of shiny metals can seem daunting at first. Instead of a solid form to grasp which obeys familiar rules of light and shade, you are suddenly plunged into an upside down world where many of the strongest tones and shapes derive from things outside the object. Indeed, in the case of a very shiny object such as a stainless-steel kettle, the form seems to be a sum of other objects, shapes and colours around it. Move it to a different place or even just shift your position slightly and you have a completely different subject.

Glass is one of the simplest of textures to render as long as you understand what is going on. You will need to learn how to deal with its two main characteristics, transparency and refraction. Transparency can be a difficult concept for the painter. You know something is there but you have to ignore it and paint the background instead. A common mistake made by beginners is to make the glass object more prominent and dense than it actually appears. The edges tend to be over-emphasized and the middle transparency filled in as though trying to make the whole object into a solid form. See if you can approach the problem from the other direction by asking yourself what is the least you can do to indicate glass. A few brushstrokes are sometimes all that is required, some light ones to show the turning of the form and a couple of rapid marks for the highlights.

The principle of refraction is also useful to the painter in revealing the texture of glass. Refraction is the name given to the way light rays are bent as they move through a denser medium. It is exactly the same phenomenon as you find when looking at the way a stick seems to bend in water. If you look through any glass you will see this to a greater or lesser extent; shapes, lines and textures of objects behind the glass will be distorted. When arranging your subject bear this in mind and see if you can exploit the effect. Experiment by placing objects behind the glass and see whether the distorted forms help show the textures of the glass. Think visually and choose objects, shapes and colours that might give an exciting image.

LIGHTING

One of the most difficult problems for painters, no matter how good they are, is to try and make sense of a confused jumble of

Drawing & Painting

METAL & GLASS

Training the eye

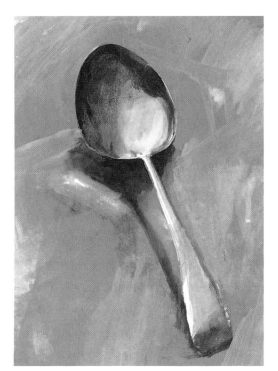

Drawing and painting the reflective surfaces of metals tends to be confusing until you grasp how these relate to the form, but there is a logic to it all. As a first exercise, choose a subject that has a comparatively simple form, such as this spoon, and observe how the changes in the surfaces create corresponding – but sometimes surprising – changes in the tone. This painting (left) began as a watercolour and as the tones built up, opaque gouache was introduced to lighten the tones and correct mistakes.

An exercise often set in art schools is to draw a piece of crumpled metal

foil; the many multi-directional facets provide a challenge even to the experienced. By looking closely, however, you can identify "pathways" of shadow and highlight, and the rhythms of light and dark are skilfully exploited in this watercolour (above).

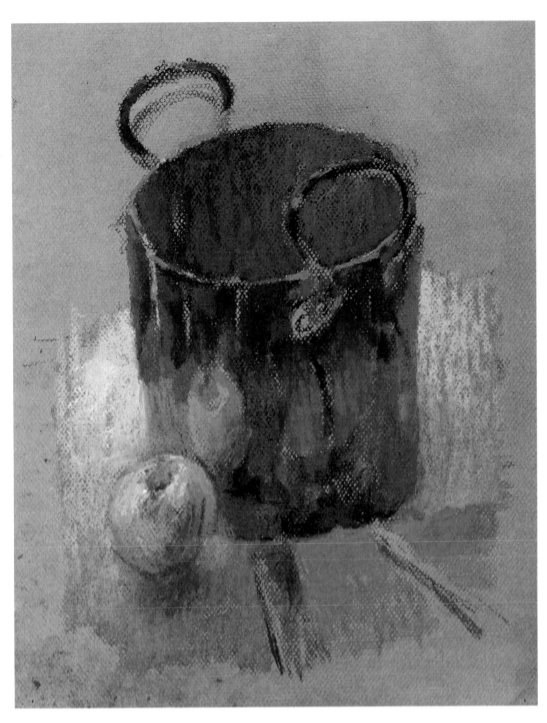

The copper pot was the inspiration for the picture, and the apple and red sketchbook were introduced to bring out its rich colours. The artist chose a paper which was close in colour and tone to the greenish-grey reflections on the pot, and then built up the pastels in layers, with frequent use of fixative. This tends to darken the pastel, but here the effect was well suited to the subject.

indeterminate tones. Look into the surface of most metal surfaces and that is usually what you will find. So whether you are simply drawing one object or tackling a still life which includes reflective surfaces, you will need to consider how to simplify and clarify the subject. This can be done by paying special attention to the lighting.

Remember that the slightest change in light and its intensity will alter the appearance of reflective surfaces and textures. Strong, direct light will tend to give hard and vivid contrasts, while softer light will break up the tones, giving more subtle effects. Although generally the stronger light will give you more

clarity, it will also give you darker and more hard-edged shadows, and is not usually advisable for subtle textures where you need as much information as possible. You can conduct your own experiment with this by comparing the texture of a metal seen by a bright light and the same one lit by candlelight. In the soft, low light of the candle the eye becomes much more sensitive to the slightest nuance of surface texture.

I find one of the simplest ways to experiment with different light sources is to place the object or objects on a tray so that the composition remains undisturbed and can be transported to different locations

Pastel

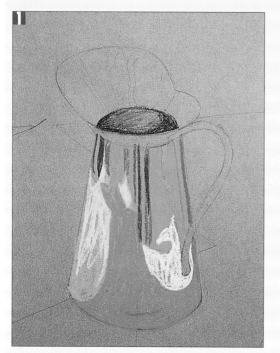

1 To make the reflections more interesting, two sheets of white paper are placed nearby. The main shapes of the reflections are established immediately.

2 To avoid smudging the pastel, the artist rests his hand on a mahlstick when drawing the detail.

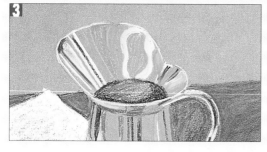

3 The shapes of the reflections are interesting in their own right, but they are also vital in describing the polished mirror-like surface of the metals.

4 The importance of the surroundings is clearly demonstrated in this photograph of the finished picture. Without the strong reflections produced by the paper the drawing would have looked rather flat.

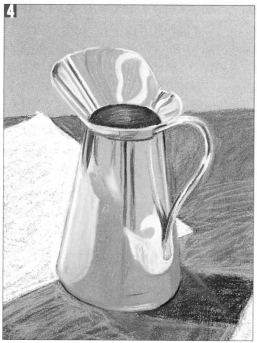

around the house. Sometimes by changing the light the whole idea of the painting can alter. I was interested in painting a small Georgian silver jug not long ago and tried out a number of places. Each one proved adequate but was not quite what I wanted, and it wasn't until I tried overhead lighting near a window that the subject came alive. Suddenly the whole inside seemed to glow with a warm light as though the silver itself was the source.

BACKGROUNDS

In any still life group – and even a drawing of an isolated metal or glass object is a still life – the background is of great importance, and in the case of metal and glass can help you bring out the reflective qualities of the objects. The smoothness of a copper pot or silver jug, for example, might be stressed by painting it against a rough-textured wall or a heavy fabric, while a plain, dark background would provide an element of contrast to make highlights and tonal contrasts in the subject stand out more strongly.

With glass, the background will always be a dominant element, since so much of it will be visible through the glass. Plain backgrounds are usually best, as a strong pattern behind a glass object will destroy its form, but the colour and tone will depend on the effect you

Oils

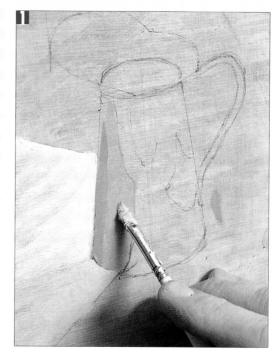

3

Watercolour

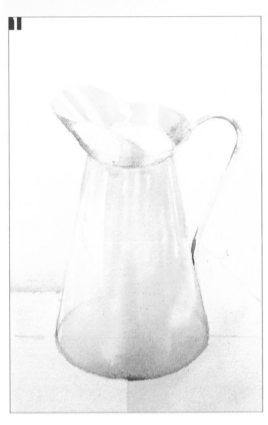

1 **An initial light pencil drawing is made to ensure the proportions and ellipses are correct, and then light washes are laid, with the highlights left unpainted.**

2 **To obtain the sharp, crisp edges to the reflections, the first wash is allowed to dry before further colours are applied wet-on-dry.**

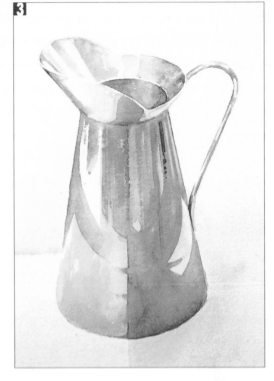

3 **The pencil lines were removed with a soft eraser and final washes applied, paying careful attention to the difference in colours** between the two metals. **The body of the pot is copper, and the top and handle brass, a yellower metal.**

2 **Even at this stage the flat shapes of the reflections and the surrounding "positive" and "negative" shapes created by the jug against the background make an interesting decorative effect.**

3 **Thick, slightly off-white paint is now introduced for the highlights on the brass. Because the artist is painting wet-into-wet, the paint merges to some extent with the warmer colours below so that it does not look too stark.**

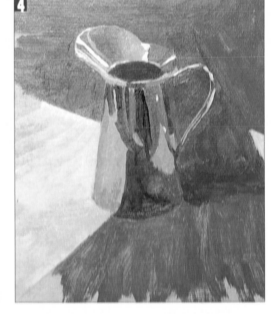

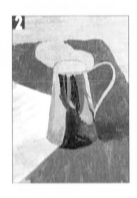

1 **The ground has been coloured a neutral grey to contrast with the warm pinks and yellows of the metals. The artist begins with the white paper and its reflection in the copper.**

4 **Although much of the emphasis has been on the flattish abstract shapes of the reflections, the artist has also conveyed the form** by adjusting the tones where the outer edges of the jug turn away.

Garden trowel

1 Gouache is well suited to complex and mixed textures such as this. Beginning with a pencil sketch the artist blocks in the main forms of the trowel with thick, opaque paint.

2 He then introduces a wash of more diluted gouache for the background tone, and builds up further detail thickly on the trowel, using a variety of calligraphic brushstrokes.

3 In comparison with the sparkling effect of watercolour, gouache can look rather dull, but here the matt surface and "earthy" tones of the palette are perfectly in keeping with the subject. When working in gouache, take care not to overlay too many colours, as each new application mixes with the one below. Here the paint has been used fairly dry to avoid this.

▶ The Alchemist's Dilemma
CHUCK WOOD
Oil
The combination of dust, top lighting and dark background create a mysterious atmosphere. The artist has given himself an intriguing set of problems, with the normally familiar textures of metal and glass obscured by layers of soft, thick dust.

want to create. Some of the most successful paintings of glass have been done on dark backgrounds, which emphasize the transparency by providing a range of subtle mid-tones and brilliant highlights. You may, however, prefer a light or neutral-toned background or even the high, bright key of a well-lit space.

MEDIA AND METHODS

Since both metal and glass are smooth-surfaced and essentially quite simple in texture, they can be rendered equally effectively in most drawing and painting media. However, within each media, some techniques and methods are more suitable than others, so in the following pages I have presented some ideas which you may like to try out.

PENCIL

Although any drawing medium can be used – with the possible exception of pen and ink, whose linear quality does not lend itself well to establishing broad areas of tone, high contrast and detail – pencil is perhaps the most sympathetic and adaptable. In a detailed pencil drawing you can begin to come to grips with the subtleties of highlight and reflection.

Make sure you use a good-quality, fairly heavy cartridge paper, at least 150 gsm. I find it easier to draw on a slightly rough paper as this gives a slight resistance to the pencil. Very smooth paper makes it more difficult to build up the tones, as the pencil tends to skate on the surface. Make sure also that the drawing can be erased without damage to the surface of the paper – you can test it by scribbling on the side with the pencil you will be using and then erasing the marks.

In pencil drawing, the eraser is more than a tool for correcting mistakes; it can also be

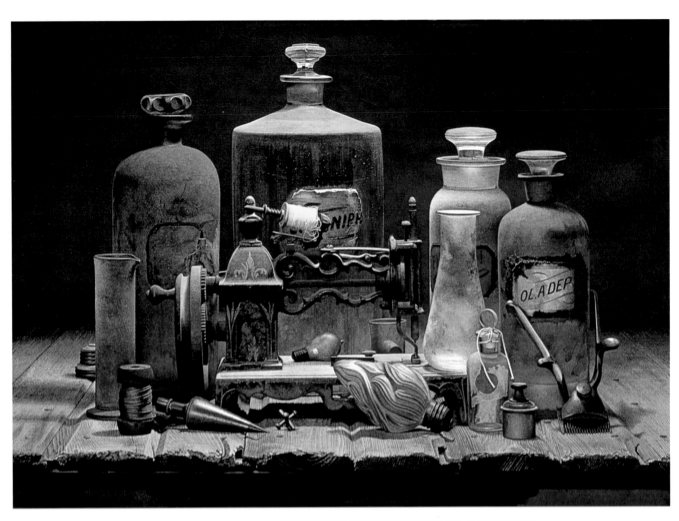

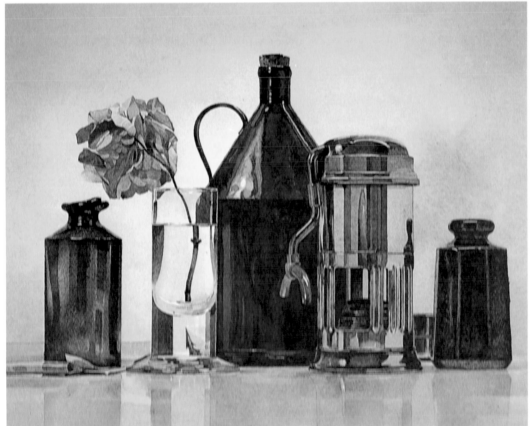

◄ **Still Life with Hydrangea**
RONALD JESTY
Watercolour
The objects have been carefully organized to create a fascinating interplay between the different shapes and textures. The transparency of the glass and water are conveyed through the disjointed stem of the hydrangea, an effect caused by refracted light, and the artist's precise wet-on-dry technique gives a "high-focus" clarity to the work.

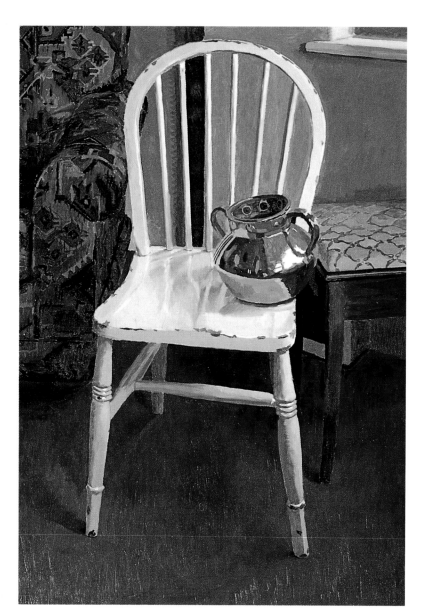

▶ **Coach Party**
SANDRA WALKER
Watercolour
This artist is always receptive to unusual compositions and subject matter, and has made amazingly skilful use of reflections in a windscreen, using wet-on-dry washes to create the kaleidoscope of fractured abstract shapes.

▶ **Chair and Copper**
JEREMY GALTON
Oil
The old white-painted chair and the copper pot make an unusual contrast in colour and shape, but are linked by the way the two shiny surfaces reflect each other. The copper takes on the bold shapes of the chair, and the chair in turn reflects the warm colour of the pot.

used positively to work back into the drawing. I have a number of different erasers which I use according to different drawing requirements. For instance, if I need to generally lighten an area of tone or establish soft highlights such as those on pewter objects, I will use a soft putty eraser. If, however, I need highlights or a sharply defined light area then I use a hard plastic eraser, which provides crisp edges and clearer whites. To get the most detail I use the edge of a plastic eraser kept in good condition by cutting frequently with a sharp blade.

PASTEL

Although precise detail is more difficult to achieve with pastel than with watercolour or oil, the versatility of the medium makes it suitable for rendering most textures, including shiny, reflective surfaces. Remember that a heavy build-up of blended colour will give the smoothest effect (see

Chapter 1). You can use the different surface qualities of pastel to suggest contrasts of textures, for example blending the colours for glass and metal objects and applying looser, rougher marks for other elements, such as the background or the table top. The effects of blending depend to some extent on the implement you use. Try a soft brush, a rag, your fingers and a torchon, and see which is most effective.

Pastel artists who use colour thickly, building it up in layers, usually apply fixative between stages to allow the new colours to adhere to the old ones. You can also work into still-wet fixative, which makes the normally crumbly pigment into something more akin to paint than pastel. Edgar Degas (1834-1917), perhaps the greatest of all pastel painters, was a pioneer of this fix-and-paint technique, and would sometimes even make a thick paste of pastel and fixative, which he then applied to the surface with a stiff brush.

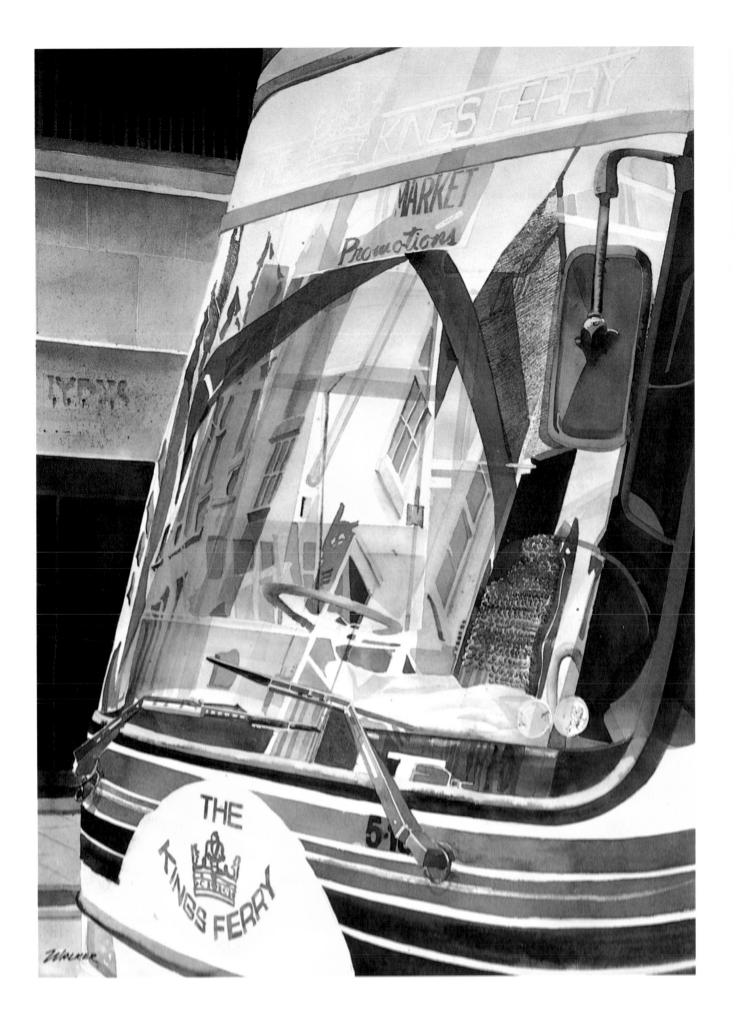

Cut glass

1 **The pattern of the cut glass decanter is first drawn with pencil onto a smooth piece of primed card. A dark brown is now painted onto the background and the middle of the decanter where it is most transparent.**

2 **Once the bright highlights and the darkest tones have been indicated the other softer lights and tones can be put in.**

3 **Making a careful drawing before painting allowed the artist to work reasonably freely without overpainting or making corrections. Notice how the small patches of coloured ground left showing between the brushstrokes contrast with the blue-greys and give a lively flickering effect to the painting.**

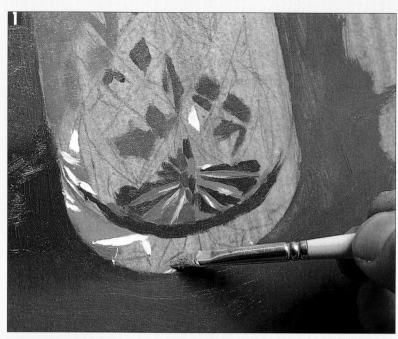

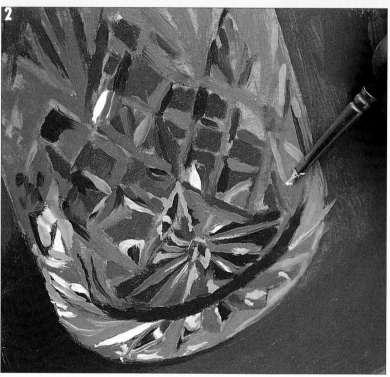

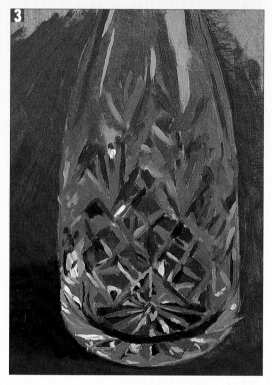

Another useful pastel technique is to spread the colour out over the paper by brushing clean water over the marks made with the pastel, which gives an effect very like that of combining pastel with watercolour washes. This could be ideal for diffused highlights, where you want a delicate effect to contrast with thickly laid and overlaid colour.

WATERCOLOUR

A successful watercolour of metal or glass should be as fresh and sharp as the forms it is describing. See if you can eliminate any unnecessary detail so that you can approach the painting with confidence. A watercolour will record every step you make, so it is essential to paint with a clear idea of what you are doing. Mistakes cannot be easily rectified. So before you begin, look carefully at your subject to see whether there are any small highlights you can safely leave out, for example, or several mid-tones you could merge into one. One of the basics of all painting, but particularly relevant in the

▲ Pendant
EARL GRENVILLE KILLEEN
Watercolour
The artist uses an unusual technique in which successive layers of opaque watercolour are painted on, dried and then sanded off. In some cases this involves the use of a small power sander, while for other stages cropped oil-painting brushes and paper towels are used to burnish the surface. Complicated effects and textures are possible with this method, the physical abrasion of the surface becoming an integral part of the painting.

context of watercolour, is to "make less say more".

One of the most useful techniques for clear, sharp effects is wet on dry, which simply means laying a wash, allowing it to dry, and then laying further washes on top. Each new wash will leave a crisp, hard edge which can be very effective for subjects like cut glass or a facetted metal object. For softer gradations of colour and tone, you can soften edges with a moist brush as described on page 00.

The rubber-based masking fluid mentioned earlier is also useful for maintaining sharp highlights throughout the painting. Once the rough drawing has been decided the whites of the paper can be preserved by painting on the fluid in those areas you want to keep white.

Wet into wet techniques can provide interesting effects in rendering glass, and you can control and soften the colours by using blotting techniques. Try dabbing a dry sponge into wet paint to suggest the soft and fluctuating tones inside the glass vessel, and use blotting paper for sharper control, to establish edges and so on. For very fine, soft, light edges such as those on the side of a glass container, the edge of the blotting paper can be used.

You can also work back into the dried watercolour with an opaque media such as gouache, lighten tones by brushing on clean water and then blotting, or rub carefully with a soft eraser, which will remove a little colour from the surface. If you use the eraser in conjunction with a thin template of card you can even establish the harder-edged highlights in this way.

More drastic methods for highlights, such as using a sharp blade to scrape back to the paper, should be used with care, but one

Glass of juice

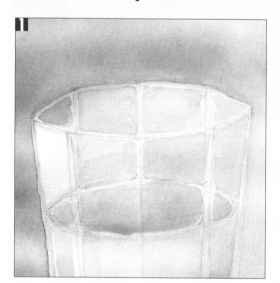

1 **A pencil drawing enabled the artist to place the first washes precisely, leaving the main highlights and some of the vertical divisions between the facets of the glass.**

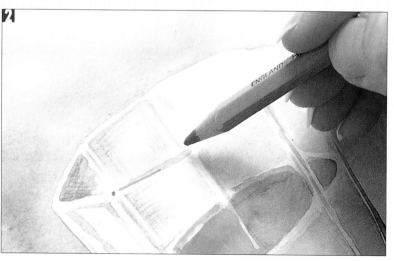

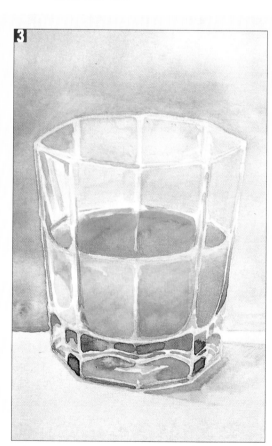

2 **Further washes of orange have been added to the liquid, together with a touch at the rim to indicate the refracted colour. Because further watercolour washes would be difficult to control, a water-soluble pencil is used to deepen the grey-blues.**

3 **The final stage was to darken the tones of the base of the glass, paying careful attention to the areas of refracted light from the juice.**

abrasive technique I have found very useful is fine sandpaper. This removes the colour only from the crest of the paper's grain. The more pressure you apply the lighter the tone.

OIL

As has been said earlier, oil paint has almost no limitations, and more or less every technique in the painter's repertoire has at one time or another been used to describe metal and glass. The method you choose will depend to a large extent on your own way of working, the subject you have chosen and the lighting conditions. For example, you will achieve crisp definition, with sharp divisions between colours and tones, if you paint wet on dry, allowing each layer to dry before adding another, while soft, diffused effects can be created by working wet into wet so that each new colour blends into those adjacent to or below it.

When painting wet-in-wet it is always best to leave the highlights until last and work up from dark to light. Although all oil paints are opaque, opacity is relative, and colours made lighter by the addition of white have more covering power than some of the darker pigments. This is a particularly important factor when you are working wet-in-wet: it is easy to put a white or near-white highlight over darker colours, but trying to add dark shadows over lighter colours seldom works — the new paint mixes with and sinks into the underlying layer and results in indeterminate mud.

One of the advantages of the wet-on-dry method is that it gives you more opportunity to vary the texture of the paint itself, and as mentioned in Chapter 1, the quality and consistency of the paint can be highly descriptive of texture. The golden rule for paintings built up in layers in this way is to work from "lean to fat", which means beginning with thin paint with a low oil

▲ **Delhi Engine**
SANDRA WALKER
Watercolour
The loving portrayal of the shapes and textures of old battered metal and rust has created a powerfully evocative painting. Walker's control of watercolour is breathtaking, with precisely placed areas of wet-in-wet and wet-on-dry washes complementing the detailed underdrawing.

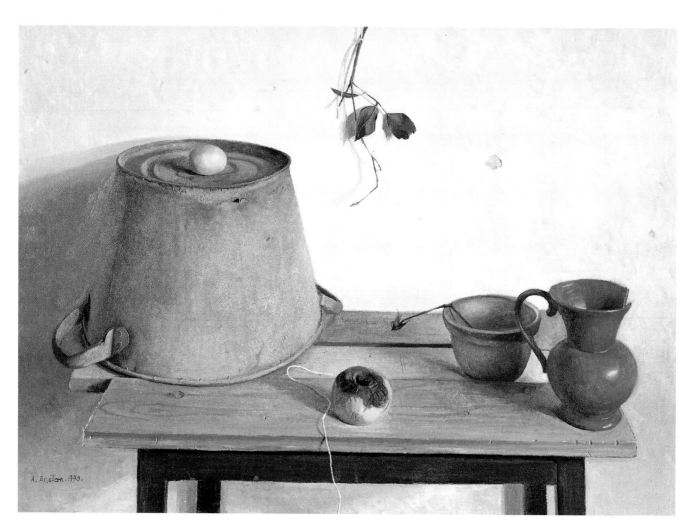

◀ **Still Life with Rotten Apple**
ARTHUR EASTON
Oil
The choice of such unusual and disparate objects in a still life often indicates a narrative or symbolic content. Here there appears to be a clear distinction between the cracked, rotten, dead or useless objects on the crudely made table and the life-affirming egg and live sprig of a tree. Viewers are left to make up their own minds about the artist's message, but there is no doubt about the skill with which he handles paint; each texture is described with complete sympathy and understanding.

◀ **Cosmetics with Lipstick and Triple Mirror**
JANET BOLTON
Watercolour
The play of differently shaped bottles, stoppers and labels have made an intriguing and unusual subject. Rather than become too involved in the details the artist has treated them broadly, juxtaposing loose wet-in-wet washes with crisper edges to provide a network of interlacing transparencies.

◀ **Fruit Bowl on a Check Cloth**
JANET BOLTON
Watercolour
Glass clearly has a fascination for this artist. In this drawing the choice of a bold check cloth as background has allowed her to describe the delicate transparency while still giving form and substance to the bowl.

content (you can thin it with turpentine or white spirit) and working up to oilier, juicier paint as the picture progresses. The paint can be left quite thin in the background, while you can use bold brushstrokes of oily white paint for, say, highlights on glass, or drag dry, thick paint across the surface of the canvas for a subject such as a copper pot. Have a look at the Chardin painting in Chapter 1 and the Dutch still life at the end of this chapter to see some of the ways in which oil paint has been used in the past.

A personal approach If you use oil paint thinly you can get the tooth of the canvas working for you. The following technique is one I have personally found particularly well suited to rendering the smooth and subtle textures of shiny and transparent surfaces.

I use a canvas with an open and even tooth and prime it thinly with two coats of a white gesso (acrylic) primer, making sure not to fill in the grain of the canvas. I then make a dark brown mixture, usually from burnt umber and a little ultramarine, give the whole canvas a rapid going over with a light tone of the colour and then begin to build up in the darker areas by rubbing. When paint is rubbed into the canvas there is always an interesting range of tone because the tooth of the canvas stands slightly proud of the paint. The more you rub the lighter the tone, and if it gets too light you can always repaint and try again. Tones can be adjusted, even dramatically changed by just working with paint, brush and rag. This is

a wonderfully flexible and versatile technique because you can push around the paint until you get it all to work without worrying about the paint drying. Either leave your painting at this stage or think of it as an underpainting. If the latter, then continue and try and match the colour values to the tones you have already established.

DISTRESSED SURFACES

So far we have been looking at the elegant shapes and reflective surfaces of fine metals such as copper and silver, but these are not the only ones that provide inspiration for artists. I live near the river at Greenwich in South London, an area still partly industrial but partly abandoned. Ship repairers and scrap-metal yards provide a wide range of subject matter, ranging from the rusty old barges to twisted abstract shapes of scrap metal spilling into the water. Large metal chains long ago encrusted and eaten away by the rust now lie forlorn in the mud, while great sheets of riveted steel lean against the river walls half destroyed by the salt water and dripping with lank green seaweed.

I often visit the river with my students and I encourage them to try their hands at watercolour. Although the medium at first might seem a little frail for these brutal and dramatic subjects, many of the specialized watercolour techniques such as those described in Chapter 3 can be adapted and

◄ Mandible
EARL GRENVILLE KILLEEN
Watercolour
**The artist has used a
similar technique to that
employed for the painting
of the padlock (see p. 72).
The process of painting and
then sanding and
burnishing seems to mimic
the actual layers of paint
on the hinge and bolts.**

altered to create an enormous diversity of textural effects. In fact I find many of the students vying with each other to improve on the techniques and to find new ways of resolving difficult textural problems.

Many of these experiments lead on to mixing the media as a variety of drawing materials are brought in to create particular effects. Spattering into wet and dry wash areas simulate the soft broken tones of rust, while turpentine or wax applied to the paper beforehand produces exciting if unpredictable effects. Light touches of pastel can be used to suggest another layer of decaying metal or a broken edge to a form.

One of the students wanted to create the effect of the texture of a painted metal sheet with rust breaking through, but without painting the subject in the traditional way. We experimented with a number of different techniques including fine spatter work, but none was quite right until someone asked whether we had tried the water-soluble colour pencils. His technique was to scribble with the pencil on a piece of fine sandpaper above a wet wash. As the particles of colour landed on the water they broke up in small soft bursts of colour. The technique seemed

tailor-made for the subject, and it wasn't long before many of the students began to use it as a refinement to textures already established.

● When arranging a composition pay special attention to the kind of reflections and patterns of light on the surface of the metal.

● Generally the tones of the reflections will be darker than the object which is reflected.

● Polished metals provide the greatest contrasts. Lights will be lighter and the dark parts much darker than on dull metals.

● The local (actual) colour of the metal is usually seen to the side of the highlight.

● The more polished the object the more difficult it is to see its own colour.

● If the reflections are too confusing, simplify by placing a piece of mounting board or large object nearby. This will effectively block out the complex reflections from the rest of the room.

Silver teapot

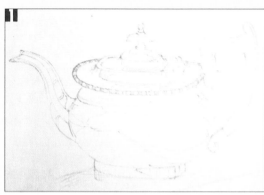

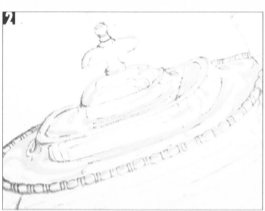

1, 2 **The structure of the teapot is complex, and the artist has begun with a detailed linear drawing which maps out its main features. He then reserves the hard-edged shapes of the highlights with masking fluid.**

3 **Silver, being almost colourless, clearly reflects its surroundings to produce a wide variety of colours and tones. Its smooth, shiny surface is conveyed by the hard-edged shapes of the reflections.**

4 **After the masking fluid has been removed and the pencil lines erased, a background wash is added to give space to the subject.**

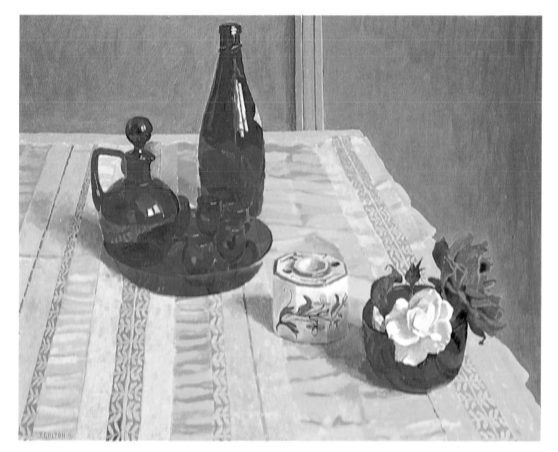

◄ **Blue Glassware and Roses**
JEREMY GALTON
Oil
Coloured glass makes a wonderful subject, as it not only reflects light but also casts its own colour on its surroundings. Galton has stressed the brilliance of the deep blue by restricting his colour scheme to a blue-pink harmony offset by the red rose and neutral background.

Willem Claesz Heda (1594-1680) was one of the most famous Dutch still life painters of his time. He specialized in subjects known as "breakfast" or "end of the meal" pieces in which half-eaten food, plates and glass goblets formed the composition. He delighted in the way light was reflected from these objects, and the same ones recur in different compositions. Many of the still lifes of the period had symbolic significance, and here the broken glass and the pocket watch would have been intended as symbols of transience, reminders of the shortness of human life.

FOCUS ON

Heda

▶ This is a particularly fine example of Heda's work. He has used a comparatively limited range of objects, but the composition is so carefully arranged that the slightest displacement of one of them would be enough to disturb the balance. In many Dutch still lifes you find this convention of tipped plates or glasses. These devices are usually introduced to give interest to the composition, breaking up formal arrangements so that the eye is intrigued and surprised by unusual juxtapositions. Notice too how the artist has contrasted the textures, setting the crumbling fruit pie next to the jagged broken glass, and the hard, reflective glass next to the soft folds of the white tablecloth. The rather restrained palette is characteristic of this period of Dutch still lifes.

▶ Here you can see the skill with which the artist has captured both the transparency of the glass and the depth of the liquid inside. The paint has been used quite thinly so that the weave of the canvas is clearly visible, except in the highlights on the right. The highlights have been very carefully observed. The reflected light is in two parts, suggesting that the window of the room in which the still life was set up had a central bar, dividing the light into two areas. Heda has continued this on the other side of the glass on the rim.

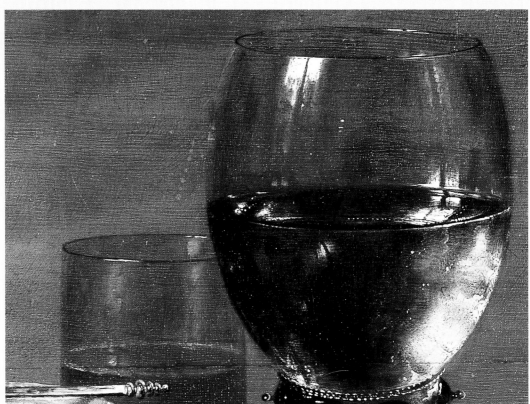

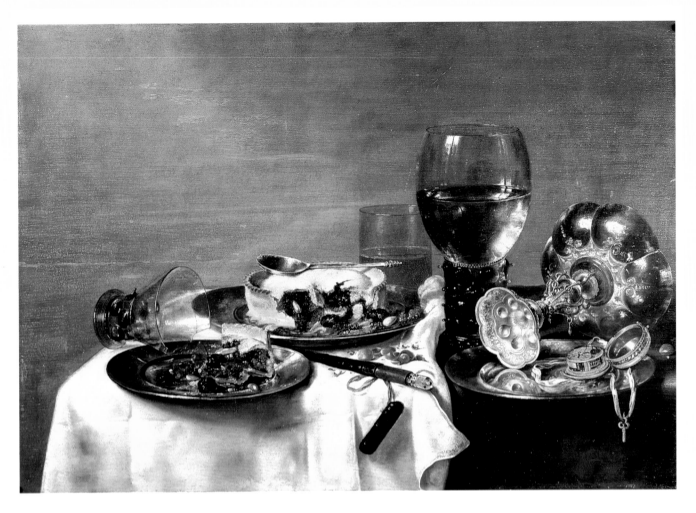

BREAKFAST STILL LIFE
WITH BLACKBERRY PIE
Oil on canvas
Staatliche Kunstsammlung, Dresden

▶ Heda obviously delighted in painting this decorative chalice, lovingly describing all the slight ridges and hollows of the decoration. Careful lighting is critical in bringing out the essential characteristics of reflective metals. Too much and the silver would be ablaze with reflected light, making it difficult to see the decoration; too little and the object would appear dull, like pewter. Here a limited range of colours and tones has been used, and the highlights grow out of softened warm tones.

Rendering the texture of a piece of fabric successfully – the sheen of satin, the richness of velvet or the rough surface of coarse cotton – has been both a problem and a delight to artists over the centuries. But painting fabrics is not as difficult as it might appear – the key is careful observation. This chapter explains the

FABRICS

important characteristics of fabrics, and provides some ideas for translating these qualities into paint.

▲ Fabrics present an enormously wide range of textures, and it can be exciting to exploit these in your paintings. You might practise by setting up a simple subject like this.

▶ The subtle matt texture of jeans could be suggested by painting on a coarse canvas or rough paper, or perhaps by using a scumbling technique.

◀ Velour and felt fabrics absorb the light, giving minimal, very diffuse highlights and small differences in tone.

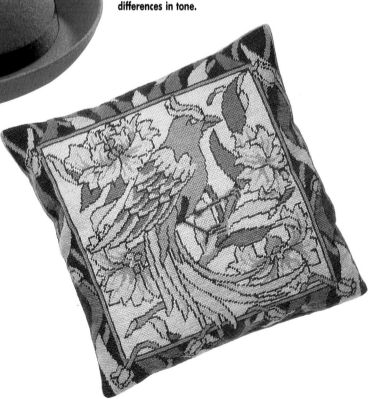

▶ To give a precise description of canvaswork embroidery, tiny, regular brushmarks would be needed, but an ingenious artist can often find ways of suggesting a texture rather than imitating it.

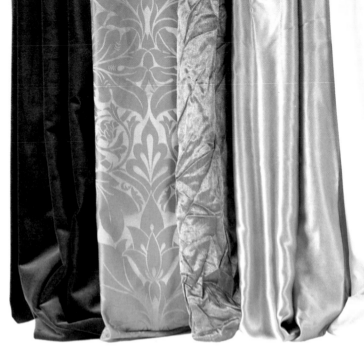

▲ At first glance this would appear a tricky subject, but the key lies in observing the folds. In this case they are soft and bulky, quite unlike the satin in the centre of the photograph on the right.

▼ Some leather produces clear, crisp highlights, but on these well-worn, scuffed shoes they are more diffuse and generalized.

▲ You will not find painting fabrics a problem if you learn to observe the key characteristics — folds, highlights and shadows. Look at the dramatic variations in this photograph.

▶ The texture of a patterned rug or carpet can be conveyed by blurring the edges of the pattern elements.

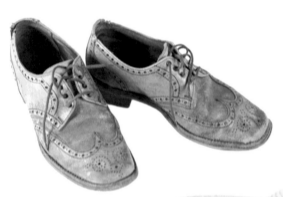

▲ Complicated textures are often best dealt with by picking out a few key details.

◀ Lace is easier than it looks, but it pays to make a careful drawing before painting.

▶ Again, pay attention to the highlights — or lack of them in this case.

Fabrics play an important part in three major branches of painting – portraiture, still life and interiors – so the only artists who do not have to think about how best to depict them are those who paint nothing but landscape. Fabrics have always represented a considerable challenge to the skill of the artist, and over the centuries you can see the way in which still life and portrait painters have "showed off" and vied with one another to produce sumptuous and minutely observed renderings of silks, satins, brocades, velvets and Oriental carpets. On occasion the costume of a sitter became more important than the face; in some of the paintings of Queen Elizabeth I a wooden, unnatural-looking head surmounts a jewelled gown of breathtaking intricacy.

This is scarcely surprising. Even today the majority of those who commission portraits expect the artist to indicate their status in the world, and status is expressed at least partly through clothing and personal possessions – to Queen Elizabeth I, the gown was probably of primary importance. Moreover, portrait painters, both past and present, can seldom keep their sitters posing for long periods of time, while clothing can be put on a dummy and painted at leisure.

The fine fabrics you see in 16th and 17th-century Dutch still life paintings also glorified wealth and status – of the new class of merchants, whose possessions reflected their material and mercantile interests. Artists who could skilfully depict these lavish fabrics, gold and silver found ready patrons.

The Venetian painters such as Titian (c 1485-1576) and Veronese (c 1528-88) also delighted in velvets, damasks and silks, but here the appeal is more to the sensual and decorative aspects. Sweeping red velvet gowns, light silk sheets and thick embroidered dresses all show how much the artists enjoyed the contrasts of the textures as well as the sheer physical pleasure of oil painting.

At the other end of the scale are painters of the Realist school, who were more concerned with painting humble textures, such as hessian or leather. The French painter Gustave Courbet (1819-77), produced, in addition to marvellous landscapes, some large oil paintings which celebrated the lives of working people. In paintings such as *The Stonebreakers* he emphasized the nature of the work and the poverty of the men by paying special attention to the rough textures of their trousers and the torn shirts.

Van Gogh also saw himself as belonging to

FABRICS

Training the eye

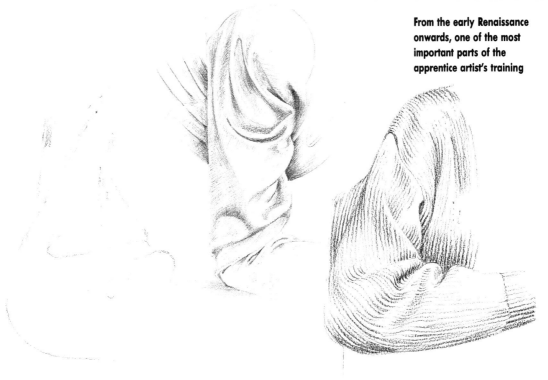

From the early Renaissance onwards, one of the most important parts of the apprentice artist's training was learning to draw drapery. Beginning with simple folds, they would then move on to more complex arrangements before tackling the fully clothed figure. Clothing and drapery is not easy to draw, and today's students would do well to practise in a similar way, perhaps starting with a garment draped over a chair, or your own sleeve seen in a mirror.

In these two drawings the artist has suited the media to the fabrics, using pencil for the smooth, thin material with its sharp creases and conté crayon for the thicker ribbed sweater.

◄ **Anna playing the Cello**
JOHN LIDZEY
Watercolour

Thin, translucent fabrics set against the light can make an exciting and dramatic composition. Here the artist has explored the delicate detail of the diaphanous material, contrasting it with the deep, rich tones of the cello. Starting off with a light pencil guide the artist has built up the painting with layer upon layer of transparent washes, mainly painted wet-on-wet, but with crisper touches of definition added wet-on-dry.

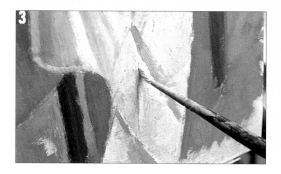

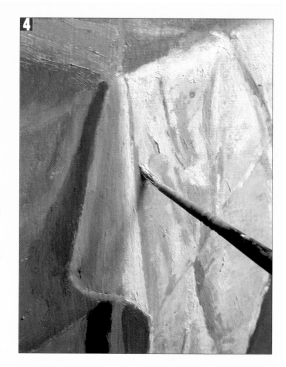

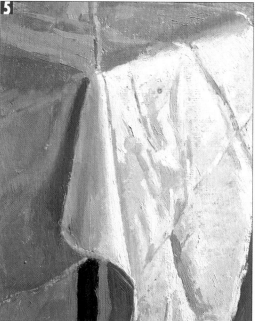

1 **Working on a light brownish-purple ground, the artist first sketches in the main lines with a small brush and thinned paint. He then blocks in broad areas of colour.**

2 **Lighter areas are built up with thicker paint, leaving some of the ground colour to show through for a lively effect.**

3 **Once the main tonal relationships have been established the highlights can be added in thick paint. To create a three-dimensional effect, the artist has ensured that each crease has a corresponding highlight.**

4 **No matter how evenly lit the material is, there will always be slight tonal differences, caused either by the angle of light or by slight undulations in the cloth.**

5 **In the shadow areas, the variations of colour and tone are due to reflected light.**

the Realist tradition, and chose to paint fabrics and materials that were part of the lives of his subjects, including rough peasant smocks, heavy woollen trousers and old, battered wooden clogs.

In our own times, non-professional artists are less likely to clothe portrait subjects in either velvets and satins or peasant smocks, but corduroy, worn denims, glossy man-made fibres and thick, shaggy sweaters are among a large range of textures that might call for our attention.

In general, artists' interests in the texture of fabrics is less apparent than in the past, but there are exceptions, among the most notable being the modern British painter Lucian Freud, (b. 1922), who takes great delight in painting decayed fabrics, with old, battered sofas and frayed cloths providing a fascinating counterpoint to the flesh of his naked figures.

GENERAL CHARACTERISTICS

When you start to draw or paint fabrics, whether the sitter's clothing in a portrait, curtains or soft furnishings in an interior, or

2 Watercolour

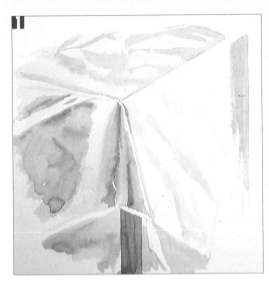

1 Washes of pale neutral colours are laid initially, and after building up the shadow areas, white gouache is introduced to emphasize the reflected light on the central fold.

2 A combination of wet-on-dry washes, which create hard edges, and white gouache has created a realistic impression of the satiny fabric.

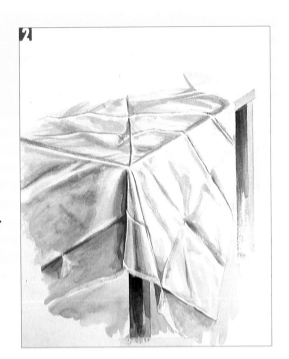

3 Pastel

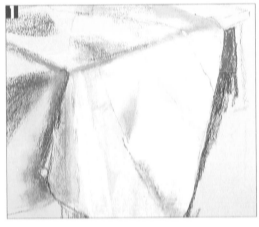

3 The slightest undulation of the cloth can be hinted at by the use of a pastel with a darker tone.

4, 5 A darker blue and a mauve have now been introduced. The liveliness of the drawing has been maintained by avoiding over-blending. In the final stages the contrast between shadow and light areas was slightly reduced. The final highlight is reserved for the crease at the top of the central fold.

1 To offset the coolness of the grey-blue fabric, a warm-coloured pastel paper is chosen. At this stage only three colours are used: pale grey for the highlights, blue for the cool shadow and brown for the shadow areas lit by reflected light.

2 A finger is used to blend the grey into the beige colour of the paper.

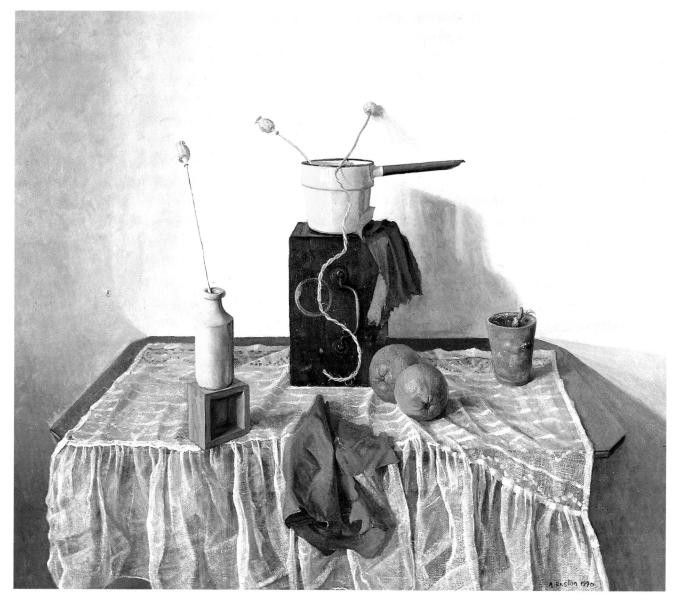

▲ **Still Life with Oranges and Blue Cloths**
ARTHUR EASTON
Oil
Easton delights in painting objects and materials with different textures, and has here positioned smooth pots, oranges and cloths to create interesting contrasts. He has suggested the cobwebby texture of the thick, open-weave muslin by using a scumbling technique, dragging grey and white paint lightly over darker dried layers of paint.

drapery in a still life, look out for three main characteristics. The first is the way light is reflected from the material; the second is the arrangement of folds or creases, and the third is the nature of the shadow areas.

REFLECTED LIGHT

Perhaps the most important of these is the highlight because it will immediately indicate the material's smoothness or roughness. Highlights for a smooth, shiny material such as silk or satin will be sharp and bright, while those for a matt-surfaced, coarse-woven or knitted one will be more diffuse and comparatively duller – they may not even be recognizable as highlights in the true sense of the word.

Another characteristic to look out for is the "speed" of the highlights. In silk you will find that they seem to zip across the material, activating the whole garment, whereas for softer materials such as wool they will be

flatter and more static. When painting these characteristic highlights look out for the way they interconnect. A common mistake is to see them as somehow isolated from the rest of the garment, and this leads to a patchy effect. Instead see if you can get a rhythm of highlight areas that passes across the material, uniting all the different parts.

Another trap awaiting the unwary beginner is to depend too much on local colour (the actual colour) without taking into account the enormous changes brought about by light. Because you know a dress is blue you tend to paint the shadows and highlights darker and lighter versions of the same colour, but shadows could be violet or greenish, while with a shiny fabric, highlights might reflect surrounding colours.

FOLDS

The folds in a fabric will indicate how thick or thin it is. Thick fabrics will fall into a small

◀ **Marcus**
SUSAN WILSON
Oil
Directional brushwork plays an important role in this artist's technique. Painting in thick impasto, she has modelled the jacket with the brush, blending the colours wet-in-wet, but using strong contrasts of tone to suggest the shiny, reflective surface of the leather.

▶ **The Well-Tampered Clavichord**
BILLIE NUGENT
Oil pastel and watercolour
The simple colour notes of the children's clothes seem in perfect keeping with the musical subject of the painting. The soft fabrics are delicately modelled with the oil pastels to give a sense of light and texture.

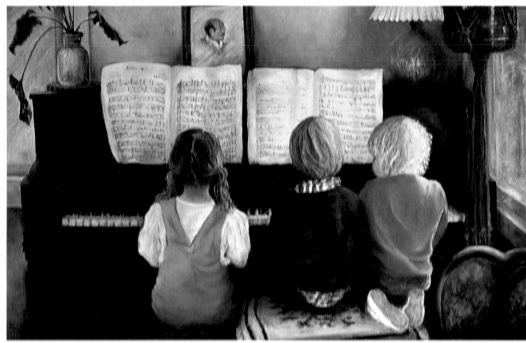

number of large folds, while thin materials will have many more folds which are smaller and multi-directional. For the figure and portrait painter these thinner materials such as cottons and silks can present a number of tricky problems, so it is always a good idea to try to minimize them before starting to paint. If the subject of the painting is a clothed figure, try and make the arrangement of the clothes as simple as possible. If you have to reorganize clothing by pulling the fabric and letting it fall again, make sure that the new arrangement fits in with the rest of the composition and also helps express the forms beneath. There is nothing more confusing to

the eye than a bunch of isolated folds – in a sleeve, for example – or the creasing in a pair of trousers which, although they might have been true to life, do not describe either the flow of the garment or the forms beneath. If you can, be ruthless, and select only the major folds and creases in the garment to draw or paint, ignoring the rest.

SHADOW AREAS

The final characteristic of fabrics, the nature of the shadows, is a vital indicator of the sheen or shininess of the material. A material such as silk or satin reflects so much light even in the shadows that you will find it

▶ Brownie Girl
BEVERLY FERGUSON DEEVY
Pastel
Strong side lighting, as used here, can be very effective in revealing creases and folds in materials. Using a close range of browns and yellows, the artist has lovingly described each dip and undulation of the girl's uniform. Notice also how she has captured the subtle tones of the folds in the white blouse, where the shadows are illuminated by reflected light.

difficult to locate a really dark tone except in the sharpest fold. Pay special attention, therefore, to the contrast between the highlight and the tone of the surrounding material. With materials such as velvet the opposite applies – you will find that the deepest folds will be very dark because the rougher surface will not reflect light, and the highlights will be much less noticeable than on a silky fabric for the same reason. Black velvet is one of the few fabrics that does look really black, regardless of lighting.

PATTERN AND TEXTURE

Pattern can also be a strong indicator of the texture of a fabric, being more sharply defined on a thin one than on a thick, coarse one. This is worth remembering if you want to include a patterned carpet in an interior – often the best way to suggest the texture is to pay careful attention to the design.

However, there are occasions when you might want to make more of the texture of something like a fine oriental rug in a painting, or even make its colour and texture the focal point of the picture. In such cases, the best general rule, whichever medium you are using, is to let the brushwork do the description for you.

When oriental rugs first came to Europe they were used as tablecloths, and they feature in many portraits and still life paintings. If you look closely you can often see

▲ **Disarray**
CAROLYNE MORAN
Gouache
Sometimes a haphazard arrangement of clothes or other objects, which can produce surprising juxtapositions of textures, shapes and colours, can make an exciting composition. Paintings such as this are in fact, usually the result of organization and planning, but the effect is one of lively spontaneity.

WATER COLOUR

Striped cotton

1 Stripes or patterns on fabric make it much easier to study the way the folds behave. Here the artist has carefully observed each stripe to produce a rhythmic drawing that expresses the folds through line. To clarify the main forms the shadows are painted a light purple.

2 Once the first washes have dried, the stripes are painted in, with the tones adjusted according to the angle of light.

3 In the final stages the shadow area is strengthened and the stripes extended.

Ribbed sweater

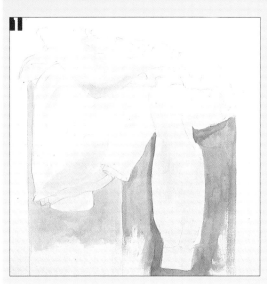

1, 2 You can acquire valuable practice in painting garments by treating them initially as a form of still life, as in this case, where the sweater has been carefully arranged to create an interesting composition. The artist begins by laying light washes, ignoring the ribbed texture at this stage.

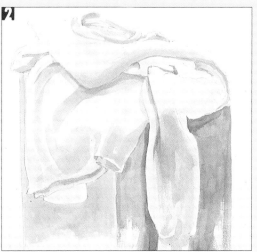

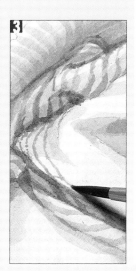

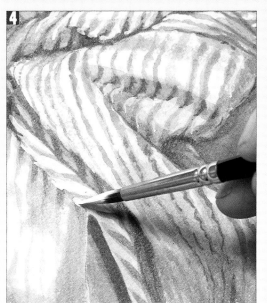

3 A fine brush is then used to paint the lines of ribbing, with the pressure varied to produce an uneven line.

4 White gouache is brought in to soften some of the edges and clarify the lines.

5 Some areas have been described very precisely, while others are suggested; loose washes with the minimum of definition are sufficient for some of the shadow areas.

that the artist has represented the small knots or woven threads with little dabs or strokes of the brush, which from a distance look completely convincing. This is easiest to do with an opaque medium such as oil, but if you are careful not to let the brushmarks run into one another you can achieve the same effect with watercolour. If you try this method, remember that the "focus" should be sharpest in the foreground; you can treat the distant parts more impressionistically, with brushwork that suggests the texture.

DRAPERY

Drapery, usually in the form of a white napkin or cloth, has been a standard element in still life paintings for hundreds of years. It is mostly employed as a means of assisting in a composition, with the folds and soft lines of the cloth helping to direct the eye across and around the picture, or breaking up the strong line of the edge of a table, but it can also be extremely useful as a foil to other textures. You will find white tablecloths used in this role in many artists' compositions, the cloth uniting the arrangement of objects, and the neat folds giving a formality to the painting.

Curtains can also be employed as a background to the composition. Cézanne (1839-1906), in many of his later still lifes, used a heavy decorated material as a backdrop for arrangements of pots and fruit, organizing the composition so that the fruit found an echo in the pattern of the material.

Drapery is also much used in figure painting. The idea of partially covering a nude

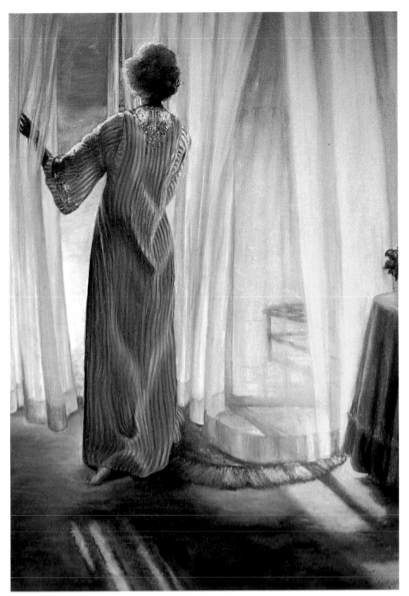

figure has an even longer history than drapery in still life, being used first by the Greek sculptors of the 6th century BC. They discovered that the soft, clinging folds lent additional desirability to the female figure, enhancing the forms below rather than concealing them. Titian and other painters of the Venetian school fully exploited the sensual potential of this device, delighting in contrasting soft, translucent flesh with lavish fabrics. There is always a touch of eroticism in the juxtaposition of exotic materials and skin, and such a subject provides the supreme test of skill for artists who enjoy conveying tactile qualities.

MEDIA AND METHODS

A medium well-suited to clothing and drapery studies is charcoal.

CHARCOAL

Because it is a broader medium than pencil it prevents over-elaboration of unnecessary detail. It is, however, both sensitive and flexible, and can be used lightly to produce delicate, spidery lines or with greater pressure to render dark, intense shadow areas. It can also be smudged to soften a line or tone, or lifted out with a putty eraser either to create highlights or correct mistakes. Charcoal comes in many different forms, so select one that will be most suited to your needs. Charcoal pencils or thin sticks of willow charcoal are generally best for linear work, while the thicker sticks are more suitable for tonal studies.

▲ Blue Shadows
BILLIE NUGENT
Pastel
Light is the real subject of this painting, and it is expressed through the careful study of the light and shadows on the fabrics. Backlighting often shows up the texture of fabrics very well.

▶ Umbrella Art
BILLIE NUGENT
Oil pastel
These vividly coloured umbrellas make a wonderfully decorative composition. Oil pastel is particularly well suited to subjects that require rich and solid colour areas.

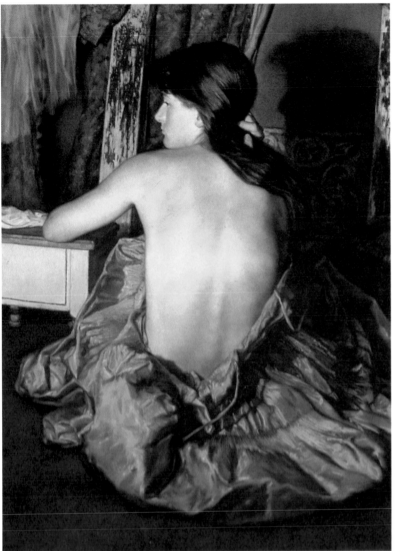

Blending techniques allow you to suggest a range of different textures. For instance, for a highly reflective material such as satin you can create subtle gradations of tone by rubbing the charcoal with a torchon or rag, working back into the drawing to define edges of folds if necessary, and using an eraser to make the highlights. A putty eraser allows you to create positive, precisely shaped white areas, and can also be used with the minimum pressure to modify tones.

For the duller surfaces of materials such as wool, a slight rubbing is usually sufficient for the highlights, which are relatively unobtrusive, and a compressed charcoal can be brought in for the more intense shadow areas.

If you are going to use erasing methods extensively it is wise to experiment a little beforehand with the paper. Generally a hard paper with a slight tooth is best as this will give depth to the charcoal and also allow the drawing to be erased without too much damage to the surface of the paper.

WASH DRAWINGS

Monochrome watercolour or dilute ink washes applied with a brush can be an enjoyable and expressive method for painting clothes and drapery. Long, sweeping strokes can suggest thick, heavy folds, while smaller, lighter brushmarks will convey the more elaborate fold patterns seen in thinner fabrics.

A variation on the brush and wash method is line and wash, in which a line drawing in ink

▲ **Nikkie's Back**
DEBORAH DEICHLER
Pastel
The smoothness of the skin, achieved by subtle blending, makes an intriguing contrast with the crumpled satin, where the network of sharp folds has been described in a more linear way.

◀ **Miss Botinelly**
DOUG DAWSON
Pastel
Dawson usually begins his pastels with a restricted palette of three sticks of colour, a dark, middle and light tone, gradually building up the colours to achieve an effect that has the expressive richness of an oil painting.

 Velvet

1, 2 The thick, short pile of velvet, although creating a smooth surface, reflects less light than a shiny fabric such as satin, so the tonal contrasts are in general less dramatic. Usually the lightest tones occur where the surface is caught by a raking light.

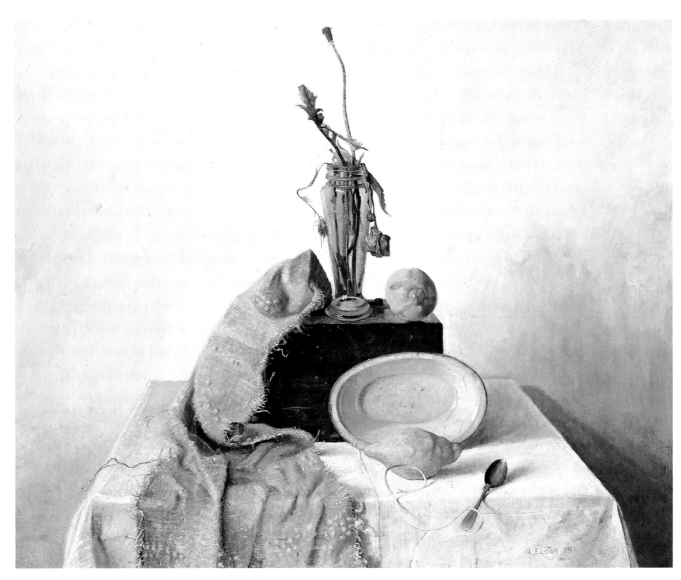

is supplemented with a rapidly drawn wash in dilute ink or watercolour to render areas of tone or light and shade. Much loved by both Rembrandt and the 18th-century Venetian painters such as Tiepolo (1696-1770), the technique can give a wonderful sense of vitality and movement to clothed figures.

PASTEL

Since the 18th century, when pastel began to be widely used, it has been a favourite drawing medium for rendering the soft folds and sharp highlights of different materials. Because it is such a versatile and controllable medium, it can also be used in a more painterly way to render soft, downy fabrics where the physical appearance of the opaque pigment can mimic that of the cloth. In many 18th-century pastels such as the one by Rosalba Carriera on page 140 you can see how layers of pastel have been rubbed into the paper, building up to form a texture that is very similar to the velvety materials worn by the sitter.

A pastel-related drawing technique that was also widely used at the time, for figures and drapery, was one known as *aux trois crayons*, a halfway house between chalk drawing and full-blown pastel. Using three chalks – usually a black, red and white – the artist would draw on a thin buff-coloured or blue paper. Black would be used for the main forms and shadows of the drapery, and white for the highlights, while the reddish brown chalk would be brought in to indicate a warm colour. Such drawings were mainly done as studies for oil paintings, and the three colours enabled the artist to introduce into the drawing most of the basic information he or she would require.

OIL

Because oil paint is so adaptable, showing the surface textures of fabrics presents no particular problem. Often the kind of brushwork you use can provide all the description you need. Carpenters have a saying, "Let the saw do the work", and in oil

**▲ Still Life with Lemons and Withered Poppies
ARTHUR EASTON**
Oil
Rough hessian is an unlikely material to include in a still life, but here it is used to great effect as a foil to the smooth objects. The texture of the sacking is beautifully painted using a scumbling technique in which the broken deposits of paint seem to mimic the coarse weave of the material.

OIL

Old jeans

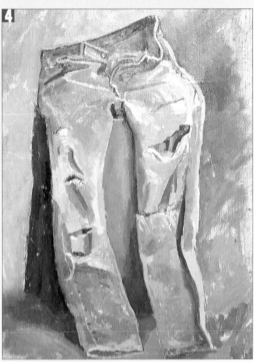

1 This artist likes to work on a coloured ground, and here has chosen a light purplish colour that blends in with the warm blue of the jeans. He begins by sketching in the main lines with diluted paint, and then starts to block in the colours.

2 Using a limited range of blues and greys, he continues to build up the picture, paying careful attention to the creases and main shadows.

3 Details such as the rips in the material are then added, painting wet-in-wet.

4 Directional brushwork has played an important part in helping to articulate the main planes and creases of the denim.

painting you can let the brush do the work by allowing it to follow the directions of folds, the ribbed texture of a thick sweater or the stripes on a patterned fabric.

As has already been said, the actual texture of the paint and the way you handle it also play an important part in creating the impression of textures. For fabric with sharp folds, giving a very distinct pattern of light and dark, you might achieve the best effects by working wet-on-dry, as this prevents the new colours from mixing with the earlier layers. For fabrics such as silk and velvet, where the shadows and highlights flow into one another in an almost liquid way, blending colours wet-in-wet would be most suitable. Look at any Velázquez painting (see page 100) and you can see how perfectly this technique has been adapted to simulate the textures he is dealing with. Fine silk bows are rapidly suggested in a flowing and near-impressionistic manner, while large expanses of velvet are given their distinctive and drier texture by just a few well-chosen highlights.

Coarser, thicker textures such as wool, rough cotton or sackcloth are best approached as a two-stage operation, by blocking in the main tones and colours, allowing this underpainting to dry and then dragging thicker paint over it. If the initial paint layer is fairly thin you will be able to exploit the grain of the canvas – the thick paint will adhere only to the "peaks" of the canvas, leaving some of the old colour showing through. This is also an excellent technique for subjects such as lace, where you want to suggest the delicate patterns and characteristic dry texture without painting in every minute detail. The paint can be used "neat", without the addition of any oil or other medium, and the best brush to use is a fairly large, square-ended one.

WATERCOLOUR
Watercolour might be considered the medium least suited to rendering fabric textures because of its fluidity and transparency, but it can be successful provided you abandon

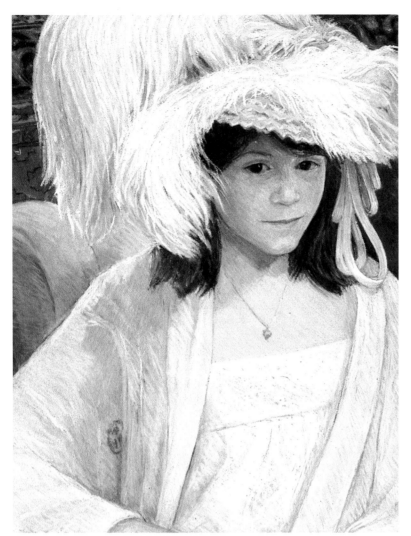

preconceived ideas about the "correct" way of working. For instance, there is little point in going to endless lengths to reserve the white paper for highlights if you find the effect of mixing paint with Chinese white is more suitable. Similarly, although you might be able to build up a texture by a slow, laborious application of tiny brushstrokes, a light application of pastel, pencil or coloured pencils over watercolour washes could be both speedier and more effective.

The wax resist method, recommended in Chapter 3 for the texture of stone and wood, is also an excellent one for fabrics. You can draw with white or coloured wax crayons (the kind sold for children), and lay watercolour washes on top to build up a variety of different textures and patterns. Very rich and exciting effects can be created in this way, and it is an enjoyable method to use.

If you are committed to pure watercolour, try making the texture of the paper work for you. The most commonly used watercolour paper has a slightly textured surface (referred to as a "Not" surface), but you can also buy papers categorized as "Rough". These are slightly tricky to use for conventional wash techniques, as the colour does not cover the surface as evenly as on Not paper, but in a texture context they are very useful. You can "drag" deliberately uneven washes over either the white paper or a previous wash in a similar technique to that described for oil painting.

▲ **Lizzie with Plumed Hat**
ELSIE DINSMORE POPKIN
Pastel
The sweeping plumes are described with long directional strokes of the pastel, while on the clothes, skin and parts of the background the artist has used the feathering technique, in which individual colours are placed over each other without blending.

▶ **Maria**
GWEN MANFRIN
Pastel
The strong contrast of red and black gives this work immediate impact. The artist has kept the internal modelling of the materials to a minimum so that their texture is largely conveyed by their open structure.

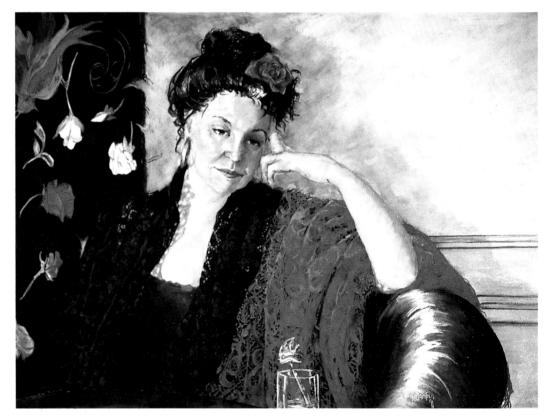

OIL

Damask

1 When painting on a coloured ground you can either choose a colour that tones in with the painting or one that contrasts, as here.

2 The main folds of the material are established before the design is added.

3 With shiny patterned materials such as this, the tonal relationship between background and design needs close study.

<div style="writing-mode: vertical">FABRICS</div>

99

TIPS

● If you find it difficult to follow the folds of a cloth, practise by drawing a simple striped material, so that the lines will define the forms.
● The thinner the cloth the more folds or creases there will be.
● Don't include all the folds in the material, choose the major ones which will help describe the form underneath and/or those that give movement to the composition.
● Even when material is comparatively flat there will always be an edge or a fold which catches more light and therefore will be brighter.

◄ Joan
PAUL ANDRUS
Oil
Sometimes you can simplify clothing by limiting the number of tones and colours. Here the blue of the jeans is basically reduced to three colours: a bleached blue for the light-struck areas, a very dark blue for the shadow areas and a mid-tone to soften the effect.

FOCUS ON
Velázquez

Diego Velázquez (1599-1660), born in Seville, became court painter to Philip IV of Spain at the age of twenty-four, and brought to the portraits of the royal family a simplicity and informality which at the time must have seemed like a breath of fresh air. The king so much admired his work that he declared he would be painted by no one else, and Velázquez's superb technical skills have been a model for artists from his lifetime to our own. Once you have seen the simple economy of his brushwork and the way he can sum up complex textures with a few deft strokes of his brush most other paintings seem laboured in comparison.

▲ It is thought that the painting was commissioned to be sent as a gift to the Emperor Leopold I, whom the Infanta Margarita was to marry in 1666. The work is one of Velázquez's last portraits of a member of the royal family and shows the characteristic dazzling brushwork of his late period; an extraordinary range of brushstrokes and marks has been used to summarize the different textures. Although many painters of the period used a grey tempera underpainting followed by oil glazes, it is unlikely that Velázquez followed this procedure in his late paintings -- it would have been too restrictive. It is more likely, as has been established with other works, that he initially sketched the composition loosely with a black or brown paint, keeping the painting process as open as possible.

▼ This is a wonderful example of economic handling of paint, and shows how little pigment you actually need to put on to create a convincing illusion. The dress is in the main painted very thinly, exploiting the tooth of the canvas to suggest the slight shifting of tones, with thicker paint establishing the highlights. The magic of Velázquez's technique is that it is so difficult to pinpoint the moment of transition, when paint turns into a piece of ribbon or braid.

▶ Here we can see how the free, gestural marks of paint merge together in the eye to create the illusion of the fabric. The repertoire of brushstrokes shows how willing Velázquez was to adapt his technique to suit individual textures, sometimes applying the paint by dabbing, and at other times using the brush as a Japanese calligrapher might have used it, with deft, flowing rhythms.

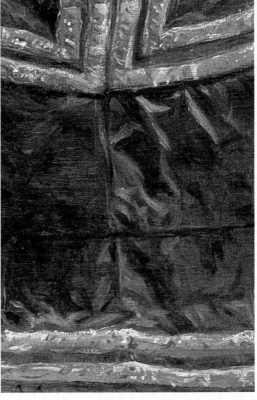

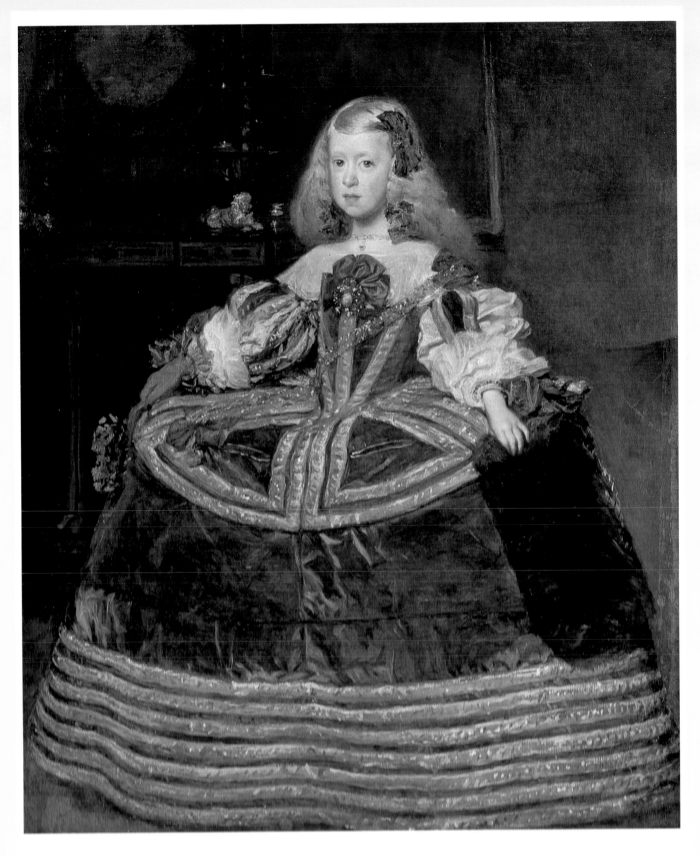

INFANTA MARGARITA
IN A BLUE GOWN
Oil on canvas
Kunsthistorisches Museum, Vienna

Sometimes texture can be merely hinted at by picking out a few details, but for realistic studies of animals or birds you will need to pay special attention to the textures of fur, hair and feathers. Here technique is of

FUR &
FEATHERS

particular importance, and here we look at some of the methods evolved by artists who specialize in this branch of painting, as well as pointing out the importance of simplification.

◀ Textures like this goat's hair can often be indicated by sweeping strokes of a brush or pastel stick.

▼ The fur of a cat, the animal's most attractive and noticeable feature, invites more detailed treatment.

◀ A photograph can be a good starting point for a wildlife painting, so if you are interested in this branch of painting, look through magazines for subjects.

◀ Smooth hair can often be suggested by a few well-placed highlights and an indication of the broken outlines at the edges of the forms.

▶ When painting animals with striped or spotted coats, take care not to make the pattern too hard-edged, as this will make the fur appear smooth.

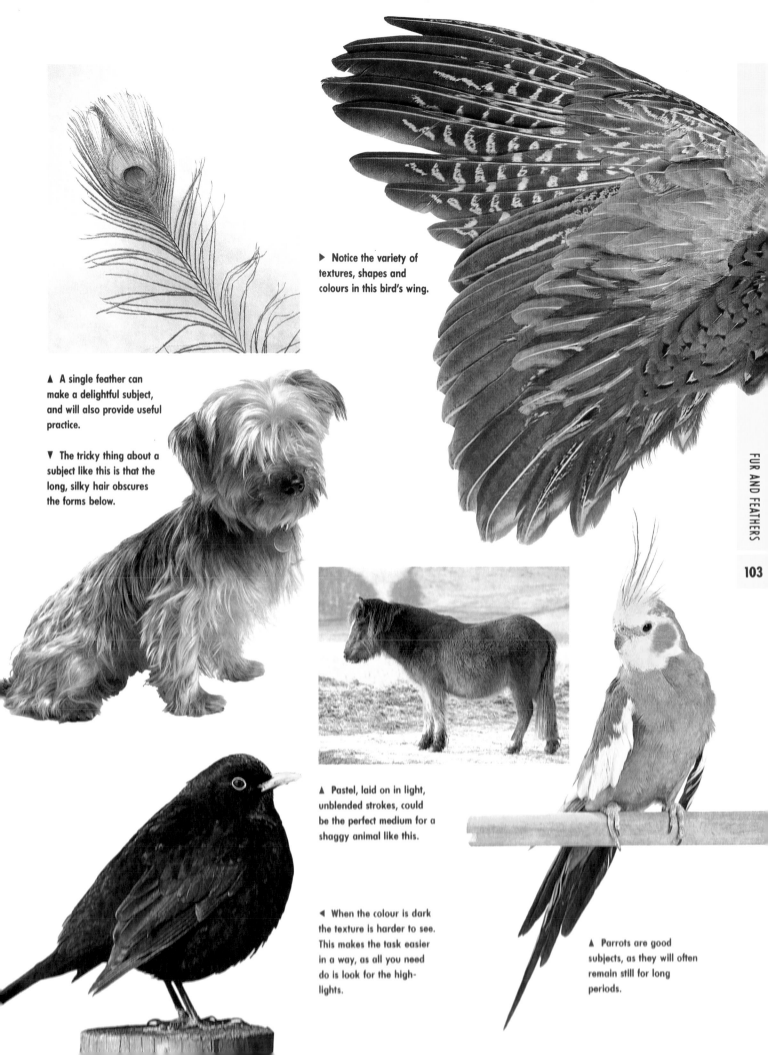

▶ Notice the variety of textures, shapes and colours in this bird's wing.

▲ A single feather can make a delightful subject, and will also provide useful practice.

▼ The tricky thing about a subject like this is that the long, silky hair obscures the forms below.

▲ Pastel, laid on in light, unblended strokes, could be the perfect medium for a shaggy animal like this.

◀ When the colour is dark the texture is harder to see. This makes the task easier in a way, as all you need do is look for the high-lights.

▲ Parrots are good subjects, as they will often remain still for long periods.

You can if you wish paint a perfectly satisfactory portrait or still life without placing special emphasis on texture, but for the subjects in this chapter it is of paramount importance. A drawing or painting of a bird or animal without some indication of the characteristics of its fur, wool or feathers would be largely meaningless, so the artist needs to be more inventive in this field than in any other.

The section on Media and Methods later in the chapter provides some ideas on how to tackle the purely technical aspects of the subject, but unfortunately technique is not the only problem the would-be wildlife painter has to cope with. Animals and birds, unlike still life subjects, cannot be studied at leisure, so an extra measure of ingenuity, combined with patience, is needed even to make the preliminary observations that will enable you to capture their forms and textures accurately.

The best way to begin is with familiar subjects. If you have a pet dog, cat, rabbit or parrot, spend some time drawing and observing them, trying to understand the way the fur, hair or feathers clothe the forms. One of the major difficulties in drawing birds and rough- or long-haired animals is relating the "top surface" to the body below; once you can get this right you are halfway there, and can enjoy yourself finding ways of expressing the textural qualities.

In the case of fur, light can often be very revealing. You are unlikely to be able to deliberately light your pet as you might a still life, but if your cat has a habit of sitting on a windowsill for long periods of time, so that it is lit from behind, study the way light interacts with the edges of the fur and make a few drawings with chalk or a soft pencil to see if you can capture the main tonal areas. If the light is strong you will find that the main body of the animal and its shadow will tend to merge together, providing an important textural clue to the soft corona of light marking the edge of the fur.

LEARNING TO SIMPLIFY

To be able to draw any complicated texture such as fur and feathers, you must be able to simplify the subject to some extent, which is less easy than it sounds. I asked a few painters how they went about the process, and got a bewildering set of replies. "I just look" said one, "and then I look again". Not finding this helpful, I asked another artist who specialized in wildlife painting. "You learn it over a lifetime's experience", he said, and then added somewhat conspiratorially, "I have my method."

This shows more than anything else that

Drawing & Painting

FUR & FEATHERS

Training the eye

Many people are daunted by the prospect of drawing fur because they see the complexities first without considering how the information could be simplified. To begin with, choose an animal that you are familiar with — or work from a photograph, which

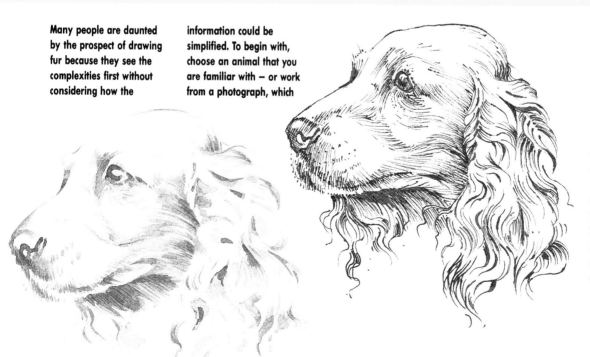

will allow you to practise at your own pace. In these drawings you can see how the artist has summarized the different lengths and quality of hair without going into too much detail. In most cases you will find that you can hint at the texture without being too specific, for instance here a few well-placed short lines have suggested the fine hair on the head, while long spiralling lines are used for the softer textures of the ears.

▲ Ocelot
STAN SMITH
Oil and oil pastel
In this wonderfully
expressive study the artist
has painted rapidly with
both brush and his fingers
to capture the image in the
fastest possible way. Lines
of movement combine with
the pattern of the skin to
give an image of great
energy.

◄ Hedgehogs
SALLY MICHEL
Watercolour
In contrast to the painting
above, this one, by a
professional wildlife artist,
deals with the animals and
their setting in minute detail.

Watercolour

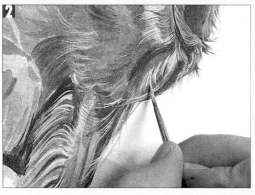

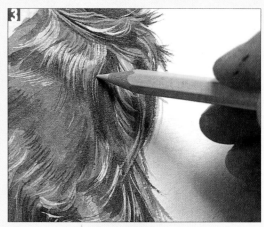

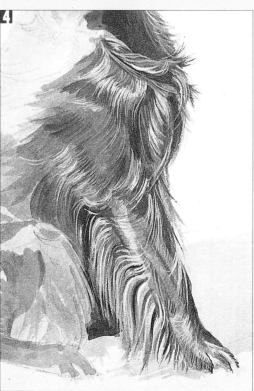

1 **A light brown wash is laid over the pencil sketch, followed by loosely painted areas mapping the different colours of the fur.**

2 **Further washes are added to convey the gentle waves of the fur, and then white gouache is applied with a small brush for the highlights. The fine lines are bunched together to help describe the undulations of the fur.**

3 **Light strokes with a yellow coloured pencil add touches of warmth in the light areas.**

4 **The final effect is a convincing representation of the glossy, wavy hair.**

there is no particular recipe – artists don't always know exactly how they do things. However, over the years I have found some of the following methods helpful. Try them and see if they work.

First consider the concept of the painting – what it is that you want to paint and why. This may seem rather obvious, but it is sometimes easy to forget once you get involved in the painting. If you want to paint a portrait of your cat, for example, it would be distracting to get too involved in some detail in the background. Keep the focus on the way the light is reflected from the fur or the special markings and make sure all the other parts of the composition are supporting this central idea.

Even when you know what you want to

paint and have got a reasonably clear focus, live subjects present you with so much visual information that you have to leave some of it out. The problem is, of course, what to leave out. Try looking at the animal or bird and memorizing as much as you can. Then turn away and quickly put down as much information as you can remember. You will find this acts as a crude kind of filter, removing the things you are not interested in and helping to isolate some of the essential aspects of the subject.

There is also a simple piece of equipment that can help with the simplifying process. Many 18th-century landscape painters used a small black convex mirror called a Claude glass after the painter Claude Lorraine (1600-82). The artist turned his back on the scene

2 Pastel

1 The main forms and colour are quickly established with broad strokes of the side of the pastel stick. A finger is then used to blend the colours softly together.

2, 3 Individual strokes with the tip of the pastel build up the details, and an eraser is used to soften tones and modify highlights.

4 Linear strokes have suggested the flow and movement of the silky hair.

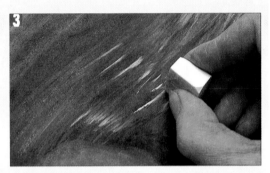

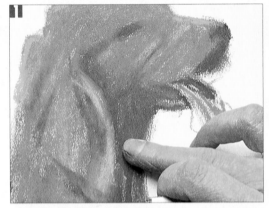

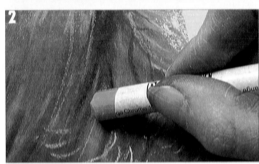

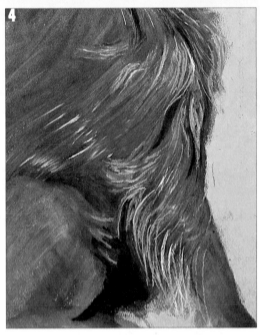

3 Oil

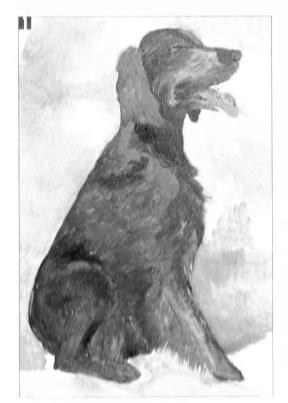

1 The oil paint is mixed with Liquin, an alkyd resin medium which makes it flow well, and applied in loose directional brushstrokes that help create the rhythms of the coat.

2 Keeping the liveliness of the initial stage, thicker paint is now added, and darker tones introduced to help give form and depth to the texture.

3 The successive overlaid layers of loose brushwork create a lively and varied surface.

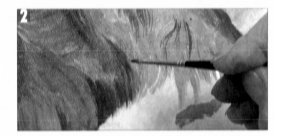

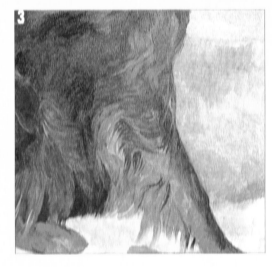

and looked at the subject through the mirror, which had the effect of suppressing the colours and thus making it easier to see the relationships between the tones. An everyday example of the same principle is when you are in a room on a dark night and see the room's reflection in the glass of the window.

You can make an equivalent of a Claude glass very easily, by applying two coats of black paint to a piece of glass measuring about 25×20cm (10×8in). When dry, look at the subject in the mirror side (i.e. the unpainted side) and see how it simplifies many aspects of the texture.

WILD ANIMALS AND BIRDS

One of the great myths that surround the painting of wild animals and birds is that the artist has somehow "captured" his subject by actually drawing or painting on the spot. This is seldom the case; it is much more likely that the painting is the result of a wide range of different influences and source material. For the dedicated wildlife artist all sorts of aids and references are used, from the rapid sketch drawn in the field, through high-quality photographs to detailed studies of dead birds and perhaps anatomical studies of the skeleton. Even the surroundings for the animal or bird may be specially drawn from separate sources or from carefully arranged materials in the studio. All become grist to the artist's mill – and all are employed to create an image which will seem as natural as possible.

In previous centuries, where it was not possible to use photographs, it was common practice for wildlife artists to shoot the birds that they wanted to paint, arranging the corpses in lifelike attitudes. John James Audubon (1785-1851), the American painter-naturalist, is reputed to have slaughtered thousands of birds in pursuit of authentic detail for his book *The Birds of America*. We may deplore the practice, but few would deplore the results – Audubon was among the greatest of all bird artists.

SKETCHING
One of the biggest problems in drawing birds and animals in the wild is getting close enough to be able to see everything clearly. As soon as you settle down to draw, the creature is likely to run or fly away, so it is vital to get in the habit of sketching as rapidly as possible, and jotting down in writing all the things that you may not have time to capture in the drawing. Here colour notes or words and phrases that summarize an aspect of the

OIL

Tabby cat

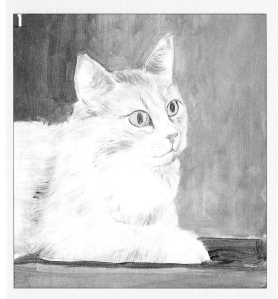

1 As the first stage, the artist makes a line drawing in a hard pencil (2H) on primed hardboard, which provides a very smooth surface. He blocks in the background and then indicates the main direction and flow of the fur.

2 For the multiple fur-like lines, he uses old, well-worn sable brushes with a comb-like appearance, and very liquid oil paint. To create the tapering effect each stroke finishes with a quick upward motion.

3 A very small sable round brush was used for the final stages, intensifying the shading. For the whiskers, a brush with only a few remaining hairs was used, rolled in liquid paint.

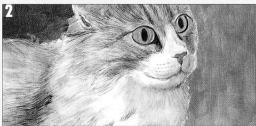

▲ Pheasant
DOUG LEW
Watercolour
**This is a fine example of
how effectively wet-in-wet
watercolour techniques can
be used to suggest the soft
textures of feathers. The
effect is enhanced by the
contrasting sharp lines of
the grass, achieved by
scraping back into the wet
washes.**

◄ Hello Louise
ELIZABETH APGAR SMITH
Watercolour
**Here wet-in-wet washes are
combined with dry-brush
work to convey a
convincing impression of
the goat's head.**

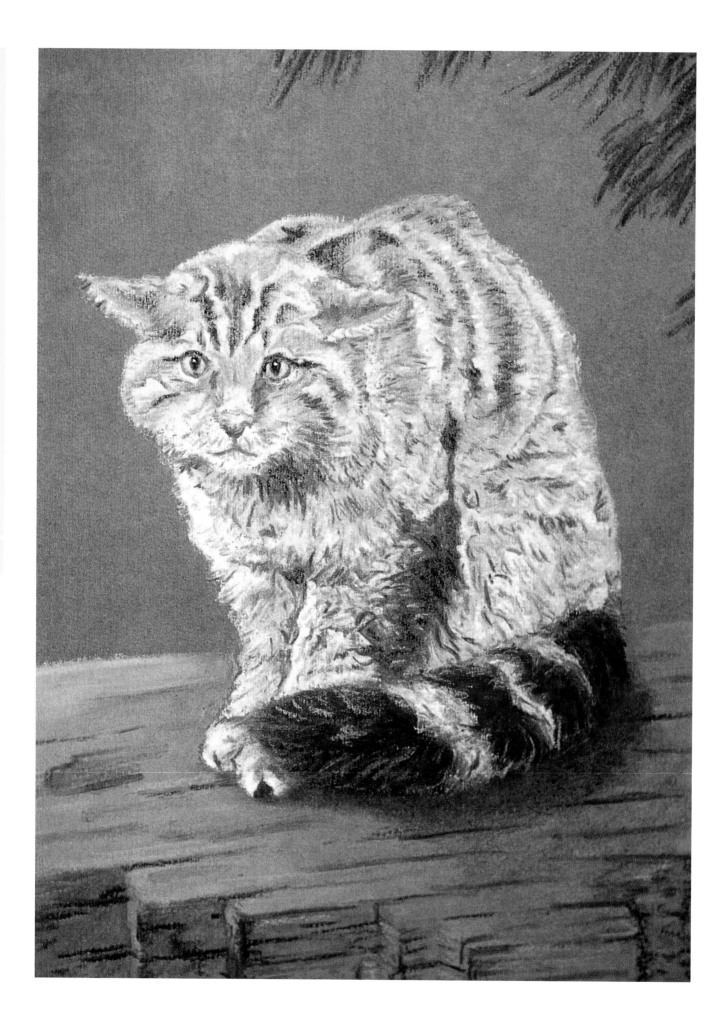

Elephant

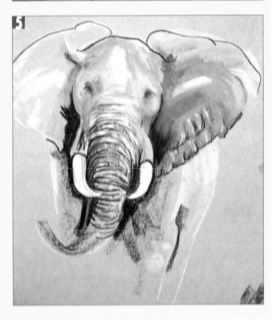

1 **The main form of the head is quickly sketched in with bold side strokes and a limited range of colours.**

2 **Black pastel behind the head and trunk helps give definition to parts of the drawing as well as bringing the head forward.**

3 **The rough concertina-like skin of the elephant's trunk is built up with layers of short strokes.**

4 **The smoother texture of the ear is created by blending the colours before introducing the small highlights.**

5 **Although the rendering is not complete, the textures have already been suggested convincingly.**

◀ **Wildcat**
STEPHEN PAUL PLANT
Pastel
The strokes of the pastel have been cleverly varied to describe the complex markings and different lengths of the fur, with soft curved shapes for the head and longer, more expressive squiggles and lines for the thicker areas.

colour or texture such as "smoky", "dark and scaly", "sharp highlight" or "velvety", can be useful jogs to the memory.

It takes some practice to be able to make sketches that contain enough information to use as a basis for a painting, so for the beginner it is a good idea to start off by drawing some creature that will remain still for long periods of time. Horses in a field, sheep, or deer in an enclosed parkland, can all make good subjects, and offer a wide range of different textures. Observation is as important as sketching, and here binoculars are a valuable aid, as you can focus in more closely on the subject.

For those who wish to draw more exotic animals such as bears or leopards the zoo is the obvious place to visit, and this is also the best possible place for sketching birds such as parrots and birds of prey. Your subjects will, of course, move, but at least, being caged, they will not disappear.

PHOTOGRAPHS

Although these rough sketches are essential practice, and can help give a lifelike feeling to the drawing or painting, you will almost certainly need more detailed information as well, and here the photograph comes into its own. There are some who still regard photographs as a form of cheating, but no wildlife artist would agree — they see them as

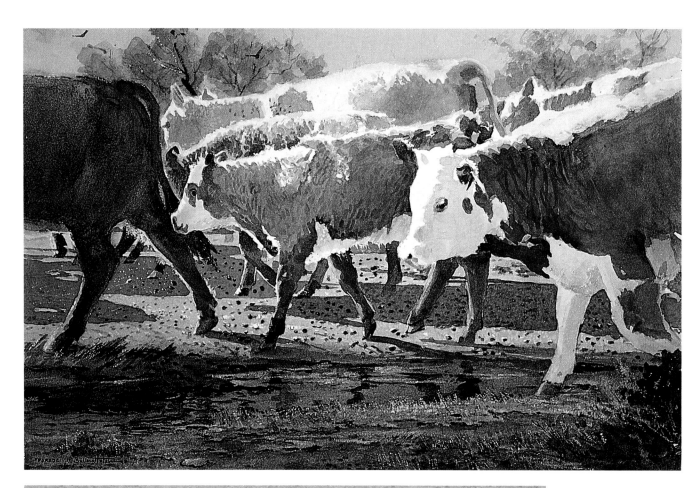

▲ **Parade**
LA VERE HUTCHINGS
Watercolour
Strong lighting is not usually ideal for showing subtle nuances of texture, but here the light is an integral part of the painting, with texture playing a secondary role. The artist has suggested the cows' hides by using delicate touches of darker colour over mid-toned washes.

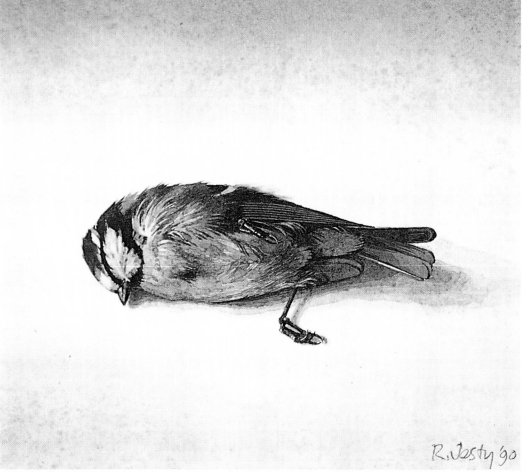

R.Jesty'90

◀ **Victim of a Gale**
RONALD JESTY
Watercolour
The colours and textures of the plumage have been built up with a series of layered washes, with a fine brush used for the precise detail.

Squirrel

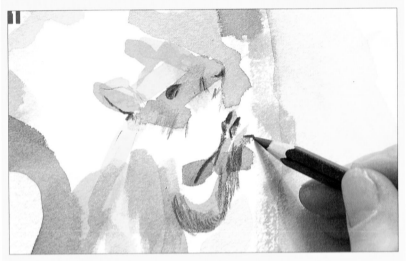

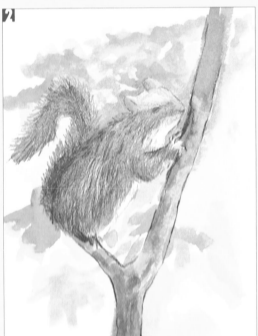

1 A series of loose watercolour washes are laid, and then a coloured pencil is brought in to define the details.

2 For the soft grey fur, the artist uses a graphite pencil, making use of the slight grain of the paper to give a broken texture.

3 Fine lines are then added on top with white gouache to indicate the silvery shimmer so characteristic of a squirrel's fur.

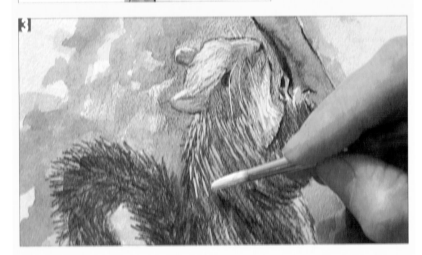

a supplement to their other studies, and indispensable when it comes to drawing and painting the smaller or rarer animals and birds. (If possible, get hold of a camera with a good zoom lens; a standard automatic camera will not provide the necessary detail.)

However, photographs do have to be used with caution. Although a good photograph will present a very realistic and detailed image of the subject it doesn't simplify the problems, because it provides you with too much information, giving you the job of deciding what to concentrate on and what to leave out. Without some other source such as a sketch it can be difficult to make such decisions.

There is another danger too. Because the photograph has already performed one of the functions of drawing and painting, which is to translate the three-dimensional world into two dimensions, it is difficult to avoid copying it directly, tone for tone. This is understandable, especially with a particularly striking photograph, but the result will usually be disappointing, a pale imitation of the photograph, with no selection or interpretation involved. It is always best to keep a little distance between the photograph and the painting so that it is used as a reference and does not become the subject of the painting. After all, it is only an image of the bird, not the real life creature.

THE SETTING

If you are painting your dog or cat in front of the fire or in the garden, you will have a ready-made setting for the animal, but when your subject is a wild creature and you are working from sketches and photographs you will have to give some thought to the environment in which you show it. If you look at many of the most successful animal and bird paintings you will notice that the artists take great pains both to make the habitat look convincing and to achieve a lively counterpoint between the textures of the creature and those of the surroundings.

Many will bring materials such as pieces of bark, twigs, stones and mosses back into the studio so that they can refer to them while they work. This has the great advantage of allowing them to study shapes and textures at leisure and choose those that make the most interesting contrasts, but when you are out drawing or photographing wildlife it is also worth building up a visual reference file of landscape features that might be used in a composition. Weatherbeaten wood, grasses, mossy tree-trunks and rough-hewn boulders will all help to provide an interesting and natural-looking environment.

Even when you have an extensive visual

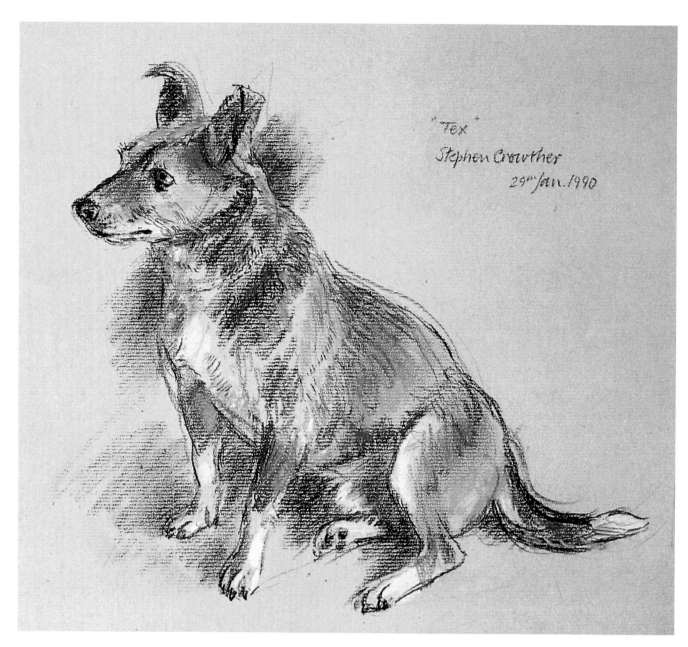

"Tex"
Stephen Crowther
29th Jan. 1990

"library" it is not easy to produce a painting in which the creature seems to fit naturally into its surroundings. Beginners often misunderstand scale, for example, and place a bird or tree-creature on a branch that is much too large or small. Another common mistake is to lavish more attention on the main subject than on the background and foreground so that the bird or animal is not properly integrated into the picture.

This can happen even when you don't have to invent a setting, for instance for a painting of sheep or cows in their home field. It is more difficult – and more of a challenge – to find ways of coping with the texture of the wool or hide, so you treat it with much more detail. Too great a contrast between the animal and its surroundings and the animal will look "stuck on". The same applies to the techniques you use, which must also be

consistent throughout the picture. For example, if you were to paint an animal in a very precise watercolour dry-brush technique and the landscape with loose wet-into-wet washes you would find it difficult to reconcile the subject with the setting.

MEDIA AND METHODS

For many wildlife artists a soft pencil is the most valuable drawing medium, combining the capacity to suggest a complex range of textures with great linear precision.

PENCIL
To get the widest possible range of marks, try sharpening the pencil to a tapering point so that you can make full use of the side of the lead as well as the tip to build up a repertoire

▲ Tex
STEPHEN CROWTHER
Charcoal and pastel
Pastel paper, which has a slight "tooth", is also a sensitive surface for charcoal. The textures of the fur are suggested by the loose patches and smudges of pastel colour, while the charcoal is used to darken the colours and provide areas of definition.

of marks that could suggest the texture of fur or feathers. You can extend the range by holding the pencil in different ways and at different angles. This will tend to free you from the rather automatic mark-making which is the result of being over-familiar with the pencil as a writing implement.

To begin with, aim to capture the essence of your subject in a few well-chosen lines. The soft pencil is much more suited to a bold approach than tentative explorations, so if you are drawing fur, start by quickly establishing the main forms and then concentrate on the basic character of the animal's coat by paying special attention to the edge of the form. With short hair this will resemble a slightly uneven contour, but with thick fur, the edge should be rendered with plenty of "air", that is, with a series of open, broken, scribble-like marks.

CHARCOAL

For feathers, this is a less suitable medium than pencil, but it is perfect for fur; some of the boldest and most expressive drawings of animals have been made with charcoal. For very intense blacks there is little to compare with compressed charcoal. Once the main drawing is complete, a few accents with this will give it a greater depth, and highlights can be created by wiping with a cloth or lifting out with a plastic eraser.

Horse's head

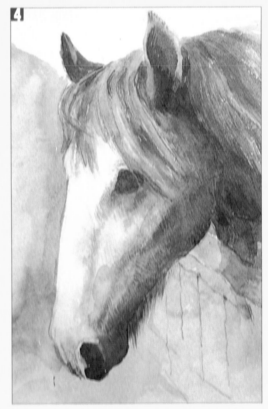

1 **Open, loose washes of blue-grey over a light pencil sketch create the initial light and shade.**

2 **Further transparent washes painted wet-on-dry complete the modelling of the head, and are left to dry before the fine hairs over the jaw are suggested with dry-brush work.**

3 **A pencil is then used for added definition in the mane.**

4 **With any watercolour, too much fiddling around can lose the freshness of the initial washes, so the dry-brush and pencil work has been kept to a minimum.**

Charcoal can also be used with great refinement and delicacy. Thin twigs of willow charcoal will give a dry and slightly fractured line which can be adapted to render many qualities of fur. To obtain an even more nervous and spindly line try holding the charcoal by the end, so that the weight of the lines are dictated by the very gentle pressure you will have to restrict yourself to in order to avoid breaking the charcoal.

PEN AND INK
For the detailed description of the texture of feathers, pen and indian ink can be wonderfully effective. It enables you to work in fine detail, and the contrast between the ink and the paper makes the textures stand out with great clarity. It is also a suitable medium for small animal drawings. It is usual to sketch the main forms first with pencil before starting the more detailed mapping of textures.

PASTEL
One of the most attractive aspects of soft pastel is that it is both a drawing and a

Cheetah

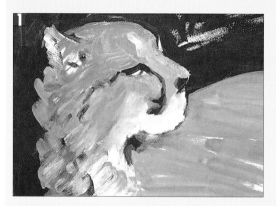

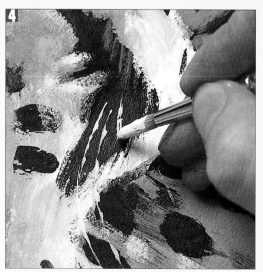

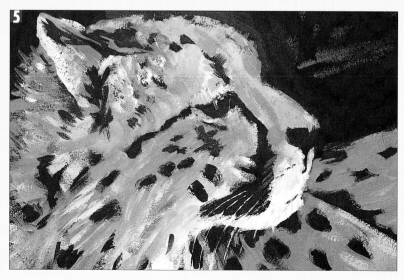

1 **The main shapes are blocked in rapidly, with the fur suggested by smudging colours into each other wet-in-wet.**

2 **A light dab with a brush laden with black is all that is needed for rendering the spots.**

3 **The first layers of colour, applied wet-in-wet, have now been overlaid with dry-brush work, using thick, opaque paint.**

4 **Opaque paint is applied with a small brush for the whiskers.**

5 **Directional brushstrokes describe the thick fur below the ears.**

painting medium, and thus lends itself perfectly to describing the whole range of textures found in the animal world. By making broad, sweeping strokes with the side of the pastel stick you can represent an animal's fur or hide with great speed and economy, while for fine detail you can sharpen the point of a stick and make crisp, linear marks, even small dots and squiggles. For soft, fleecy or downy textures such as those of a sheep or an owl you could build up the pastel thickly, using it in layers very much like paint, while the texture of a rough-haired animal could be described by a series of short lines of varying thickness, following the direction of the hair.

Pastel pencils are well worth considering for animal subjects, particularly those where you want detail rather than broad effects. These are simply thin sticks of pastel encased in wood, slightly harder than normal pastels, and more controllable. They are often used in combination with soft pastels, both to add areas of detail and to make the preliminary drawing (pencil should not be used for an initial drawing as graphite has a slightly greasy texture which repels the pastel colour). Pastel pencils also go well with watercolour – try blocking in the main forms with watercolour washes and then drawing on top with the pencils.

WATERCOLOUR

Watercolour is an ideal sketching medium because it is so responsive and can be used with such rapidity, but it is also ideal for more detailed studies. Most of the great bird and

▲ **Nesting Pheasant**
PAUL DAWSON
Mixed media
The clarity of Dawson's style is the result of a methodical build-up of layers of watercolour wash followed by gouache and acrylic.

▶ **Otter and Kelp**
SALLY MICHEL
Watercolour
For the sleek body of the otter the artist has avoided any hard edges, suggesting the fine, dark fur of the animal by long flowing lines which echo the form of the body. The sheen of the wet fur is just hinted at with a finely controlled use of white highlight.

animal artists of the 19th century used watercolour to record every detail of their subjects with extraordinary precision.

A technique used by many wildlife artists to convey the effect of fur and feathers is dry brush. This is a method of painting with the minimum of paint on the brush so that the colour only partially covers the paper, resulting in a rather broken rasping texture.

You will need to practise to get the consistency of the paint right – if it is too wet you simply have a rather blotchy wash, so you may need to thicken it with some gouache or Chinese white. With a small amount of the colour on the brush, experiment by dragging, rolling or even stabbing with it to build up a vocabulary of different marks. The most common method for fur is to build up the textures by flicks of the brush starting at the "roots" and ending by lifting the brush off the paper to produce a slightly uneven and tapering effect. For the more detailed areas and for shorter fur try splaying out the bristles of the brush with your thumb and forefinger and dragging it over the paper to create a series of fine parallel lines.

Dry brush is extremely effective when used in conjunction with thin washes of watercolour. If you look at the watercolours of Andrew Wyeth (see page 60) you can see how the washes have provided the main tonal information and the dry brush has been used afterwards to establish the textural detail.

MIXED MEDIA
The possibilities of watercolour and pastel or pastel pencil used together have already been

▲ **The Ram**
MICHAEL WARR
Tempera
Top lighting can be very effective, as in this painting, where the ram's head, with its coarse, wispy hair, is highlighted as though from a vertical beam of light. The matted long hair of the body is cast in shadow.

▶ **Last of the Ayrshires**
MICHAEL WARR
Tempera
Lighting also plays an important role in this painting, creating a pattern of light and shade on the body of the cow.

mentioned, but there are several other mixtures you can exploit to advantage for bird and animal subjects. The more demanding the textures the more you need to experiment and try out different approaches. Birds, in particular, present a range of very different textures, from hard beaks and scaly claws to the soft down of head and breast and the taut, linear quality of the main flight feathers.

In general, such differences are best expressed by combining a drawing medium with a painting one so that you can set off areas of fine detail with broader ones of colour and tone. One of the best known and most used of these is pen and wash, in which fine pen lines are counterpointed by watercolour washes. The traditional method is to begin with an ink drawing and lay the colour over it, but you can also work the other way round, or develop both drawing and painting simultaneously. The latter is often most satisfactory, as one of the difficulties with pen and wash is integrating the line and colour so that the result does not look like a "coloured in" drawing.

A less usual combination is pencil and pastel, in which the pastel is used to lay in broad areas of colour very much like a watercolour wash and the pencil provides the linear detail. This method is not difficult but it does require a light and delicate touch. If the build-up of pastel is too heavy – or the colour too dark – pencil lines made on top will not show up, and dense pencil shading will tend to repel the pastel colour. Use soft pencils, not harder than 2B, as any pencil is hard in relation to the soft, crumbly pastels.

OIL

As in painting fabrics, discussed in Chapter 5, varying the brushwork is one of the best ways of describing the texture of fur and feathers. By using directional brushwork for fur, for example, the painter can immediately suggest both the way it lies and the movements within it. Smooth, sleek furs are best painted with a stroking action, while for the rougher and shaggier coats, multi-directional use of the brush will help convey the thicker tufts and waves.

Care should be taken selecting the right brush for the task. For the more complex textures it is best to keep to the filbert and round brushes (see Materials), which are capable of delivering a wide variety of irregular marks as well as fine lines. Discover their potential by experimenting – try using different paint consistencies and holding the brush at unusual angles. Also attempt different strokes, such as dabbing the paint

on, dragging it in long fluid lines, or applying it in short stippled strokes. The more you can extend the range of brushmarks, the easier it will be to find your personal style. You will notice that all the great masters have a recognizable brushwork "signature". This doesn't happen overnight but is the result of many years painting, so be patient.

Using dry paint. For animals with a fluffy or shaggy coat you could try a method which will give you a rich, thick effect, such as impasto or scumbling, the technique of scrubbing rather dry, thick paint over an existing dried layer. I have found that mixing paint with whiting gives it the ideal consistency for the dry fluffiness of a cat's coat. This creates a matt paint which rather resembles pastel, and scumbling with it can be seen as the painterly equivalent of drawing with a chalk on a rough-surfaced paper – the paint only picks up on the "outcrops" of the underlying paint layers. This dry application of the paint

▲ Donkeys on a Beach
STEPHEN CROWTHER
Oil

The texture of the animals is skilfully suggested by slight variations in tone, with short, stabbing brushstrokes used for the stiff, bristly manes.

is wonderful for capturing the soft and powdery lighting effects of some furs.

A related method is dry brush, which can be very useful as a final layer. In this method, similar to that described under watercolour, small amounts of thick colour are applied to existing dry layers of paint in a light skimming action to produce a rather broken texture in which the underlying layers of paint strike through. It is particularly useful for modifying areas of the painting and for establishing the drier and more diffuse highlights that you might find with thicker fur or massed feathers.

Underpainting In establishing complex forms and textures it can be helpful to begin with an underpainting, either using a thin oil paint (diluted with turpentine or white spirit) or acrylic. Oil can be used over acrylic, and

Falcon

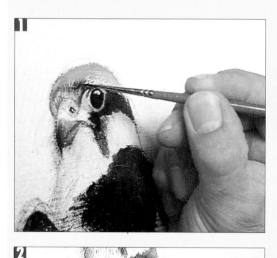

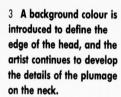

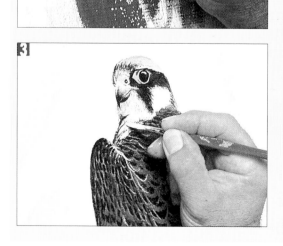

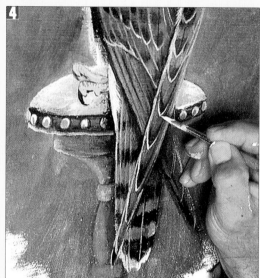

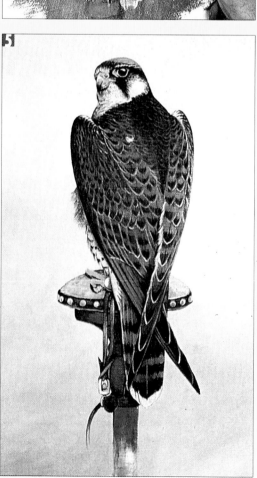

1 The artist began with a working drawing, which he transferred to the primed painting board by dusting the back of the paper with charcoal powder and tracing through. The head and beak are painted first.

2 The main body colour is blocked in with a brown-grey mixture, and a light grey used to outline the feathers.

3 A background colour is introduced to define the edge of the head, and the artist continues to develop the details of the plumage on the neck.

4 The tail feathers are outlined with white paint and a small, pointed brush.

5 The beauty of acrylic is that you can overpaint as often as you like. The artist was not happy with the background colour, and decided to paint over it with a pale neutral colour.

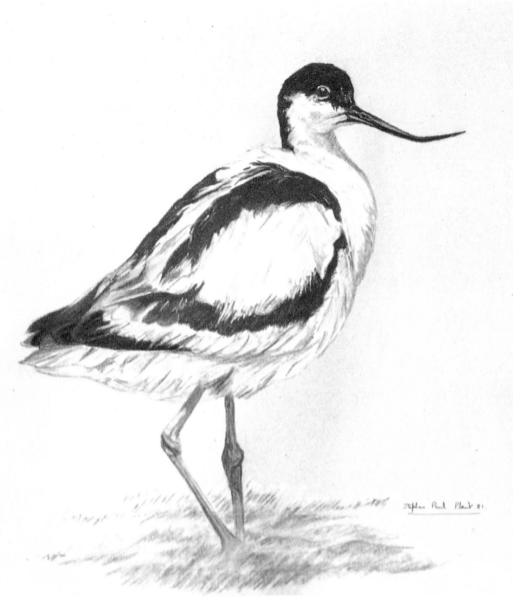

▲ **Avocet Wading**
STEPHEN PAUL PLANT
Pastel and charcoal
Charcoal can be a surprisingly delicate medium, combining well with pastel and useful both for defining details and building up dark, rich colours.

because it dries so quickly it is often used for underpainting. The traditional method is to block in the main dark and light areas of the painting and allow the paint to dry before proceeding. This has the great advantage of enabling you to see roughly how the painting will look when finished, so you can check the composition and the overall tonal balance before concentrating on colour and texture.

There is no rule about the colours used for an underpainting. Some artists select a warm brown such as a burnt umber to give a good range of tone and an underlying warmth to the painting, while others choose a colour that will complement the succeeding layers of oil colours to create a shimmer in the final painting. Generally it is advisable to choose a colour that is fairly neutral and which has a good tonal range. If the underpainting is too vivid it will be difficult to assess the subsequent colours.

TIPS

● Keeping a reference file of photographs and drawings of animals and birds is an invaluable aid for those interested in wildlife subjects. These need not necessarily be your own work; you can cull magazines and newspapers for suitable material, so get into the habit of looking at printed matter with possible compositions and subject matter in mind.

It is wise to devise some simple system of cataloguing, so that you can find the information quickly when you need it. For example, you could have sections on farm animals, exotic birds, breeds of dog and so on. Or you could classify under different kinds of photograph, such as those showing movement, close-ups and more distant shots of creatures in an environment.

● Never throw away experiments with different media and techniques, as these can be useful for future work. If they are successful, make a note of how you achieved a particular effect; if less successful, make notes about how you might improve the technique, perhaps by using a different brush or thicker paint.

The English painter Sir Edwin Landseer (1803-73) was one of the most gifted wildlife artists of his time, and the favourite painter of Queen Victoria. His tendency to humanize his animal subjects appealed to Victorian sentimentality, but was also responsible for his later decline in popularity. "His are not mere animals; they tell a story. You see them not only alive, but you see their biography and know what they do, and, if the expression is allowed, what they think." (from an article in *Blackwoods Magazine)*. We may no longer admire animal paintings which tell a story or point out a moral, but we can still admire Landseer's skill as an artist.

FOCUS ON
Landseer

▶ The subject of the painting is Queen Victoria's pets: her two favourite dogs, Islay and Tilco, a macaw and two lovebirds. Landseer has resolved what could have been a difficult composition by using the bird stand as a central linking device. The painting also shows the artist's attempt at humour and narrative – he has made the macaw a schoolmaster figure, the terrier a fawning courtier and the black and tan spaniel a man of letters.

▶ Landseer would have begun by painting very thinly and broadly, establishing the main forms of the animal before starting to define the detail. His technique can be seen very clearly around the ear. There you can see the weave of the canvas and the clear layering of the different applications of paint. Notice how he has captured the translucency of the ear and added the fine hairs in shadow that give a softness and density to the image. The brushwork is directional, each stroke flowing with the hair and lifted off at the end to provide a fine, tapering finish.

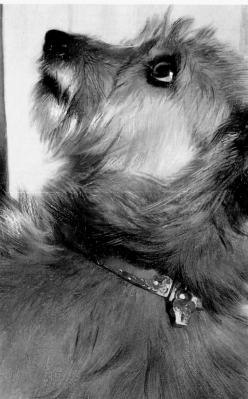

▲ The key to painting many of the textures of feathers and fur lies in the careful study of the highlights. Landseer has reserved the sharp white highlights for the smooth and scaly surfaces of the beak, claws and central shafts of the flight feathers, using a gentle lightening of the colour for the softer plumage. The red feathers on the main part of the body are wonderfully conveyed in very general terms, with the main clues about the texture given by the directional brushwork at the edges.

MACAW, LOVEBIRDS,
SPANIEL AND TERRIER
Oil on canvas
The Royal Collection, St. James's Palace

The varying textures of skin and hair have always presented a challenge to artists, and anyone interested in

▶ When drawing or painting curly or "flyaway" hair be careful to avoid hard outlines at the edges.

SKIN & HAIR

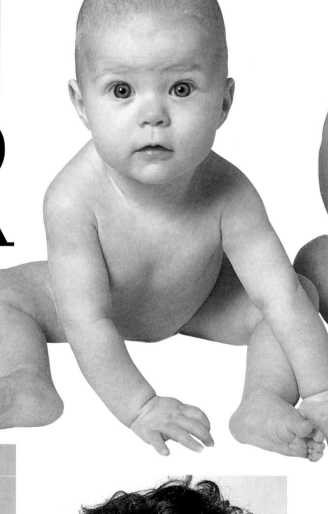

portrait painting will need to consider the best ways of depicting them. How, for instance, do you give the impression of the soft skin of a child, suggest the rougher, more lined skin of a middle-aged person, or the intricacy of frizzy, unruly hair? This chapter provides some useful ideas.

▶ The soft skin and rounded limbs of babies and young children requires careful blending, whatever the medium used.

▼ A dry-brush technique would be suitable for a short beard such as this, or perhaps a mixture of watercolour and pencil.

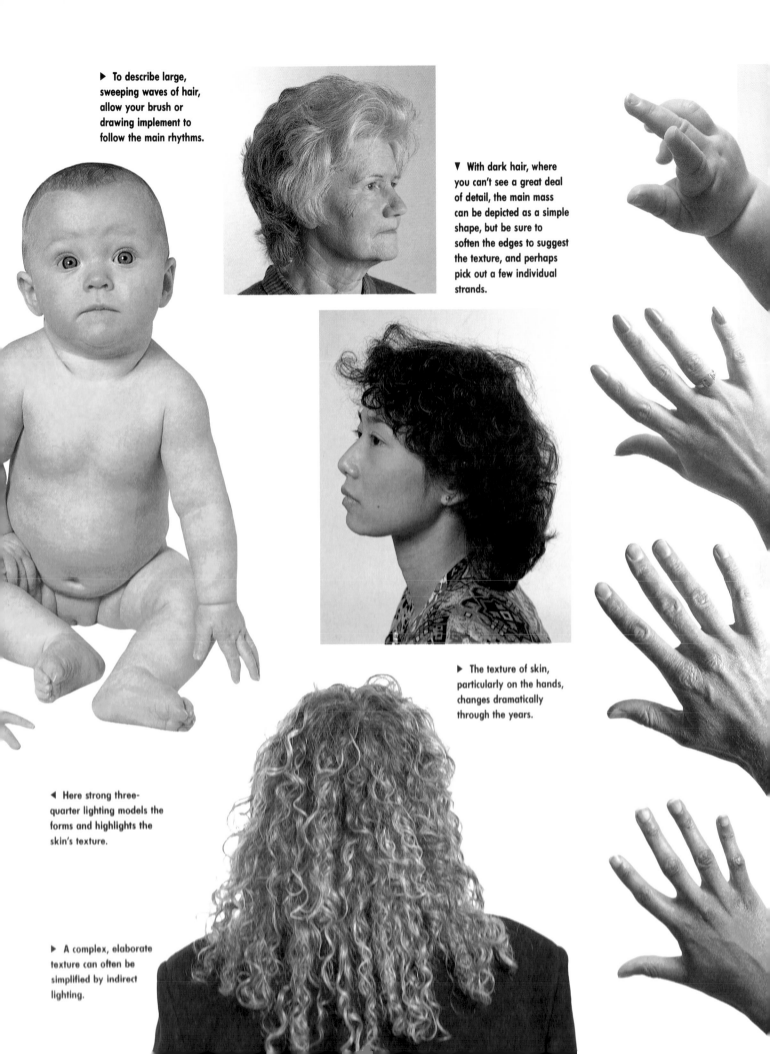

▶ To describe large, sweeping waves of hair, allow your brush or drawing implement to follow the main rhythms.

▼ With dark hair, where you can't see a great deal of detail, the main mass can be depicted as a simple shape, but be sure to soften the edges to suggest the texture, and perhaps pick out a few individual strands.

▶ The texture of skin, particularly on the hands, changes dramatically through the years.

◀ Here strong three-quarter lighting models the forms and highlights the skin's texture.

▶ A complex, elaborate texture can often be simplified by indirect lighting.

One of the many problems the portrait painter has to face is dealing with what are virtually two opposites in terms of texture. The bark of a tree or the fur of an animal is a relatively uniform texture, but human skin is entirely different from human hair, giving the artist the task of finding a technique that can equally well express both. If you were to use a meticulous dry-brush watercolour technique for the hair and a fluid wet-in-wet for the face, the effect would be bizarre and unpleasing, though each of these techniques would be perfectly appropriate in the context of a single texture.

SKIN

Of all the textures discussed in this book, skin is the most subtle and elusive, and painting it so that it looks alive is one of the greatest of all challenges to the painter's skills. Skin is not a homogenous and opaque substance, it is reflective and to some extent translucent, affected not only by what is around it – even the weather – but also by the bone, blood and muscle beneath. The most dramatic changes in the texture of skin are wrought by time; the skin of a baby or young child is soft and "peachy", while that of an old person, especially one who has spent a lifetime working out of doors, can often resemble leather or hide.

But this is not all – the texture also varies according to the part of the body. In an adult, hands and faces, constantly exposed to the air, are nearly always rougher than the torso, covered by its protective layer of clothing for most of the time – something which those who paint and draw the nude must often have noticed. Skin stretched tightly over a bone, such as the nose or forehead, is smoother and more reflective than that with a substantial layer of flesh and fat below. These are just some of the differences you can readily observe in any one person.

The ever-changing appearance of skin has fascinated painters for hundreds of years. For Leonardo da Vinci (1452-1519), unusual in his day for insisting on working only from live models, the differences between individuals in terms of facial expression and skin colour and texture were of paramount importance. Rubens (1577-1640) delighted in the contrasts of different kinds of flesh to help convey the allegorical significance of his figures. Thus a lascivious satyr is given a rough earthy complexion and painted in an expressive style with many of the features dashed in, while a female nude is painted in a subtle blending technique which emphasizes the delicate porcelain-like flesh.

Drawing
& Painting

SKIN & HAIR

Training the eye

Drawing your own hand is excellent practice, and helps you to understand both the textures of skin and the underlying forms. If you find it difficult drawing your non-working hand, use a mirror and draw the reflection. In this pencil drawing the main form of the hand is contained by a precise linear contour, which has been completed by light shading. When adding tone to your drawing use the pencil experimentally to try out different effects.

To practise drawing hair, begin with a style that has clear shapes and forms – you can work from a photograph if you like. Ignore individual strands of hair and instead look for the main rhythms and movements, which you can simplify if necessary. Look out also for the highlights and notice how they tend to move across the main flow of the hair. Different

► Man from Juemaibo
JOHN HOUSER
Pastel
Strong sources of light will always bring out the reflective qualities of skin. In this confident pastel the artist has responded to the bright reflected light by giving it the same intensity as the white material.

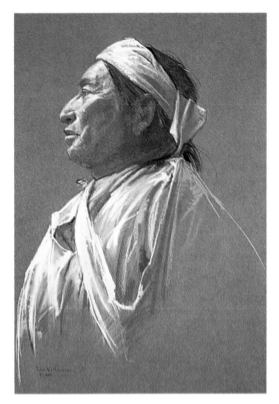

▼ Man with Braids
CARMEN CORRIGAN
Pastel and gouache
The artist has chosen indirect lighting for this portrait to bring out the colours of the skin, and the buff-coloured paper imparts an overall warmth to the picture. Much of the liveliness of the portrait derives from careful attention to the highlights. The bony forehead receives an accent of white and blue, the fleshier nose and mouth have a dash of orange-red, and the wiriness of the beard is suggested by a few well-placed white lines made with the tip of the pastel.

COLOURS AND HIGHLIGHTS

Even when you are drawing rather than painting you need to be aware of the colours of flesh, because colour can provide important clues about texture. A piece of advice from the 14th-century Italian artist Cennino Cennini is revealing – as well as amusing. He was discussing tempera, a medium in which pigment is bound with egg yolk, and he recommended that when mixing colours for young people the artist should use a town egg "because those are whiter yolks", while "for tempering flesh colours for aged and swarthy persons" the darker yolk of a farm egg was more suitable. Although a rather naive generalization, there is truth in it – older skin is usually darker in colour than that of a young person.

An even more important clue, however, is the quality of the highlights. Chapter 1 stressed the importance of highlights in describing texture, and the principle is

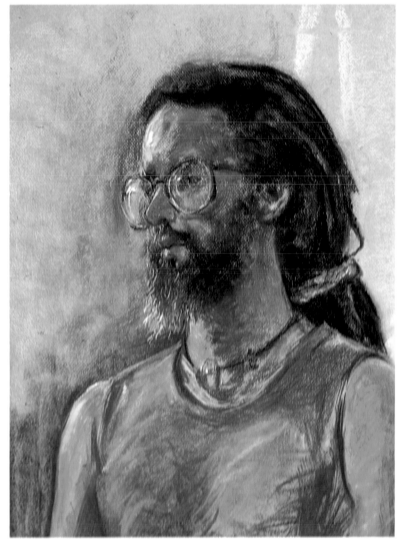

drawing materials can also be useful in showing different textured hair. Pencil, good for soft effects, has been used for the left-hand drawing, with conté crayon giving greater depth and contrast in the right-hand example.

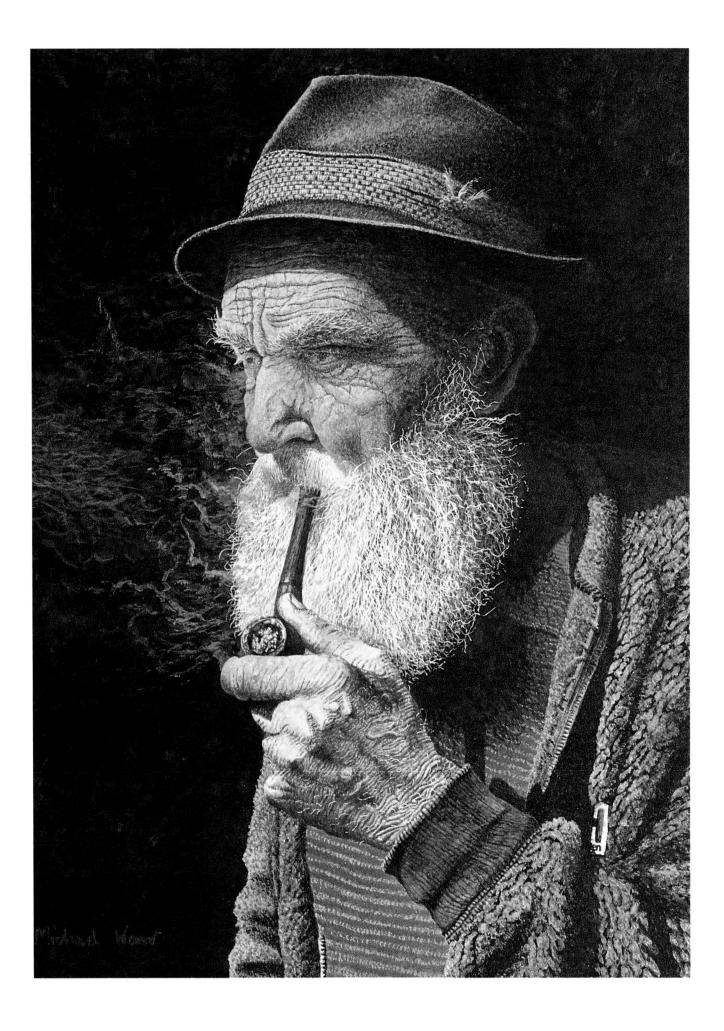

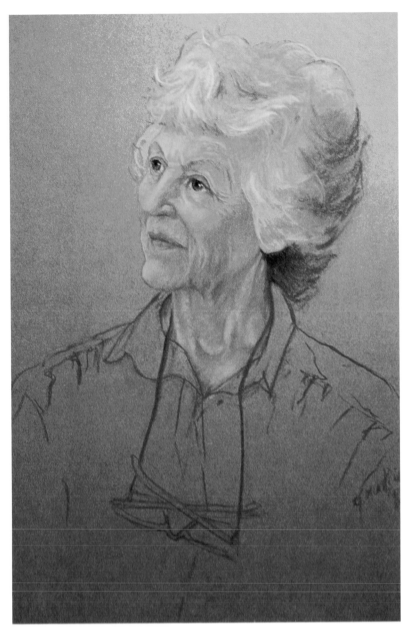

◀ **Dorothy**
GWEN MANFRIN
Pastel
The movement of hair and the sweeping lines of the face give the portrait movement and energy, as well as describing the textures with great accuracy. Pastel is well-suited to this kind of treatment, where the drawing is largely built up from linear rhythms.

◀ **Gertch**
MICHAEL WARR
Acrylic on gesso board
Warr's general approach to texture is to slightly exaggerate the characteristics so that the subject can be seen with greater clarity. Here the creases in the skin are painted in sharp focus so that in areas such as the back of the hand the wrinkles seem almost to be carved out of wood. This artist also works in egg tempera, examples of which medium can be seen elsewhere in the book.

exactly the same for skin, though the effects are rather more subtle. On oily skins the highlights will usually be brighter than on drier "dustier" skins, where it will be more diffused. When painting look out for these highpoints of light as they are extremely important indicators of form as well as texture. They usually occur at corners or where a plane changes direction, for example on the forehead where the two planes of the head meet, or the top of the lip, where the flesh of the lip begins to turn.

HAIR

There is such a range of textures and styles seen on the human head that it is impossible to generalize about them, but there are some points to bear in mind when you are drawing or painting. The most important is to ensure that you relate the hair to the head itself. This sounds obvious, but if your subject has an elaborate hairstyle it is only too easy to become so involved in the intricacies of curls and waves that you forget about the shape of the skull beneath and the way the hair relates to the face. Start by blocking in the main masses and then pay careful attention to the rhythms of the hair.

The way hair flows and falls into a series of gentle waves was a source of particular fascination to Leonardo da Vinci, who saw it as analogous to the movement of water as it eddied and twisted past obstacles; you can see this idea at work in a painting such as *The Virgin of the Rocks* in the National Gallery in London. Starting off as gentle undulations, the tumbling hair of the Virgin then begins to form waves and finally breaks up into those characteristic plaiting forms which Leonardo loved to use in so many of his drawings of water. These analogies can be extremely helpful because they tend to reinforce central ideas such as rhythm and flow which are so essential to being able to paint hair convincingly.

Look for the weight of the hair, too, as this is important in giving shape to the style, even in the case of short hair. All hairstylists know that thick, heavy hair holds its shape better than thin, wispy hair, and the more shape it has the easier it is to paint — you can simplify the forms, using long sweeping brushstrokes that follow the flow of the hair. Thin, frizzy or "flyaway" hair is trickier because it does not always follow the shape of the head very precisely, and is in general more demanding in terms of technique.

The final quality to look out for is the sheen of the hair. For the painter this is the most important characteristic of all, the highlight giving the vital textural clues. Dark oily hair will have very pronounced highlights; thick, dry hair diffused ones, and thin, dry or frizzy hair almost no recognizable highlight.

MEDIA AND METHODS

Pencil is a sympathetic medium for drawing skin and hair because of its ability both to capture the softest nuance of tone and to describe fine lines and rhythms.

PENCIL

For soft skins, such as those of young children, the pencil is best used lightly, as the tonal contrasts will be relatively slight, and an over-emphasized shadow will destroy the light and transparent appearance of the skin. For the more uneven textures of older skin the pencil can be used more energetically, but take care not to stress the more linear aspects of uneven and wrinkled skin too much. A common error is to exaggerate wrinkles so that you end up with a kind of caricature, with each crease shown as a dark line.

For long hair, try sharpening the pencil to a fine, tapering point so that there is plenty of exposed lead and draw using the side and the point of the lead. Use a soft 2B pencil to begin with, and hold the pencil in a way that will give you the sweeping rhythms without feeling restricted. For short, curly hair, try a light scribbling motion, using a combination of different marks.

Impressing An effective method of drawing fine strands of hair is to use a technique of impressing thin lines into the paper with a sharp metal instrument. The method requires a little planning ahead to ensure that the lines will be in the right relationship to the rest of the drawing, but the results can make it well worth while. Use a fairly thick paper and begin the drawing by impressing those strands of hair you want to reserve as white with a fine metal point, such as a nail (not so sharp that it will cut the paper). After this initial statement the drawing can be continued in a traditional manner with a soft pencil, and the impressed lines will remain white throughout the drawing process.

WATERCOLOUR

Although many successful portraits and figure paintings are done in watercolour, it is not the easiest medium to handle for a subject that is difficult in any case, and beginners in watercolour would be well advised to practise before embarking on a human subject. It demands a clear and direct approach, particularly when it comes to rendering the subtle textures of skin. The translucent quality of young skin can often be conveyed by painting wet-in-wet so that

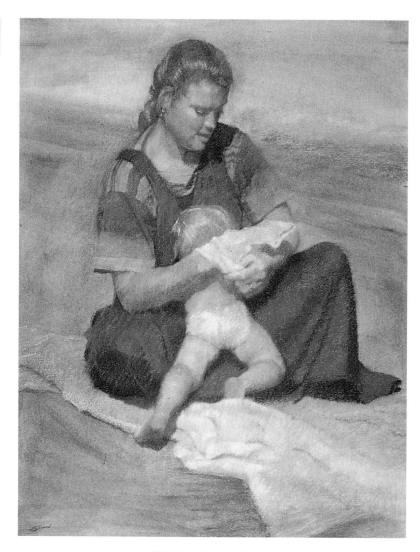

▲ **Mother and Child**
SALLY STRAND
Pastel

On the mother's face and the child's body, the colours are gently blended, while the treatment of the dress is broader, with linear strokes visible in places. Strand works on a large scale, and works on watercolour paper which she first tints with broad washes of watercolour.

colours and tones blend into each other, but for older skin, with a more lined and opaque appearance, you will need a technique which gives more control, especially when it comes to the detail. Instead of broad washes, the texture and form are perhaps best conveyed by broken areas in which the brush is applied in individual touches. Remember, though, that each small wash or brushstroke creates a slight hard edge, so keep these to a minimum by building up gradually and avoiding strong tonal contrasts.

Hair can also be described very well by

Pastel: hair

1 **An off-white coloured sheet of rough (recycled) paper was chosen for this drawing, to act as a sympathetic background and also a basic skin tone.**

2 **The main shape and colour of the hair is laid in with the side of the pastel stick, while detail and movement are suggested with an ochre pastel used in a linear manner.**

3 **Here you can see how the texture of the paper plays an important role in the drawing, breaking up the pastel strokes.**

4 **More dark brown has now been introduced in the shadowed areas near the face, while the outer edges of the hair have been lightly blended to produce a softer effect.**

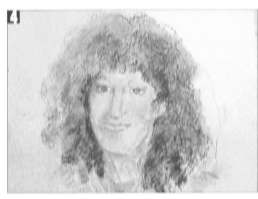

◄ **Self Portrait**
MARTIN DAVIDSON
Oil
For this painting the lighting was kept low and soft so that the slight changes in tone and colour could be easily identified. The painting was made on a fairly coarse flax canvas, which was first given a coat of burnt sienna. The head was loosely modelled with broad colour patches, and the paint was then allowed to dry before further layers were lightly scumbled over the rough weave of the canvas to modify underlying colours.

▲ **Promise**
BEVERLY DEEVY
Pastel
The slight sheen of the skin and the structure of the head are skilfully conveyed by the beautifully observed highlights and the use of warm and cool colours.

2 Watercolour: hair

1 **After making a light preliminary pencil drawing, broad, loose washes are laid over the whole of the hair. These are allowed to dry before crisper definition is added.**

2 **The artist is aiming at a hard-edged effect, so he works wet-on-dry to give distinct edges to each wash. He also uses masking fluid to reserve the clearer highlights.**

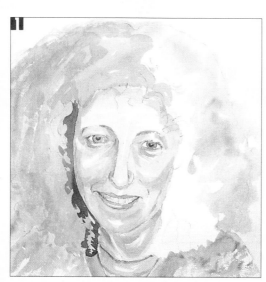

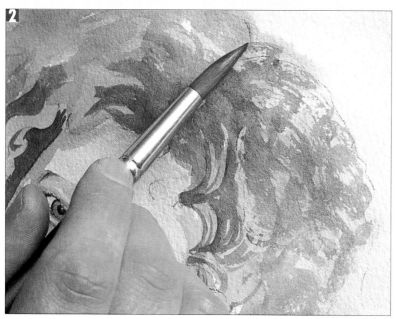

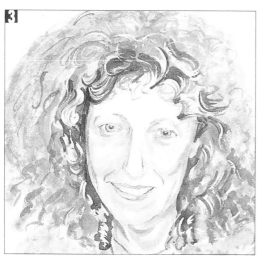

3 **In the final stage the effect of the masking fluid can be clearly seen, giving the effect of "negative" brushstrokes in the area above the forehead.**

▼ **Portrait of the Artist**
JOHN ELLIOT
Pastel
A loose, linear sketching style has been used all over the picture area, giving both liveliness and unity to the picture. For the hair and beard, the artist has used scribbles and short stabs of the pastels, overlaying colours without blending.

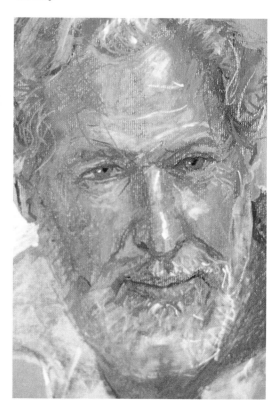

either method, or a combination of the two, with wet-in-wet washes allowed to dry before touches of detail are added. Interesting hair-like effects can also be produced by scratching into watercolour with various implements. These will vary according to the implement used and whether the paper is wet or dry. If the paint is wet the tool will tear some of the paper fibres, creating a darker line by allowing the wash to penetrate further into the paper, but scratching into dry paint will remove the pigment and leave a sharp white line.

Try combining the wet and dry methods to achieve the contrast of the fine dark lines and crisp white ones, and experiment also with a variety of different tools such as the tip of a paintbrush handle, a sharp scalpel blade or a fine-nibbed pen. The technique works best when it is done with speed and confidence, but be careful not to dig into the paper, as this

3 Oil: hair

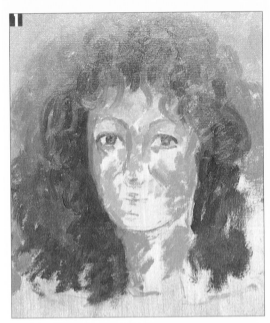

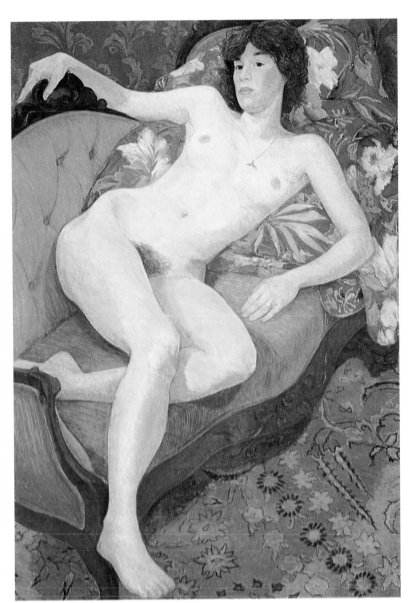

1 The artist begins by blocking in the main areas of colour and tone, painting the hair wet-in-wet to blend the colours.

2 He then uses the handle of a paintbrush to scratch back into the wet paint (sgraffito). This is an effective and simple method for rendering strands of hair.

3 Describing the waves and curls of hair is largely a matter of common sense. Still painting wet-in-wet, the artist uses directional brushstrokes to suggest the complex rhythms.

4 In the finished painting you can see how well the movement of the hair has been suggested by a combination of two well-integrated painting techniques.

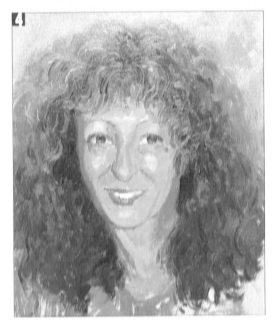

▲ **Arabesque**
ELSIE DINSMORE POPKIN
Pastel
The full richness of the pastel medium has been used to good effect in this elegant nude study. The modelling on the flesh has been kept to a minimum to allow the sinuous and decorative shape of the figure to dominate the composition. Notice how the artist has used strong, warm colours for the surroundings to bring out the cool luminosity of the flesh.

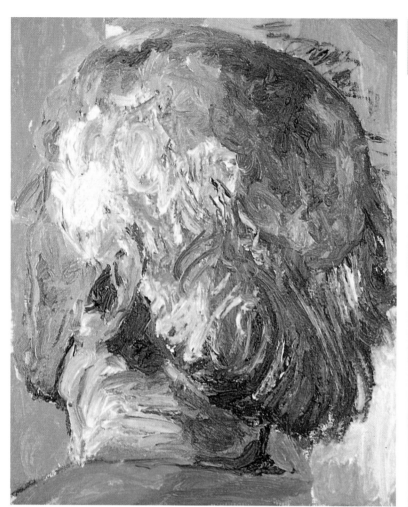

Hand

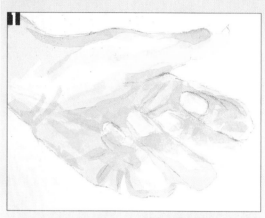

1 After an initial pencil drawing, open transparent washes of ochres and pinkish browns are loosely layered over each other wet-on-dry. Areas of white paper left uncovered help to give a lively impression of skin. Notice how the artist controls the washes on the nails to suggest a smoother surface.

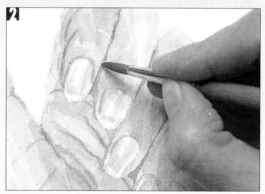

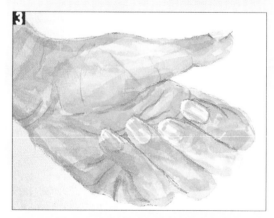

will spoil the surface.

Dry brush, explained in Chapter 6, is another means of establishing fine strands and textures of hair, it is best used in conjunction with washes to give the texture solidity; first establish the main forms of the hair with watercolour washes and then, once dry, add small areas of dry-brush work to suggest the hair. You will probably have to practise to get the tones and colours correct, but the results can be very effective.

PASTEL

Pastel seems the ideal medium for rendering skin and hair, and was extensively used for portraiture during the 18th century. Because it is both a drawing and a painting medium it allows you to achieve a wide variety of effects, from soft blends and subtle gradations of tone suitable, for example, for young skins, to energetic directional marks or broad, flowing strokes with the side of the stick, perfect for representing hair.

Perhaps the only real difficulty with pastel is that you cannot make a very detailed under-drawing, and this is usually necessary for portraiture and figure work. As mentioned earlier, pencil should not be used, and even

▲ **My Father**
SUSAN WILSON
Oil

In this unusual study the artist has clearly been struck by the play of colour on the head and its fringe of grey hair. The paint is applied with irregular brushstrokes, wet-in-wet but with little attempt at blending, and a remarkably wide colour range. To convey the reflective qualities of the skin and also to unify the painting, the artist has introduced shades of the background green into the skin colour. Touches of the blue of the shirt also appear in the hair.

2 Because of the reflective and translucent nature of skin there are rarely any intense shadows. Here a mid-brown is sufficient to give depth and detail to the hand.

3 The only white paper now remaining is reserved for the brightest highlights on the fingernails.

pastel pencil can create problems since it is difficult to erase marks completely, leaving little margin for trial and error. If the subject is relatively dark, charcoal is perhaps the best medium for the preliminary drawing, as mistakes can simply be brushed off, and the charcoal blends in very well with the pastel laid on top.

OIL AND ACRYLIC

One of the most effective methods of rendering the translucency of skin texture is by the method of glazing, a system that involves painting thin films of transparent colour over other dried layers to build up rich colour areas and subtle shadows. Each glaze modifies and slightly alters the preceding ones, because the glaze, being transparent, lets the light pass through and is reflected back from underlying surfaces to produce an optical mixture of colours. If the painting is placed in good light the glazed areas tend to glow and have a lively appearance quite unlike those of opaque paint. As one artist has commented, "the painting seems to breathe".

You can see such effects quite clearly in

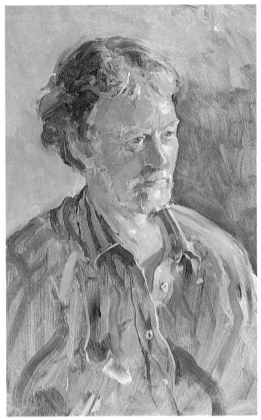

◀ Portrait of Roland
DAVID CURTIS
Oil

The open, "sketching" style of painting makes it possible to see how the painting has been built up. Starting from a warm-coloured ground, the main lights and darks of the composition were established with broad brushstrokes and heavily diluted paint. Thicker paint was then added to model the figure with a more methodical use of the brush. The main form and texture of the hair is largely the result of the first stage of painting, over which the artist has added a few accents of highlight and shadow to complete the effect.

WATER COLOUR

Young skin

1 When painting the smooth skin of children it is essential to avoid too many hard edges. Here they are used only for the distinct shadow areas, such as the brows, while the colours for the rounded cheeks are blended wet-in-wet.

2 Further washes are introduced, with the artist still paying special attention to the balance of hard and soft edges.

3 The hair acts as a frame to the face, but the artist is careful not to treat it in too much detail as this might draw the eye away from the features. The mass of the hair is painted loosely, wet-in-wet, with crisper wet-on-dry brushstrokes over the forehead.

Beard and moustache

1 Beginning with a pencil sketch, the artist blocks in the skin with a loose wash of thinned gouache paint, leaving the area of the beard unpainted.

2 Since some skin colour shows through the beard in places, light pinkish washes are added to the area, followed by a pale grey for the lightest tone of the beard.

many of the paintings of the old masters. Rembrandt used glazes both in shadow areas, where the underlying paint was left very thin, and over the thicker areas of impasto, where they settled in the cracks and crevices of thick paint, emphasizing the physical texture of the paint surface. Rubens in many of his works, achieved his flesh tones by glazing warm colours over an underpainting of terre verte (green), to produce a subtle balance of cool and warm colours that beautifully suggest the translucency of skin.

Glazing, like most traditional oil painting techniques, is a slow process, as each layer of paint must be completely dry before the next one is added. For this reason it went out of favour for some time, but is now gaining a new popularity, particularly with acrylic painters. Acrylic dries so rapidly that it is seldom necessary to wait for more than half an hour for each glaze to dry. Oil painters who like the technique often use acrylic for the first underpainting, or even for most of the painting, and glaze on top of this with oils.

To make sure the glaze has an even consistency and will not run, use one of the glazing mediums sold for the purpose. These are specially formulated to give a tough and flexible lustrous finish to the glaze. If you want an even, thin film of colour, apply the glazes a little like a watercolour wash with a large, flat soft-haired brush. If you want a little variety, it is easy to modify a glaze by

4 One of the tricky aspects of a painting such as this is to ensure that the different painting techniques are fully integrated. Here the detailed treatment of the beard is balanced by the clear line of the mouth, glasses and eyes.

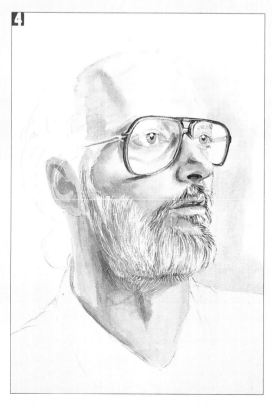

3 A darker grey wash is now applied to build up the density of the beard, and fine lines added to indicate the dark hairs. Thicker white paint is then used, the directional brushstrokes following the line of the hair from the root and tapering at the tip.

partially blotting with paper or rag, laying it unevenly, or wiping with your hand.

Brushmarks A method well suited to the rather leathery appearance of old skin is to apply the paint quite thickly, working wet-in-wet so that the marks of the brush and the way the colours blend together help to describe the more rugged textures. If you look at a Rembrandt painting, particularly any of the late self-portraits, you will see how effective this method can be, the rich build up of paint giving a lively appearance to the skin. There are no hard edges – in places colours blend softly into each other, while in others they remain as separate brushmarks.

This use of discrete brushmarks for rendering flesh tones can also be seen in the work of the painter Lucian Freud. Unlike Rembrandt, who preferred soft lighting, Freud works much of the time by bright fluorescent lights which gives a harsh appearance to the skin. His interest in the expressive possibilities of oil paint has also led him to choose pigments that would give a rich, thick deposit of colour. For this reason he uses Cremnitz white, a heavy lead-based paint, as the main pigment for his flesh tones; this provides the necessary density and fullness to the finished work.

Middle-aged skin

1 **A careful drawing made with a fine brush and burnt umber is the first stage, after which the main colours and tones are established.**

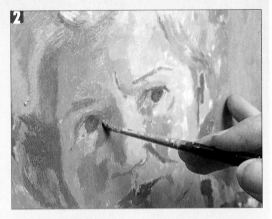

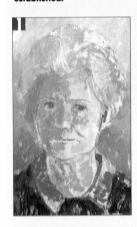

2 **The artist continues to model the head, placing a series of small, separate brushstrokes, but avoiding too much detail at this stage. He pays special attention to the role of warm and cool colours** (notice the touches of blue and green on the forehead). While the tones establish the shapes and forms, it is the colours that give the skin its distinctive character.

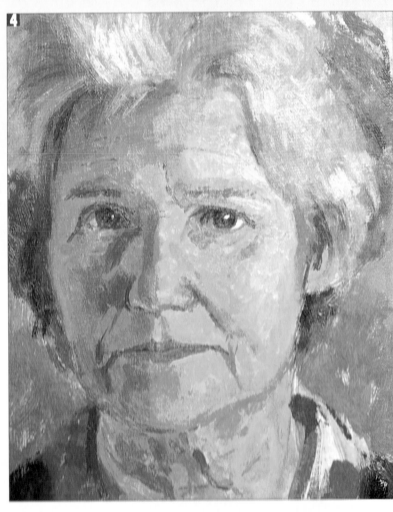

3 **Once the skin colours of the face are completed the finer detail such as the lips, can be added. It is always much easier to assess the correct value and intensity of colour for a detail such as this with the surrounding colours in place.**

4 **The texture of the skin is suggested rather than described in minute detail, though in the final stages the artist has used a fine brush with reddish brown paint to add small touches of crisp definition.**

Removing paint Inexperienced oil painters often find that applying the paint thickly can result in problems – the paint layer simply becomes too thick and unwieldy, and any new colour added mixes with those below. When this happens you can, of course, scrape some of the paint off with a palette knife, but a better method, particularly if you don't want to lose the main lines and tones of the composition, is to remove the surplus paint layers by blotting with absorbent paper such as newsprint.

This method is known as "tonking", after Henry Tonks (1862-1937), one-time professor of painting at the Slade School of Art in London. He used it to remove the top layer of paint after each working session, thus providing a dry surface for subsequent work. It is particularly useful in portraiture because it eliminates details, giving a thinned out version of the painting, with the main

▶ **Loris in Pink**
DOUG DAWSON
Pastel

The smoothness and slight sheen of the skin is indicated by the close colour range and the comparatively bright highlight on the cheekbone. The artist has also cleverly emphasized the skin by contrast: on the face, neck and breast the pastel colours have been softly blended, while a rougher, more energetic treatment has been used for the clothing and background.

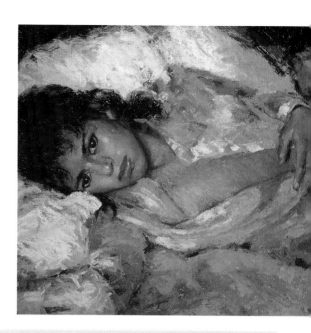

Long hair

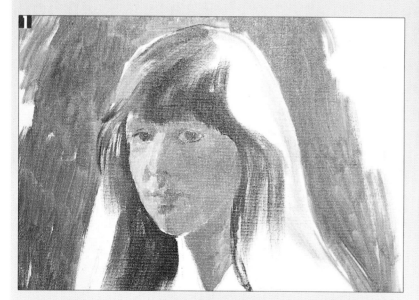

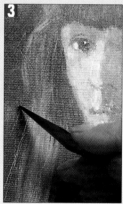

3 She now mixes the paint with a medium called Liquin, which makes it flow well, and describes the hair with downward sweeps of a soft brush.

4 The combination of sgraffito and thinly painted oils has created a delicate and lively portrait.

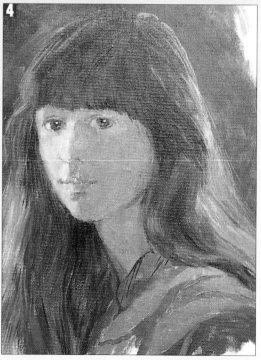

1 Having made a light pencil drawing on canvas board, the artist uses paint well-thinned with turpentine to block in the main colours and tones.

2 With the thinned paint now dry, she scratches into it with the point of a painting knife to suggest the fly-away strands of hair catching the light.

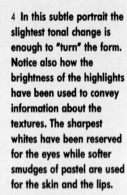

PASTEL

Dark skin

1 The colour of the paper is important in pastel work, and here the artist has selected one that serves as the main skin colour. She begins with an underdrawing in charcoal, which blends well with pastel.

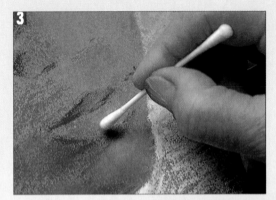

4 In this subtle portrait the slightest tonal change is enough to "turn" the form. Notice also how the brightness of the highlights have been used to convey information about the textures. The sharpest whites have been reserved for the eyes while softer smudges of pastel are used for the skin and the lips.

2 Brown pastel, in a darker tone than the paper, is now introduced to model the cheeks, nose and mouth, and white is used to bring the head forward and produce soft highlights on the forehead, cheek and chin.

3 The colours on the lips are blended with a cotton bud, a useful and sensitive implement for small areas.

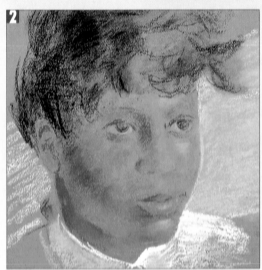

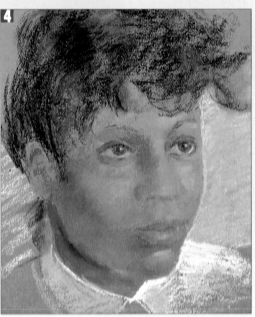

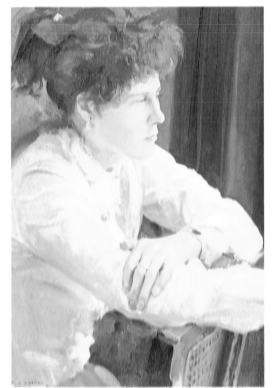

◄ Portrait of Amanda
DAVID CURTIS
Oil
The texture of the skin is beautifully observed; with only minute changes in colour and tone, the artist manages to capture the delicate luminosity of the skin. The effect is heightened by the white blouse, so that the reflected light seems to envelop the whole head with light. The hair has been painted with broad, soft directional brushstrokes, with the dusty brown-greens in perfect harmony with the pale skin of the face.

structure still intact. It is usually the details, such as eyes and mouths, which become too heavily loaded with paint, since there is a tendency to overpaint in order to correct mistakes. Sometimes you will find that a painting which has been tonked needs very little more work, or even none at all. I have found, for instance, that this softer, simpler paint surface perfectly expresses the texture of hair, giving it an overall unity which can be completed by adding just a few details.

A related method is removing paint with a knife. Like tonking, this is seen primarily as a correction method, but it can also be used creatively to produce a whole range of effects suitable for hair textures. Areas of paint are removed from the canvas with the flat edge of a palette knife or some other implement, leaving the paint between the weave more or less untouched. This could be a good method for broad, diffused highlights on long hair, while for more detailed areas where you want to suggest individual hairs or strands of hair, you could use implements with finer points such as a brush handle or knitting needle.

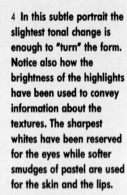

139

osalba Carriera (1675-1758) was a Venetian artist and a remarkable pioneer. As well as being one of the first to exploit the pastel medium seriously, she was also one of the first women artists to make a successful career out of her work. Travelling throughout Europe, she specialized in rather flattering portraits, winning many important commissions. Her work also had a great influence on contemporaries such as Quentin de La Tour (1704-88), one of the great names in pastel portraiture. She favoured a rather subdued palette, and was praised by critics for her "light precise touch" and the "happy harmony of colour only she knew".

FOCUS ON
Carriera

▶ This portrait shows Carriera's mastery of the medium, and also demonstrates how well suited it is to the delicate textures of skin and hair. The techniques range from an extremely delicate fusion of colours to looser and more suggestive strokes and fine, precise drawing. The portrait was probably made on a rag paper (made from linen or cotton fibres), and the pastel has picked up the small surface fibres, giving an added richness to the build-up of the colours.

▶ Pastel is a wonderfully sympathetic medium for conveying the translucency of skin. The artist has softly modelled the forms of the face, blending the colours together to produce soft and subtle gradations of tones and colours. The soft turning of the lip is particularly well observed, the range of colours used showing the confidence of an artist thoroughly at home with her medium. Pastel has been added directly and without modification to introduce colour on the bottom lip and the nostril, while on the top lip a blue-purple colour has been introduced to give a faint suggestion of "five o'clock shadow".

▲ To show the texture of the wig Carriera has used a much bolder approach, catching the general powdery effect of light by exploiting the texture of the fine-grained paper. Instead of blending the final layer of pastel, she has finished off by lightly following the main lines of the hair with a loose and broad use of the white pastel. The soft transitions between the hair and the skin, and the hair and the background, are so delicately controlled that the eye is always drawn back to the more focused and detailed features of the face, in particular the heavy-lidded eyes.

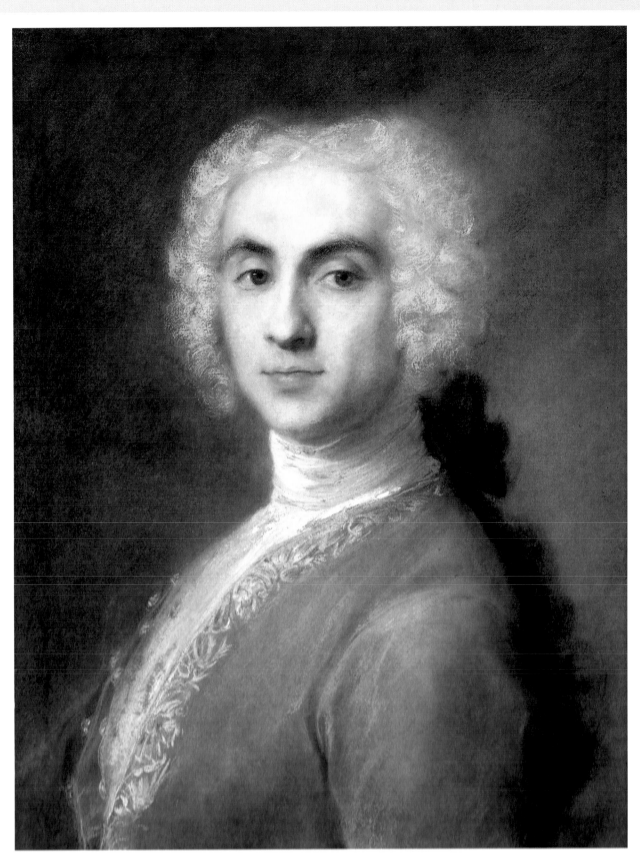

PORTRAIT OF A MAN
Pastel
National Gallery, London

Index

Credits

Quarto would like to thank all the artists whose work has been reproduced in this book, and in particular the following, who loaned work and/or agreed to do demonstrations but whose names do not appear in the captions:

Martin Davidson p 64; Jeremy Galton pp 18, 36 left, 41, 46, 57, 66-7, 72, 95, 99; Walter Garver p 108; Hazel Harrison pp 15, 38, 87, 107, 117, 131, 138, 139; James Horton pp 86, 97, 133, 137; Ronald Jesty pp 44, 64; Jan Kunz p 135; Sally Launder pp 12, 22, 30, 36 right, 47, 67, top, 74, 84, 91, 104, 126; Judy Martin pp 14, 20, 37, 47, 54, 71, 107, 111, 113, 116; Roy Preston pp 48-9; Mark Topham pp 21, 23, 39, 52, 66 top, 68, 79, 87, 92, 106, 132, 136; Michael Warr p 17.

Quarto would also like to thank NATURAL IMAGE for the work of the following photographers: Bob Gibbons p 103 middle; J Poole p 102 bottom right; Mike Powles p 102 middle, 103 bottom.

Thanks also to the following museums and galleries for supplying transparencies and giving permission to reproduce works in their collections:

William A Farnsworth Library and Art Museum pp 60-1; Staatliche Kunstsammlung, Dresden pp 80-1; Kunsthistorisches Museum, Vienna pp 100-1; Royal Collection, St James's Palace © Her Majesty the Queen pp 122-3; National Gallery, London pp 140-1

Special thanks to John Elliot, who researched pictures by American artists.